The Medieval Calendar Year

Bridget Ann Henisch

The Medieval Calendar Year

The Pennsylvania State University Press
University Park, Pennsylvania

Library of Congress Cataloging-in-Publication Data

Henisch, Bridget Ann.
 The medieval calendar year / Bridget Ann Henisch.
 p. cm.
 Includes bibliographical references and index.
 ISBN 0-271-01903-4 (cl. : alk. paper)
 ISBN 0-271-01904-2 (pa. : alk. paper)
 1. Calendar—Europe—History—To 1500. 2. Calendar art—Europe—
History—To 1500. 3. Civilization, Medieval. 4. Social history—Medieval,
500–1500. 5. Seasons—Social aspects—Europe—History—To 1500.
6. Europe—Social life and customs. I. Title.
CE57.H46 1999
529′.3′094—dc21 99-20706
 CIP

Copyright © 1999 The Pennsylvania State University
All rights reserved
Printed in Canada
Published by The Pennsylvania State University Press,
University Park, PA 16802-1003

It is the policy of The Pennsylvania State University Press to use acid-free
paper for the first printing of all clothbound books. Publications on uncoated
stock satisfy the minimum requirements of American National Standard for
Information Sciences—Permanence of Paper for Printed Library Materials,
ANSI Z39.48-1992.

Contents

To Heinz

Preface
and
Acknowledgments

The pictorial calendar convention known as the "Labors of the Months" has a very long history and a very wide circulation. So vast a subject warrants study from many points of view, and light may be shed on it from many lanterns. The present treatment does not explore in any detail the sources of the tradition in the classical past, or its ebb-tide after the early sixteenth century. Instead, the motif is here considered mainly as it was used in that period when enthusiasm for it in Western Europe was in full flood, during the later Middle Ages.

The "labors of the months" cycle depicts the year as a round of seasonal activities on the land. Each month has its allotted task, and each of these represents one stage in the never-ending process of providing food for society. The animated little scenes offer delightful glimpses of everyday activity, and for this very reason have often been used as illustrations of daily life in the medieval world. Their surface-realism is deceptive, however, and the aim of this study is two-fold: to explain the principles of selection which shaped the cycle and determined its contents, and to examine the ways in which the conventions and assumptions of art at a particular time styled and disciplined the unwieldy, unsatisfactory complexities of life, to create an image of reality more beguiling and beautiful than any attempted re-creation of reality itself.

As an armchair scholar, I may glean only where others have already harvested. I owe one debt that can never be paid, to the patient work and

careful records of those who have gone before me in the field, and another to the photographers whose unsung labors have brought to my study so many treasures scattered here and there throughout the world. Thanks are due to the following institutions for permission to examine and reproduce images from their collections:

Die Bayerische Staatsbibliothek, Munich
The Bodleian Library, Oxford
The British Library, London
The Burrell Collection, Glasgow
The Carnation Gallery, State College, Pennsylvania
Musée Condé, Chantilly
The Fitzwilliam Museum, Cambridge, U.K.
The Folger Shakespeare Library, Washington, D.C.
The J. Paul Getty Museum, Los Angeles
The Houghton Library, Harvard University, Cambridge, Massachusetts
The Metropolitan Museum of Art (Cloisters Collection), New York
Newnham College, Cambridge, U.K.
The Pattee Library, The Pennsylvania State University, University Park, Pennsylvania
The Pierpont Morgan Library, New York
The Victoria and Albert Museum, London
The Walters Art Gallery, Baltimore

The staff of the Rare Books Room and of the Interlibrary Loan Service at The Pennsylvania State University's Pattee Library have been helpful at every turn, as has the University Photographic Service. I am, besides, grateful to many friends who have followed the quest with affectionate interest over the years, and drawn attention to special points and special treasures along the trail: Priscilla and Nigel Bawcutt, Sandra and Ron Filippelli, Diana and Robin Gregson, Jean and Ernest Halberstadt, Charles Mann, Nolene Martin, Marianne and George Mauner, Bernice and Brian Read, Anna Ross, Susan Scott, Lorna Walker, Phoebe and Peter Wilsher, Marion and Philip Winsor, Carol and John Wood, and Vicky Ziegler.

Above all, I thank my husband, the Merlin who with his computer has conjured order out of chaos, and the staunch companion who has shared the pain and pleasure of the journey, every step of the way.

1

In Due Season

When a medieval artist was told to illustrate a calendar, he knew exactly what he was expected to provide. It made no difference whether he was working in wood or in stone, tracing the design for a stained-glass window, or brushing gold onto a sheet of vellum. He reached into his store of patterns and pulled out not twelve scenes, or emblems, one for each month of the year, but twenty-four. One illustration showed a characteristic occupation for the month, and the other displayed the month's dominant zodiac sign. The artist then proceeded to group his pictures in any number of configurations, of which the simplest and most straightforward was the matched pair, as can be seen in Color Plate 1-1, an example from a fifteenth-century French manuscript that offers a crude and cheerful representation of July, with a man cutting wheat in one compartment, and Leo the Lion flourishing his tail among the stars next door.

The presence of the occupation scene can be readily understood. The

sequence of twelve activities, almost always drawn from the countryside and the farm, represents the annual, endlessly repeated, cycle of necessary, basic tasks which put food on the table. The presence of the zodiac sign needs a little more explanation. The zodiac is the narrow pathway across the sky in which the sun, the moon, and the principal planets seem to move throughout the year. It is divided into twelve equal sections, or signs, each named after a constellation whose position once, long ago, lay within it. The sun passes through one of these sections each month, as it makes its progress from one year's end to the next. Because the sun was all-important in the life of men and women, its movements were studied with the greatest attention, and it was only natural and fitting that the twelve divisions of the calendar should be marked with the zodiac signs, as reminders of the sun's journey through the sky, as well as with the scenes that show the round of labors needed to sustain society on the earth below.

The general outline of the "labors cycle" is clear. As the year unfolds, each season has its own special character and concerns. The winter months are spent indoors, in feasting and keeping warm by the fire. In the early spring work begins on the land, getting it ready to yield the best crops in the months ahead. At spring's high tide, in April and May, there is a pause to celebrate the new life bursting out of the ground, the vigor and vitality coursing through the world's veins. After the joy, the hard work starts again. June, July, and August are dominated by the raking of hay, the reaping of wheat, and the threshing of grain. In September, attention turns to the grape harvest and the making of wine. In the late autumn, fields are plowed and seed is sown, for next year's food supply, and animals are fattened and killed, to make sure there is plenty to enjoy when the year swings around once more to the time for feasting by the fireside.

There may be many small deviations from the pattern in the details of any given cycle, but it is never hard to trace the overall pattern itself, or to identify the major divisions within the framework. To make matters even simpler, the occupation scene for each month is usually linked in some way with the month's zodiac sign, whose familiar emblem helps to pinpoint the position of each activity on the year's map:

January	Aquarius, the Water Carrier
February	Pisces, the Fish
March	Aries, the Ram
April	Taurus, the Bull
May	Gemini, the Twins

June	Cancer, the Crab
July	Leo, the Lion
August	Virgo, the Maiden
September	Libra, the Scales
October	Scorpio, the Scorpion
November	Sagittarius, the Archer
December	Capricorn, the Goat

Little jingles—like the following, copied down in mid-fifteenth-century England—also served to make the general plan well-known and easy to remember:

Januar	By thys fyre I warme my handys;
Februar	And with my spade I delfe my landys.
Marche	Here I sette my thynge to sprynge;
Aprile	And here I here [hear] the fowlis synge.
Maij	I am as lyght as byrde in bowe;
Junij	And I wede my corne well I-know [enough].
Julij	With my sythe [scythe] my mede [meadow] I mawe [mow];
Auguste	And here I shere my corne full lowe.
September	With my flayll I erne my brede;
October	And here I sawe [sow] my whete so rede.
November	At Martynesmasse I kylle my swyne;
December	And at Cristesmasse I drynke redde wyne.[1]

Such a bare-bones account of the scheme sprang from the same stock as the rhyme, chanted by children throughout the centuries, that begins "Thirty days hath September." Each was designed to jog the memory, and to become part of the baggage of useful information carried by everyone through life, rather like those tables of weights and measures, national currencies and capitals, found in any self-respecting diary today. Indeed, there still exists a medieval almanac, made in England in the late fourteenth century, in which an extraordinary amount of practical advice has been packed onto six sheets of parchment, cut and folded individually to pocket size. There, tucked among ways to predict weather, war, birth, death, and harvest, a table with which to work out the date of Easter, and pictures of the major saints honored in the church year, is a tiny labors cycle.[2] Its inclusion in this kind of portable potpourri offers a hint of just how much a part of the mainstream the tradition had become.

The months and their activities were thus lodged securely in the conventional wisdom about mortal life on earth that furnished the medieval mind. Their place was ensured, because the cycle itself was a familiar decorative detail in the much-frequented settings of the everyday world. It was possible for anyone, in any rank of life, to find the little scenes in very public places. They have been woven into the intricate mosaic design of the mid-twelfth-century marble floor of the nave in the cathedral at Otranto, in southern Italy, a floor walked over or knelt on by every member of the congregation. In the early thirteenth century they were used to decorate a baptismal font at Lucca, and the pillars of a doorway on the west front of Notre-Dame in Paris. The pictorial scheme had been part of the mental landscape and the daily scene for a very long time. On the mosaic floor made at the beginning of the twelfth century before the altar in the crypt of San Savino in Piacenza, the occupation scenes and the signs of the zodiac are surrounded by appropriate quotations about the seasons, from the Latin *Eclogues* of Ausonius, composed in the fourth century A.D.[3] In short, the convention was widespread, long established, and well-known. And so, when Chaucer turned to the tradition for an image of winter,

> Janus sit by the fyr with double berd [beard],
> And drynketh of his bugle-horn the wyn [wine]
> [*The Franklin's Tale*, lines 544–45],

—or when his contemporary, Gower, evoked the season of high summer in two lines,

> Whan every feld hath corn in honde
> And many a man his bak [back] hath plied [bent]
> [*Confessio Amantis*, Book 7, lines 1098–99],

each poet could be confident that his glancing allusion would be noted and understood by every reader.

Over the centuries, the tradition of calendar illustration became as comfortable as an old slipper. And just because it was so comfortable, the artist could play with it, presenting the same dear, familiar scenes in a variety of conventions, from the use of isolated figures set against a plain or patterned background (Color Plate 1-1), to groups of people moving in a fully developed landscape; see Figs. 1-2, 1-3.

The calendar tradition had very long roots, tapping into the classical

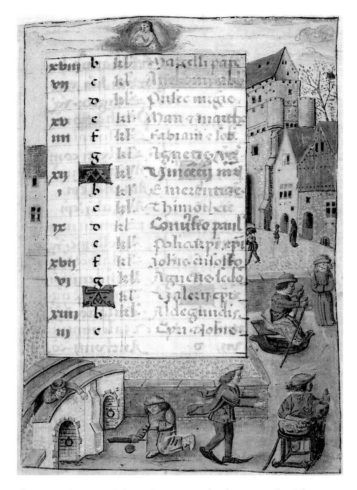

Fig. 1-2. January. Winter Sports. Book of Hours, Flemish,
c. 1490. The British Library, London, Add. MS 18852, fol. 2 recto.
By permission of The British Library.

past. In Western Europe, we begin to find traces of it from the ninth century onward; by the twelfth century it had become firmly established, and was to grow especially strong and popular in France, Italy, England, and Flanders. As the Middle Ages drew to a close in the early sixteenth century, the convention still showed great vitality, with splendidly rich examples in those devotional manuals known as "books of hours," many made in Flanders for an international market.[4] The illustrations used in this

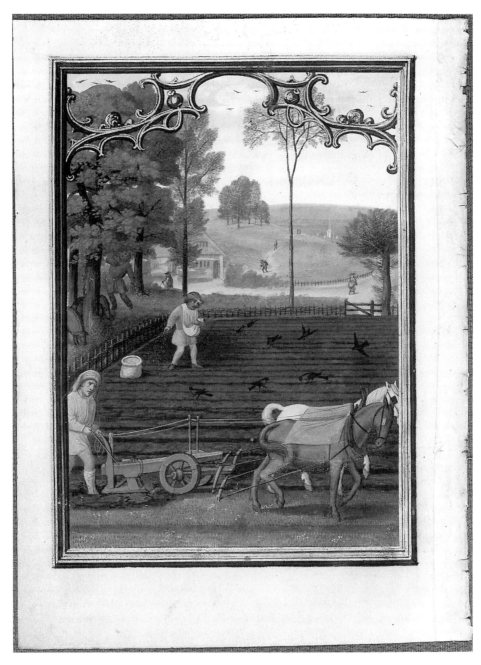

Fig. 1-3.　September. Plowing and Sowing. Da Costa Hours, Flemish (Bruges), Simon Bening and others, c. 1515. The Pierpont Morgan Library, New York, MS M399, fol. 10 verso.

study come indeed from Flanders and the other major centers, but the little figures that animate the cycle's scenes respected no frontiers. They were common coin, found and familiar in every corner of the civilized world. They decorate the calendar pages of a Byzantine copy of the four Gospels, composed c. 1100, probably at a monastery in Constantinople,[5] and they have left their traces in one or two Jewish manuscripts made in Italy in the late fourteenth and mid-fifteenth centuries.[6]

The name often given to the tradition is "The Labors of the Months," but in fact by the end of the medieval period it had become a cycle of occupations rather than labors. Thus, for instance, Fig. 1-2 bubbles with activity, but it is fun, not duty, that calls the tune. Several small pleasures of the seasons were tucked from time to time into the scheme, from snowball fights in December (Fig. 6-19), to boating parties in May (Fig. 7-11). But, however frivolous the incidental details of any particular calendar might become, always at the core there was the round of activity on the land, planned to pile provisions high in the larders of society.

The cycle might be shown anywhere, up on a roof boss, or down on a misericord, half-hidden in the shadows beneath a choir-stall. It could decorate the pages of a book of hours, for the private pleasure of a private owner, or be carved as a public statement for all to see, around the imposing entrance to a great church. The choice of subject for each scene is governed by tradition, and a remarkable overall consistency is sustained, whatever the cycle and wherever its chosen setting may be. Inevitably, however, the context in which an individual example is placed has its effect on the way in which it is regarded. The cycle changes with circumstance and, like a chameleon, assumes the color of its surroundings. Set inside an intellectual or theological framework, it is a consciously chosen detail in a didactic design. When sculpted as an ornamental band, surrounding the twelfth-century relief of the Last Judgment on the west front tympanum of the cathedral at Autun,[7] or painted on a ceiling in the eleventh-century cathedral of León, as part of a picture scheme whose central figure is that of Christ as lord of the universe,[8] the little calendar scenes are invested with the high seriousness of the entire teaching program in which they play a role.

By contrast, whenever a calendar scene escapes from the confines of such a frame and stands alone, it can be enjoyed just for itself, as a delightful decoration. Thus, the stained-glass roundel for February shown in Fig. 2-8 was placed in the window of a private house as a luxurious embellishment, a charming, cheerful addition to the dining hall.

Most of the illustrations in this study have been chosen from the calen-

dar pages of psalters and books of hours—for example, Fig. 1-2. Placed at the beginning of such a volume, this calendar section contains practical information about the feasts of the church and the saints' days for each month, but it is separated physically, by the turn of a page, from the spiritual programs of daily devotions which make up the main body of such a manual; see Appendix. Safely corralled and isolated in this way, the little "labors" scenes no longer seem burdened with any special significance. Within this neutral space, artists were free to deploy them as ornamental motifs or to develop them into more ambitious and absorbing vignettes of daily life.

No matter where it appeared, whether in solemn majesty or as light-hearted frivolity, the calendar cycle was the embodiment of a deeply-felt, long-held belief that human life on earth was an unending round of work, shaped and driven by the year's unending round of seasons. It was an accepted truth that Adam's fall from grace had led to the punishment of incessant toil and struggle in the world beyond the gates of Paradise. The terrible words of God to the unhappy sinner in the third chapter of Genesis summed up the consequences: "In the sweat of thy face shalt thou eat bread, till thou return unto the ground; for out of it was thou taken: for dust thou art, and unto dust shalt thou return" (Genesis 3:19). Nature herself had been corrupted by the disobedience of Adam and Eve, and the corruption showed in Nature's contrariness, and lack of cooperation with her masters' efforts: unpredictable weather, difficult soils, rampaging weeds, ravening wildlife. Adam had been God's first gardener in Paradise, but his undemanding round of duties in that blessed enclosure was but a poor preparation for the realities he had to face once thrust into the hostile world outside. To drive the point home, in some pictures of the expulsion he is handed a spade as a parting present by a reproachful angel. It was a very rude awakening.[9]

Although the curse of unending toil had been laid on the whole of society, not everyone was expected to toil in the same way. Every man and woman had to face a verdict after death on the life they had led on earth, but there was no expectation that, in this world at least, the reward for effort would be quite the same in every case. According to a very simplified shorthand scheme, which remained popular as a teaching-tool for centuries, despite its obvious limitations, society was served by three groups: those who looked after its spiritual needs, those who defended it against injustice, and those whose job it was to feed it: the Church; the governing class of kings, lords, and knights; and the laborers. It was a

coarse but convenient grid, laid over the teeming complexities of real life, to create a bold, easily memorized platitude.[10]

Of these three groups, all were necessary, but some, undoubtedly, were more equal than others. Just as history is usually written by the victors, so rules are drawn up by those already in position to derive most benefit from them. The relations between two, the Church and the secular government, showed an endless jockeying for real power in the world throughout the period. The third group, of laborers, was regarded, by and large, as a necessary evil. It was worked very hard, punished harshly for ordinary misdemeanors, and ruthlessly for any stirrings of revolt. It was also held in some contempt. Then, as now, there was no strong desire felt by those blessed with some comfort and authority in their own way of life to change places with anyone in obviously less agreeable conditions. Voluntary poverty, accepted as a spiritual education, was one thing. Ordinary, grinding poverty imposed by circumstance was quite another, and often had a dishearteningly bad effect on the character of its victim. Preachers pointed out, frequently, that as much pride, and greed, and anger, lurked in a peasant's heart as in that of the most arrogant baron.[11]

The poor, in short, were not very attractive, not in clothes, in appearance, in habits, in situation. That remarkable man, Henry Grosmont, Duke of Lancaster, who was not only one of Edward III's great magnates and military commanders but also a devout layman who was able to write his own manual of devotion, confessed there, quite frankly, that he did not like the smell of the poor. He was sorry for that, he prayed for forgiveness, but there it was: he found the smell most disagreeable.[12] The same kind of attitude is found in another aristocratic author, Joinville, the biographer of Saint Louis, King of France. He loved and honored his master as a saint, but was appalled when Louis insisted on following Christ's example to the letter and actually knelt to wash the feet of some poor men on Maundy Thursday. Joinville's rigid disapproval is recorded in his own book,[13] and remembered in an early fourteenth-century illustration of the scene.[14]

The lot of the poor was sometimes described with compassion, and the figure of the honest worker was sometimes held up for imitation, but even in such cases the emphasis was on the harshness of the peasants' life, the courage and obedience with which they shouldered their heavy burdens. Remarkably little was ever said in praise of the good sides of that life. It is very rare to come upon this kind of remark, set down in a schoolboy's exercise book in the late fifteenth century: "It is a great pleasure to be in

the contrey this hervest season . . . to se the Repers howe they stryffe who shal go before othere."[15]

To turn from the written record to the pictorial calendar is to step with a shock into a very different world. In comments about the peasant and life on the land, the three notes most often struck, whether in sermons, in manuals for priests, or in the secular literature of the age, are contempt, criticism, compassion. Not one of these is sounded in the labors of the months tradition. In the calendar cycle, men and women seem to have exchanged one paradise for another. Admittedly, they are always busily at work throughout the year, but in circumstances never to be matched this side of heaven.

The emotional tone of the cycle is noticeably calm. This is one of the few places in medieval art where serenity, not suffering, is the order of the day. The pictorial presentation of the passing seasons is pierced with no sense of sin, no sense of paradise lost. The harmonies are disturbed by no fear of death, no forebodings of disaster. There is no hint of the effervescent high spirits proper to musical comedy, but everywhere we look there is an air of quiet purpose and confidence; Fig. 1-3. The figures know what they are doing; no one is getting in anyone else's way, no quarrels flare up. No one is in despair that he will ever finish the job in time. The work may be back-breaking, but it is never heart-breaking.

One reason for this happy state of affairs is that the weather is always accommodating, always appropriate. No untimely drought shrivels the new growth of springtime; no sudden hailstorm flattens the harvest. Nature provides the right weather, at the right time; workers take the right action to reap best advantage from ideal conditions.

Peace of mind is further guaranteed by the fact that not only the weather but also the equipment is in perfect shape. The necessary tools for any job are always in working order. We never see a broken plow-share or a rusty bill-hook, and there is never any sign of an accident.

In the world set forth in medieval literature, it is not hard to find distinctly unflattering descriptions of the peasant's physical appearance:

> His hosen overhongen his hokschynes. on everiche a side,
> Al beslombred in fen. as he the plow folwede. . . .
> This whit waselede in the fen. almost to the ancle.

> [His stockings hung down round his legs,
> All splattered with mud, as he followed the plow.
> He was mired in mud, almost up to his ankles.][16]

Alternatively, it is not hard to find the peasant presented as an object of pity, as in an early fourteenth-century English poem on the daily miseries he had to face, miseries summed up in a somber last line: "Ase god in swynden anon as so forte swynke" (Might as well die straightaway, as struggle on like this).[17]

In the calendar world, the impression of the peasants and their life is quite different. The figures going about their work may not be strikingly handsome, but they are sturdy, trim, capable. They have had enough to eat. They are dressed not in rags and tatters but in appropriate clothing, warm in winter (Fig. 1-4), loose and easy in summer (Color Plate 1-5). They are shown at just the right age: young enough to have energy and strength, old enough to have experience.

Ideas of death and decay are firmly kept at bay. Only in two related traditions, bound to the labors cycle by a family tie (the shared use of the seasonal round as a central motif), is the tone darkened by any intimations of mortality. In the first of these, the year is viewed as an obstacle course of health hazards. With gloomy relish the hidden dangers lurking in each month are listed, and the remedies set forth. These guidelines, attributed to Galen, the great physician of the classical world, were sometimes inserted in the calendar pages of a book of hours, as reminders to the reader. Sage advice on "whyche metys and drynks be goode to use in every monyth" is laid down in brisk note form. Wine is good in January, stewed pork hocks in February, lettuce in June. Baths are rarely helpful, and specially bad in March and November.[18] In the second of these traditions, the tone is distinctly more somber; there no diet can delay the inevitable. The stages of life on earth are linked to the months of the year, in an inexorable progress from birth in January to death in December. (For more on this theme, see Chapter 6.)

In contrast, death plays remarkably little part in the subject of this study, the "labors cycle" itself. The human figures show no sign whatever of advancing age or dwindling energy, and the only death that occurs in the entire year is in November or December, when animals are slaughtered for the meat supply. Almost always, in the calendar tradition, the animal chosen is the pig. Even here the idea of death is controlled and colored by the theme of the tradition as a whole: the promise of life's ever-returning, ever-renewing cycle. Death is accepted with composure. The pig is killed to fill the larder in December, but as we look at the scene we hear no squeals of agony, see no blood stains, smell no sweat. We know, and the pig knows, that, in the calendar cycle at least, he is absolutely safe and indestructible. Come next November, he will be resurrected, to rootle

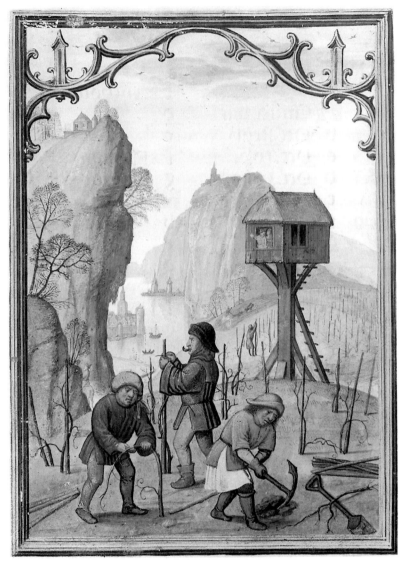

Fig. 1-4. February. Pruning. Da Costa Hours, Flemish (Bruges), Simon Bening and others, c. 1515. The Pierpont Morgan Library, New York, MS M399, fol. 3 verso.

happily for acorns once again (see Fig. 1-10). On this point there is a yawning gap between the treatment of time's passage in art and in literature. In medieval poetry, the haunting question is always:

> Who wot nowe that ys here
> Where he schall be anoder yere?[19]

In calendar art that question is never raised, because it is never needed. Everyone knows what will happen next year: exactly the same round of seasons, and the same round of activities, as in the present one.

Calendar scenes are small. They are ornaments, whether decorating a page, a lead font, or a stone porch. This limitation in size takes the figures one step further from reality. There is a doll's house air to many examples and, even in the severe medium of stone, the little figures often look more like pixies than like men. One of art's mysterious powers is the ability to draw pleasure from pain. Just as, in our own day, Samuel Beckett's prose gives a mesmerizing beauty to disintegration and decay, so the artists in the labors tradition transformed the mud and misery of demanding work into satisfying harmonies. The medieval mastery of line and pattern creates from everyday movements, in everyday jobs, the choreographed rhythms of a dance, the disciplined grace of a dancer; see Fig. 1-6.

Wood and stone offer the spectator the satisfactions of contour and texture, of actions and gestures caught by the artist and modeled by light and shadow. In manuscript examples, bewitching harmonies of color soften the rigors of work, and add a bloom of beauty to the most humdrum activities. Refinement of line, and the precious pigments chosen for the scene, give an early fifteenth-century illustration of manure being poured around a vine-stock, in early March, an elegance strangely, and soothingly, at variance with its subject matter; see Fig. 1-7. In such a treatment there are no unpleasant smells to offend the nose, no heavy, sticky mud to clog the shoes.

In the same way, a typical calendar scene of harvesting is all bright gold against a bright blue sky; see Color Plate 1-1. Its smooth perfection of surface, and its serenity of tone, offer not a hint of the muddle and discomfort of an actual day spent cutting the wheat. Gertrude Jekyll, the great English garden designer, touched on the truth of the matter when she once spoke about her memories of holidays on a farm when she was a little girl, and remarked: "Anyone who has never done a day's work in the harvest-field would scarcely believe what dirty work it is. Honest sweat and dry dust combine into a mixture not unlike mud."[20]

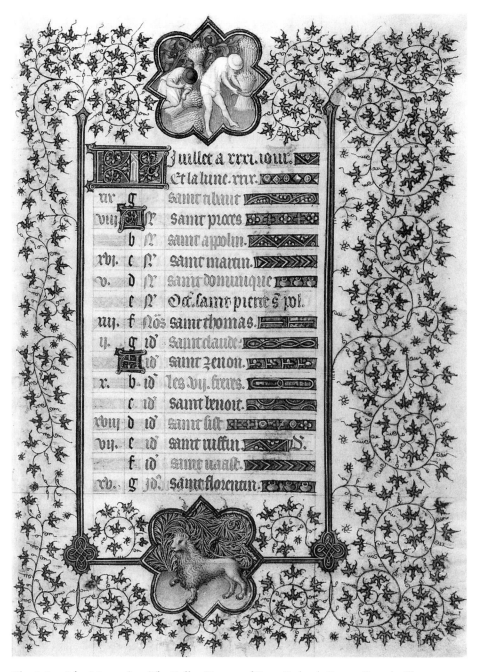

Fig. 1-6. July. Harvesting. The Belles Heures of Jean, Duke de Berry, French. Illustrators: Pol, Jean, and Herman de Limbourg, c. 1410–13. The Metropolitan Museum of Art, New York, The Cloisters Collection, 1954, MS 54.1.1, fol. 8.

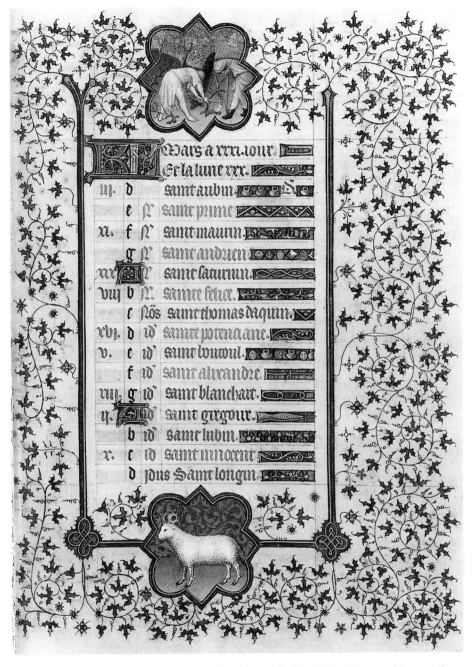

Fig. 1-7. March. Pouring Manure Round a Vine Stock. The Belles Heures of Jean, Duke de Berry, French. Illustrators: Pol, Jean, and Herman de Limbourg, c. 1410–13. The Metropolitan Museum of Art, New York, The Cloisters Collection, 1954, MS 54.1.1, fol. 4.

The idea of life as a round of unremitting toil is softened in some calendar scenes by yet another touch: the element of enjoyment. Tiny details, caught by the artist, add a sweetness or a zest to the yearly round. A cart-horse is offered a tidbit, after hauling a heavy load; see Fig. 8-2. A peasant in an enormous vat presses grapes, which are not quite untouched by hand because he is helping himself to a cluster while his legs keep up the good work down below. Workers look forward to a picnic lunch in the harvest-field; see Fig. 1-8. It is significant that the touch of relaxation or pleasure here and there never interferes with the work at hand, never breaks the rhythm of purposeful activity. It is not an interruption, and never antisocial. It is never a protest against the rules of the game, a sullen gesture made against the system. The relaxation comes at appropriate times. One of the traditional images of Sloth, in manuals on sins drawn up for preachers, is the laborer sitting idle by his plow.[21] In the calendar tradition this sin is avoided, because workers relax only when a particular job has been finished, or in ways which do not affect the task in hand, like munching grapes while still treading the vat. Just as no one in a calendar scene is ever shown stealing from the crop, sneaking home with a few ears of corn, so no one steals time. Work moves to the rhythm of the seasons. Pleasure moves in counterpoint, and fills the natural pauses in the measure; it never disrupts the dance.

Beneath the smooth, deceptively simple surface of the cycle lurk many surprises, and many closely guarded secrets. The biggest surprise of all, in a medieval work of art, is that there are no obvious religious overtones. Occasionally, a religious scene is chosen as the occupation of a month as, for example, the distribution of ashes on Ash Wednesday, the first day of Lent, in a few calendar pages for March (see Color Plate 7-14). At the core of every cycle, however, lies the agricultural story of the year, and there no religious touches of any kind are to be found. There is never a hint of divine intervention, never a turning for help or consolation to the Virgin Mary or to some local saint. There is no scene which shows the offering of harvest tithes to the Church, no blessing of the fields at Rogation-tide by the parish priest. Work goes on quite outside the framework of religious belief, doctrine, or discipline.

There is another big surprise, another missing ingredient; nowhere to be found is any sense of social context. Little figures are hard at work, but they are not shown in any recognizable community. They are busy and, apparently, independent. Very rarely indeed is there any person in authority directing operations, or any hint of coercion. The occasional exception, as in an early fourteenth-century English scene of an overseer in the har-

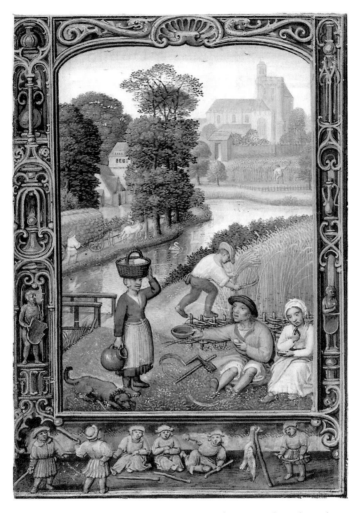

Fig. 1-8. August. Harvest Picnic. Book of Hours, Flemish, early
sixteenth century. The British Library, London, Add. MS 24098, fol.
25b. By permission of The British Library.

vest-field, only goes to prove the rule.[22] Every activity seems to be free,
planned and carried out by the peasants themselves. Usually, masters and
men, when shown together in the same picture, seem to inhabit entirely
separate worlds, as in an August scene where lords and ladies ride out
hawking in the foreground while, in the far distance, the harvest is gath-
ered in.[23] Only in some of the very late examples, produced at the end of

the fifteenth century or at the beginning of the sixteenth, is it possible now and then to find orders being given and received. In a few gardening scenes for early spring it is made quite clear that the garden belongs to an owner, and the gardeners work under watchful, proprietorial eyes; see Color Plate 3-4 and Chapter 3.

While there is scarcely a trace of an order given or obeyed in the calendar tradition, absolutely no suggestion at all can be found of resentment, let alone actual rebellion, against the system itself. Peasants had ample grounds for grievance throughout the period, and every now and again violent protest flared up, met in due course with even more violent retribution. When Froissart wrote his chronicle, and described the Peasants' Revolt of 1381 in England, he put into the mouth of John Ball, a leader of the rebellion, a speech which is a mosaic of traditional complaints against the high and mighty: "They have the wines, and spices, and the good bread; we have the rye, the husks and the straw, and we drink water. They have shelter and ease in their fine manors, and we have hardship and toil, the wind and the rain in the fields. And from us must come, from our labor, the things which keep them in luxury."[24]

Rulers were uneasily aware that their thrones rested on tinder-boxes, and the thought of peasant turmoil often troubled their dreams. In the mid-twelfth century, Henry I of England had a most unpleasant nightmare, one so upsetting that it was not only recorded but also illustrated in a contemporary chronicle. Henry dreamt that maddened peasants pressed around his bed, menacing him with their pitchforks and their scythes.[25] Of such explosive anger and pent-up fury, or indeed of any breakdown in the social system, not a hint scratches the smooth surface of the calendar tradition.

The principles of selection which shaped that tradition remain shrouded in mystery. Of all the myriad, varied jobs that had to be done on the land, only a few ever found their way into the calendar cycle. Considering that the tradition flourished most vigorously in northern Europe, in France, Flanders, and England, it is a little surprising that one of the most frequently represented tasks for early spring is the pruning of vines (Fig. 1-4), and the almost invariable one for early autumn is some aspect of the grape harvest. (See Chapter 5.) Does this preoccupation stem from the grape's very special place in human history? It was one of the first crops to be harvested in the ancient world, long before recorded time, and the cultivation of the vine was a characteristic task in those regions around the Mediterranean basin from which the calendar tradition sprang. Or does it owe more to another, later circumstance? The grape also has a very special

place in the language and symbolism of Christianity itself. Wine played a central role in worship services in every Christian country, no matter how far it lay to the north. As a result, it was necessary to produce some kind of wine for the Church, however thin or however acid, in every region of the Christian world. Even in cold, damp Cambridgeshire, in southeastern England, a record of grape-clusters harvested one year can be found, scratched at some time in the early fourteenth century, on the wall of St. Mary's Church at Westley Waterless.[26] Whatever the reason may be, the calendar's emphasis is always on the grape and the vine. No beer-making, no cider production, is ever shown.

The same problem is posed by the cycle's preoccupation with another crop, and can be explained away with the same arguments. Why is the core of the calendar year the growing of wheat: breaking ground, sowing seed, harvesting the ears, winnowing the grain from the chaff? (See Chapter 5.) Grain, like the grape, was first among the crops cultivated when human settlements began to form. From time immemorial, bread has been a staple of life in the West and, like wine, has a pivotal position in the liturgy of many Christian churches. In the absence of hard evidence, such answers must stand clouded in speculation, but what is undoubtedly true is that salt, another symbol and staple, never managed to squeeze its way into the charmed circle of tradition. And, to descend from the level of symbol to that of mundane reality, it may be idle, but it is always interesting to ponder the reasons why there is never any kind of attention paid to the backbone of the medieval diet: dried peas, dried beans, and cabbage.

Considering how important sheep-farming was in the economy of Europe throughout the medieval period, it is puzzling that it appears only now and then as an occupation in the calendar cycle. Scattered examples are to be found here and there throughout the earlier centuries, as in the May scene of shepherds guarding their flock in an English calendar of the first half of the eleventh century (The British Library, London, Cotton MS Julius A.VI, fol. 5), and the topic had become quite fashionable by the end of the Middle Ages (see Chapter 4), but it never did establish itself as an absolutely regular feature of the scheme. This hesitation may stem from the fact that the sheep was prized as a source of wool, the raw material of the cloth trade (Fig. 1-9), and so sheep-farming does not fit with perfect propriety into a cycle concerned above all else with the production of food. Alternatively, the hesitation may be due to concerns about the pastoral life itself. The shepherd alone with his sheep was an isolated figure, and his hours and conditions of work set him a little apart from ordinary village life. In some important ways the shepherd's life was more primitive

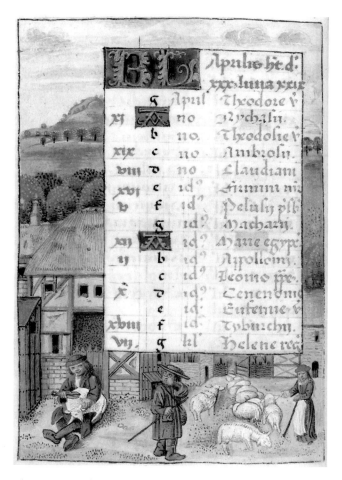

Fig. 1-9. April. Sheep-Shearing. Book of Hours, Flemish,
c. 1490. The British Library, London, Add. MS 18852, fol. 4
verso. By permission of The British Library.

than life on the farm. Certainly it did not depend to the same degree on
cooperation, and so was perhaps less satisfactory than farm life as an image
of society productively at work.

One other problem has no easy answer. Why do women appear more
and more frequently in the calendars of the fifteenth and early sixteenth
centuries? (See Figs. 1-10 and 1-11.) Women had always, by long-estab-
lished custom, labored side by side with men in village farmwork. Is their
absence from most earlier calendar cycles due to the fact that so many

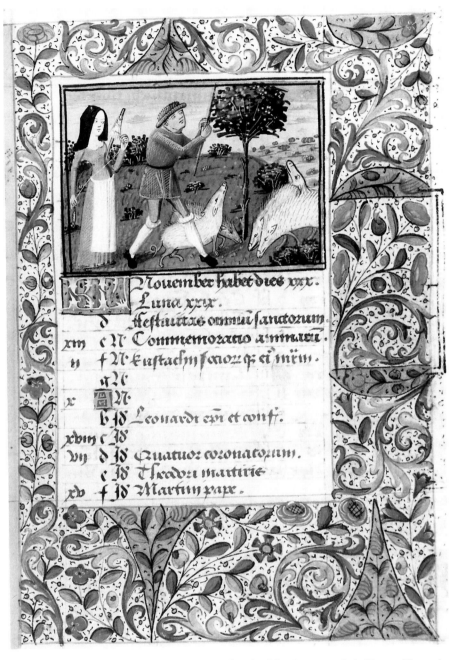

Fig. 1-10. November. Collecting Acorns. The Playfair Hours, made in France (Rouen) for the English market, late fifteenth century. The Victoria and Albert Museum, London, MS L475-1918. Courtesy of the Board of Trustees.

Fig. 1-11. April. Shepherd and Shepherdess. Book of Hours, Flemish, c. 1490. The British Library, London, Add. MS 18852, fol. 5 recto. By permission of The British Library.

scenes are presented within small medallions, or confining frames, inside which there was simply no room for more than one figure? Did they have to wait until the artist had a little more elbow-room? Does their entrance on the scene have more to do with changed economic conditions, caused by the many plagues which swept through Europe at frequent intervals after the mid-fourteenth century? Was women's contribution needed— and felt—more keenly in this period of labor shortages created by the high rate of illness and death? Was that contribution acknowledged at last, quite simply, on aesthetic grounds, with the delightful discovery that to include the figure of a woman was to add a new interest, a new charm of line and detail, to a very old scene? Or does the growing presence of women in the cycle stem from a heightened awareness of diversity, an acknowledgment that the fabric of mortal life on earth is woven from many strands? The single figure of a man always remains the most frequently chosen representative of society in the convention, but in the later period, when space permits, he may be joined by helpers or companions and, among these, a woman can at times be found. (For more on this theme, see Chapter 7.)

The characteristic arrangement and appearance of the calendar cycle hide more than they reveal, and foster an agreeably distorted view of reality. They help to sustain the illusion that everything in medieval society was on a very small scale: one field, one plow; two men, two scythes. There is scarcely a hint in the tradition, from one century to the next, of commerce or of trade, either of the great international markets that punctuated the year, and drew merchants from all over Europe, or of the local ones, held any week, in any town.

When an elderly husband in late fourteenth-century Paris gave his young wife advice on how to plan a special dinner-party, he directed her, as a matter of course, to buy her supplies at the many specialized shopping districts in the city. Beef was sold by one group of butchers, pork by another. Delicate wafers were to be ordered from one expert, garlands and table decorations from another. And when the husband suggested a recipe for a sweet confection made from carrots, he took care to add this helpful note: "Carrots are red roots, which are sold in handfuls in the market, for a silver penny a handful."[27] The cheerful, controlled confusion of such commerce finds no foothold in the "labors" tradition, and it is rare indeed to find a scene in which any farm produce is actually being exchanged for money (Fig. 1-12). Trade requires surplus, but in the calendar the emphasis is all on sturdy self-sufficiency. (For this, see Chapter 5.) Only in the very last stages of the medieval tradition—for example, in some of the Flemish

Fig. 1-12.　November. Pig Market. Book of Hours, Flemish, probably Bruges, c. 1500. The Fitzwilliam Museum, Cambridge, MS 1058-1975, fol. 11 verso.

calendars made in the early sixteenth century—do we begin to catch a glimpse of large-scale operations, and detect a hint of agro-business in the scene. After the diminutive, doll's house scale of most calendar activities, it comes as a shock to see a gigantic crane, for hoisting barrels, looming in the background of an autumn scene which shows the tasting of the season's new wine (Fig. 5-9), and realize that its presence there points to an economic system considerably more sophisticated than could ever have been suspected from the clues provided by the tradition as a whole.

Everything about that tradition, from its tone to its contents, from what it puts in to what it leaves out, should warn the viewer against the temptation to regard the calendar cycle as the equivalent of a careful, even-handed documentary film about work on the medieval farm. Peasant life has been distanced and refined by art, and the human burden made bearable by being shouldered within the sustaining dream of a world not fatally flawed but, instead, in perfect working order.

Within the confines of this old tradition the peasant, in real life so despised or disregarded, became the representative, the image of everybody. Ideas about the dignity of the human race shaped his appearance and his bearing. The harmony between his work and the seasons was a potent and satisfying image of the well-regulated society, in which forethought in planning and skill in execution drew the appropriate reward from a responsive, and equally well-regulated, nature. The cycle's harmonies express something of the spirit to be found in other images of the properly functioning society. Its figures move not through the polluted air of the real world but within the pellucid atmosphere of an ideal model of that world. They are related not so closely to real peasants as to those honest laborers who, in an image elaborated by John of Salisbury in the mid-twelfth century, were described as the feet of a "Body Politic," in which every member was an essential part of an organic whole.[28]

In the 1370s, a translation of Aristotle's *Politics* was made for King Charles V of France. Aristotle describes four possible kinds of democracy, of which he picks the agricultural model as the best, with the disarmingly frank explanation that farmers are "always busily occupied, and thus have no time for attending the assembly," and making a nuisance of themselves with their opinions.[29] The manuscript illustration of this section, labeled "Good Democracy," follows the same careful rules about the relation of work and pleasure that can be found in the calendars.[30] While some peasants are harrowing in the foreground, the men—and horses—that have done the first plowing of the field are enjoying a well-earned picnic, one that does nothing to disrupt the rhythm of the job in hand.

The high seriousness which underlay the old calendar tradition was also, in time, sweetened and softened by a far more frivolous but most engaging dream, the dream of a very different kind of good life. In this, the wearisome vexations and disappointments of wealth and privilege were contrasted with the pleasures of poverty. Viewed from the vantage point of high position and, perhaps, in the digestive pause after a satisfactory dinner, the simple, strenuous life in the open air, the fiber-packed diet of black bread and pure water, the untroubled dreams of the contented peasant, could seem positively enviable, and such attractions found praise in a number of elegant poems composed in the fourteenth and fifteenth centuries. (See Chapter 4.) Neither authors, nor readers, had the slightest intention of actually exchanging their own comfortable life for the rigorous realities of the farm, but it became fashionable to play with the idea. One may suspect that the charm and grace of many calendar pictures owe something to this agreeable fancy and were intended to please the eyes of just such patrons.

One of the most beautiful of all the calendar cycles, and certainly the one best known today, is that in the manuscript known as the Très Riches Heures, made for the great Duke de Berry (Musée Condé, Chantilly, MS 65), a man not noted for his love of farm life or, indeed, of peasants. In another manuscript that he commissioned, he is shown being welcomed by Saint Peter into Paradise.[31] If this happy event ever did take place, outside the duke's fond dreams and the pages of his very own books, there must be a strong presumption that he was received into heaven on the strength of his generosity as a patron of the arts, not for his generosity as a lord and master. In that role, he showed a harsh indifference toward his peasants, and a positively rapacious interest in the profits he could wring from their exertions. His record as a master of men called forth not paeans of praise from grateful subjects but resentment and rebellion throughout his vast domains.[32] For him, at least, the calendar pictures he enjoyed as he turned the pages of his book of hours must have woven a beautiful veil of illusion, to mask the ugly reality of the world outside his castle walls.

Illusion is a refuge for everyone, not just for royal dukes. It softens life's cruelties, and smooths the sharp edges. The calendar cycle offers a sustaining image of pattern, order, and attainable achievement, to counter the confusions and disappointments of real life in the real world. For this reason, its little pictures continued to be welcome for centuries, long after they had grown detached from any teaching program and dwindled into decoration. In this afterglow they lived on as ornamental details, reassuring and endearingly familiar. They might be used in any context: a bed-

spread, a gingerbread mold, a tile on a porcelain stove, and wherever found they brought a smile of pleasure and of recognition. As time rolled by, the calendar's most needed labor for society, in any month of any year, was no longer to instruct but, instead, to charm, to comfort, and to cheer.

Chapter 1 Notes and References

1. R. H. Robbins, ed., *Secular Lyrics of the XIVth and XVth Centuries* (Oxford: The Clarendon Press, 1955), no. 67, p. 62.

2. J. Alexander and P. Binski, eds., *Age of Chivalry; Art in Plantagenet England, 1200–1400* (London: Royal Academy of Arts, with Weidenfeld & Nicolson, 1987), item 222, p. 288.

3. P. Mane, *Calendriers et Techniques Agricoles (France-Italie, XIIe–XIIIe siècles)* (Paris: Le Sycomore, 1983), pp. 43, 284, 303, 308.

4. For calendar cycles of the early period, see James C. Webster, *The Labors of the Months* (Princeton: Princeton University Press, 1938). For a rich anthology of later, Flemish examples, see W. Hansen, *Kalenderminiaturen der Stundenbücher; Mittelalterliches Leben im Jahreslauf* (Munich: Georg D. W. Callwey, 1984).

5. Margaret M. Manion and Vera F. Vines, *Medieval and Renaissance Illuminated Manuscripts in Australian Collections* (London: Thames & Hudson, 1984), pp. 23–25.

6. T. and M. Metzger, *Jewish Life in the Middle Ages; Illuminated Hebrew Manuscripts of the Thirteenth to the Sixteenth Centuries* (Secaucus, N.J.: Chartwell Books, 1982), p. 22 and n. 119; p. 212 and fig. 319.

7. D. Grivot and G. Zarnecki. *Gislebertus, Sculptor of Autun* (Paris: The Trianon Press, and London: Collins, 1961), pp. 28–32 and plates A–S.

8. A. Viñayo Gonzalez, *San Isidoro in León; Romanesque Paintwork in the Pantheon of Kings* (León: Edilesa, 1993), pp. 34–43.

9. Expulsion of Adam and Eve from Paradise, in Winchester Psalter, English, c. 1150, The British Library, London, Cotton MS Nero CIV, fol. 2.

10. For a full discussion of the theme, see G. Duby, *The Three Orders; Feudal Society Imagined,* trans. Arthur Goldhammer (Chicago and London: University of Chicago Press, 1980).

11. For examples of sermon criticism of peasant behavior, see G. R. Owst, *Literature and the Pulpit in Medieval England,* 2nd ed. (Oxford: Basil Blackwell: 1961), pp. 365–69.

12. E. J. Arnould, ed., *Henry of Grosmont, Duke of Lancaster, "Le Livre de Seyntz Medicines"* (1354) (Oxford: Anglo-Norman Text Society, Basil Blackwell, 1940), vol. 2, pp. 13–14, 25.

13. M. R. B. Shaw, trans., *Jean de Joinville, "The Life of St. Louis"* (1309) (Harmondsworth, Middlesex, U.K.: Penguin Books, 1963), p. 169.

14. Saint Louis washes the feet of the poor, in Hours of Jeanne d'Evreux, Jean Pucelle, Paris, c. 1325–28, The Metropolitan Museum of Art, New York, The Cloisters Collection, MS 54.1.2, fol. 148 verso.

15. W. Nelson, ed., *A Fifteenth Century School Book* (Oxford: The Clarendon Press, 1948), p. 5.

16. W. W. Skeat, ed., *Pierce the Ploughmans Crede* (c. 1394), Early English Text Society, Original Series 30 (1873), lines 426–27, 430.

17. R. H. Robbins, ed., *Historical Poems of the XIVth and XVth Centuries* (New York: Columbia University Press, 1959), pp. 7–9, "Song of the Husbandman," line 72.

18. R. E. Hanna, *A Handlist of Manuscripts Containing Middle English Prose in the Harry E. Huntington Library* (Cambridge: D. S. Brewer, 1984), p. 38.

19. R. Greene, ed., *A Selection of English Carols* (Oxford: The Clarendon Press, 1962), no. 27, p. 85, lines 1–2.

20. B. Massingham, *Miss Jekyll* (London: Country Life, 1966), p. 24.

21. R. Tuve, *Allegorical Imagery; Some Mediaeval Books and Their Posterity* (Princeton: Princeton University Press, 1966), pp. 96–97, fig. 19.

22. August, Overseer and Harvesters, in Queen Mary's Psalter, English, early fourteenth century, The British Library, London, Royal MS 2B VII, fol. 78 verso.

23. August, Hawking Party, in the Très Riches Heures of Jean, Duke de Berry; the Limbourg brothers, France, c. 1413–15, Musée Condé, Chantilly, MS 65, fol. 8 verso.

24. G. Brereton, trans. and ed., *Jean Froissart's "Chronicles" (c. 1369–c. 1400)* (Harmondsworth, Middlesex, U.K.: Penguin Books Ltd., 1968), book 2, p. 212.

25. Henry I's Nightmare, in Chronicle of John of Worcester, England, c. 1130–40, The Bodleian Library, University of Oxford, MS Corpus Christi College, 157, fol. 382.

26. V. Pritchard, *English Medieval Graffiti* (Cambridge: Cambridge University Press, 1967), pp. 62–63.

27. E. Power, trans. and ed., *The Goodman of Paris* (c. 1393) (London: Routledge, 1928), sec. 2, art. 4, pp. 221–47, 296: "How to Order Dinners and Suppers."

28. J. Dickinson, trans., *John of Salisbury, "The Statesman's Book (Policraticus)"* (New York: Russell & Russell Inc., 1963), book 5, chap. 2, p. 65.

29. E. Barker, trans. and ed., *Aristotle, "The Politics"* (Oxford: The Clarendon Press, 1961), book 6, chap. 4, sec. 2, p. 263.

30. "Farming in a Good Democracy," Aristotle, *The Politics,* translated into French by Nicole Oresme, Paris, c. 1372, Bibliothèque Royale, Brussels, MS 11201–2, fol. 241.

31. Saint Peter welcomes the Duke de Berry at the gate of Paradise, in The Grandes Heures of Jean, Duke de Berry, French, c. 1409, Bibliothèque Nationale, Paris, MS Lat. 919, fol. 96.

32. M. Meiss, *French Painting in the Time of Jean de Berry; the Late Fourteenth Century and the Patronage of the Duke,* 2nd ed. (London: Phaidon Press, 1969), text volume, p. 32.

2

Winter; By the Fireside

It is a curious paradox that, in a pictorial tradition where every labor honored plays some part in the feeding of society, remarkably little attention is paid to food itself. The focus is on the raw ingredients, not the kitchen chemistry, and for the most part each month's scene is so full of purposeful activity that there is no space in which to show anyone actually savoring the fruits of all the hard work.

Only at rare moments are we granted a glimpse behind the curtain of convention. Sometimes we see the serious business of sampling the new wine (Figs. 5-9 and 5-10), and sometimes the snatched pleasure of an apple munched at picking-time (Fig. 8-3). Thirst is quenched in the heat of harvest (Fig. 8-4), and reapers wait expectantly for their picnic dinner in a half-cut field (Fig. 1-8). Tiny background details may hint at future treats in store. Butter is being churned in the cool shadows of a doorway in Fig. 6-10 and, in the Très Riches Heures of the Duke de Berry (Musée Condé, Chantilly, MS 65) a neat row of snow-capped beehives can be found in February, and the chimneys of a castle kitchen in September.

In real life, of course, the hard-working peasant had to be fueled with a little nourishment every day throughout the year, but in the calendar world there was just one season when conditions permitted the possibility of a digestive pause. It is in the dead of winter that weight is placed on the actual preparation, and enjoyment, of a meal. Occasionally, for example, in a December scene, a baker is chosen as the principal actor and placed at center stage, busily at work by the oven, pushing dough in and drawing loaves out; see Fig. 2-1. December is also the month in the calendar scheme when attention is paid to the winter food supply. Usually this is indicated by the slaughter of livestock, but from time to time the next stage in the progress from meat on the hoof to meat on the table is selected. In Fig. 7-3, a whole array of joints and chops and steaks is displayed on market stalls, to tempt the sharp-eyed housewives planning the next meal.

Even the finest ingredients, however, are not sufficient on their own to guarantee a decent dinner. Certain skills have to be called on, to bring about the transformation of hard grain into fragrant loaf, raw meat into succulent roast. Cooks are always in demand to work this necessary magic, but in the calendar it is only in the months from December to February that their presence can be felt. The strightforward explanation is that a little window of opportunity opened for them at this point in the cycle because, even in temperate Mediterranean regions, winter is the time when outdoor work on the land slows almost to a standstill, and life withdraws inside the shelter of four walls. But there is a less prosaic reason for the introduction of cooks and of sustaining creature comforts at this particular stage of the year. There was, quite simply, an aesthetic and emotional need for them.

Winter posed a serious problem for the calendar artist. It was a season passionately detested in the Middle Ages. The tracery of bare branches against a water-laden sky, the harmonies of black and gray and white, these were beauties still waiting to be discovered, let alone appreciated. Such incidental pleasures were not at the forefront of the medieval mind. Fear was the dominate reaction—fear of famine, fear of sickness, fear of bone-chilling cold; fear of death. And that fear and hostility show through in representations of winter. In 1240 the Queen's Chamber at Westminster was decorated with figures of the seasons. Winter was the one chosen for the place above the fireplace in the room, and the official description of the picture was noted down in the royal accounts book: "The figure of Winter which, by its sad look and other miserable portrayals of the body, may be justly likened to Winter itself."[1] Again, in the mid-fifteenth century, the Duke of Gloucester entertained his guests with an elaborate dinner, and it was decided, as a special touch of elegance, to coordinate the

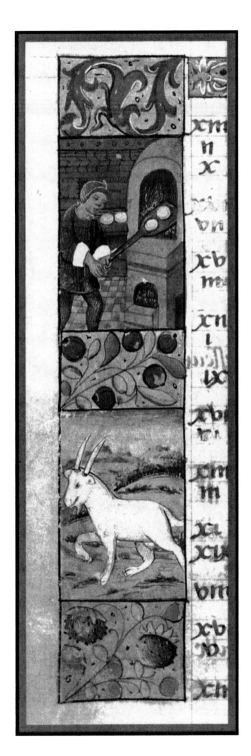

Fig. 2-1. December. Baking
Bread. Book of Hours, northern
France, late fifteenth century.
Newnham College Library,
Cambridge. By permission of
the Principal and Fellows of
Newnham College, Cambridge.

sotelties, those table decorations which were to be brought on and enjoyed with every course. Each was to represent one of the four seasons. And so, with the first course, there was presented the figure of Spring, dressed, according to the note, as "A gallant Young Man, light as air, standing on a cloud." In contrast, at the end of the meal, carried in with the spices and the wine, was Winter, "with his grey locks, feeble and old, sitting on cold, hard stone, niggard in heart, and heavy of cheer."[2]

All this dislike and fear of the season was totally at odds with the calendar tradition, whose tone is one of unruffled serenity. Within its boundaries, each month is given equal value. Each season is woven into the seamless fabric of the year, and accepted on its own terms, for its own sake. Accordingly, it was necessary to modify the perceived hatefulness of winter, to sweeten and soften the image, and to make its note chime with the calendar's harmonies. To achieve this, the horrors of the season were played down, and the emphasis was placed instead on the measures taken to offset them. First and foremost among these was the building of a blazing fire. Indeed, the choice of winter as an appropriate decorative motif above the fireplace of the Queen's Chamber is explained by a Latin phrase from Ovid's *Remedia Amoris*, scratched on yet another mantelpiece, this one in Sawston Hall (Cambridgeshire): "Igne levatus hyems" ("Winter is eased with fire").[3]

Fuel for such remedial countermeasures lay readily at hand. One of the minor occasional activities for the late autumn in some early calendars is the chopping and collecting of wood. The tiny roundel for December in an early twelfth-century manuscript (Saint Isidore, *Homilies*, Saint John's College, Cambridge, MS B.20, fol. 2 verso) contains just one figure, a man with a bundle of firewood on his back. The same work, driven by the same need, goes on throughout the winter. While trees are pruned in a February scene (Fig. 7-5), a woman is crouched on the ground gathering up the scattered cuttings. Another picks up sticks on the frozen snow as a man chops a log into kindling; Fig. 6-1. The reward for all the hard, cold work can be seen behind these figures in this January scene: a cozy cottage interior, a table laid for dinner, and a family gathered in comfort around a glowing fire. Not every household had to make its own log pile for winter; in Fig. 5-13 a November delivery of ready-cut, neatly packaged firewood is about to be made to the prosperous, pampered citizens of a town.

Almost invariably, wood is the fuel of choice but, from time to time, in later calendars, alternatives are on display. A January roundel in a mid-fifteenth-century book of hours from southern France (The Pierpont Morgan Library, New York, MS M358, fol. 2) is a picture of contentment: a

solitary diner gets down to some serious eating while he warms his toes at a pan of bright charcoal, conveniently placed just below the well-laid table. An ingenious variation is shown in another French manuscript of the same period, where the figure of Winter himself sits beside a small, mobile charcoal brazier mounted on four wheels.[4] No matter what the fuel may be, the calendar fire is never allowed to die down. Nothing is less of a comfort on a winter day than a hearth filled with cold, gray ashes, and so in Fig. 2-2 one man is bringing in a basket of faggots to sustain the blaze, while another pumps a pair of bellows to make the flames leap high. For bellows at work, see also Fig. 7-12.

Once the link between cold weather and hot fires had been forged, it could only be a matter of time before a little actual cooking would manage to squeeze into the picture. The step was made all the easier by the convenient fact that the dead of winter was the season for feasts as well as fires.

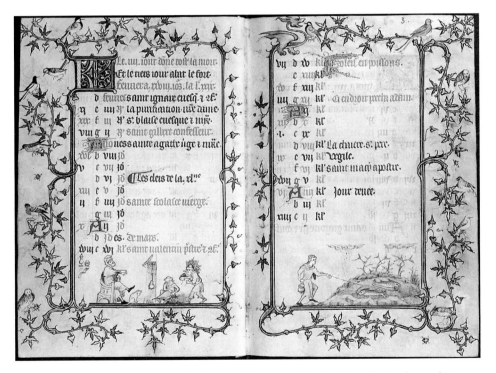

Fig. 2-2. February. Warming by the Fire, and Pisces, the Zodiac Sign. The Psalter and Prayer Book of Bonne de Luxembourg, French, 1345. The Metropolitan Museum of Art, New York, The Cloisters Collection, 1969, MS 69.86, fols. 2 verso – 3 recto.

In the real world, there was another time of high festivity, because Easter always falls in spring, but this was not acknowledged in the pictorial tradition. It is true that a spendid dinner is enjoyed in the April scene of an idiosyncratic Anglo-Saxon manuscript, made in England in the eleventh century (The British Library, London, Cotton MS Julius A, fol. 4 verso), but this is a rare exception. In the conventional wisdom of the calendar world, autumn filled the larders, while celebrations of Christmas and the New Year were designed to do their best to empty them.

Those celebrations, as we know, begin at the very end of December, and spill over into the next month, and so, in the calendar, January was given the scene of feasting. When cooking does figure in December, it is of a very sober, humdrum, necessary, everyday kind: it is the task of making bread. Occasionally, this is shown by itself as the principal, chosen activity for the month, as in Fig. 2-1. A few variations offer two stages in the process: the actual kneading or shaping of the dough in the bread trough, and the thrusting of a long pele, laden with loaves, right into the oven for the actual baking; see Fig. 2-3. See also Fig. 7-1. Calendar bakers rarely aim for anything more elaborate than a plain round loaf, but every now and then, as in Fig. 6-9, one or two promisingly plump pies can be found, ranged near the oven's mouth.

Western society has always thought of bread as the staff of life, the basic food for everyone, and so baking was a particularly appropriate branch of cookery for the "labors of the months" tradition. In the late Middle Ages there was another pictorial convention, known as "The Children of the Planets," which was designed to illustrate the power that the planets had over human life by showing each one surrounded by its own "children," those social groups and occupations that came under its special influence. Thus, among the protégés of Saturn, whose power was dominant in the depths of winter, were peasants and bakers.[5]

It is interesting to note that baking managed to insert itself into the calendar tradition as a winter occupation, not as one for high summer. In the labors cycle, grain, the all-important ingredient of bread, is threshed and winnowed at harvest-time, but references to bread itself are very hard to find at that point in the scheme (see Chapter 5). Instead, the combination of wood-cutting and fire-building for winter, with the relative emptiness of the winter working-day, created just the right conditions in which this secondary occupation could take root and flourish.

There was, moreover, a natural bond between baking and bad weather, because of one other fact of life that lies concealed by the convention's ground rules. Although in the picture cycle the task of grain-making is

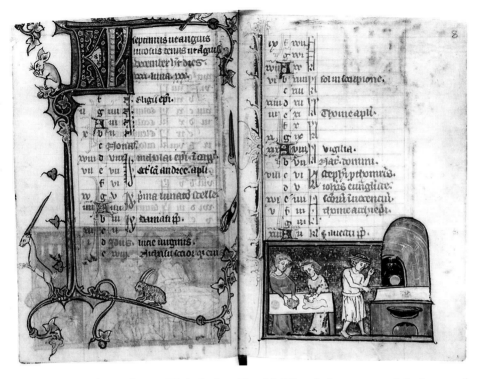

Fig. 2-3. December. Bakers at Work. Psalter, Flemish (Ghent), first quarter of the fourteenth century. The Bodleian Library, University of Oxford, MS Douce 5, fols. 7 verso – 8 recto.

tackled only in summer, in reality the job was well suited to winter conditions just because the work was done indoors, in some sheltered enclosure. An early fifteenth-century essay of advice for any woman in charge of an estate points out that such a task is one way to keep the household profitably occupied during cold, wet days: "In the wintertime . . . if the weather is too inclement [for wood-cutting] she will have them [her young men] thresh in the barn."[6] This hidden link between bread-making and winter is hinted at in the same independent-minded Anglo-Saxon calendar which placed feasting in April. In this particular, unusual scheme, December has been selected as the month for threshing and winnowing, and two men are pictured bearing away from the threshing-floor a gigantic bag of grain, suspended by its handles from a long pole (The British Library, London, Cotton MS Julius A.VI, fol. 8 verso).

The other corner waiting to be filled with some cooking activity is in the January–February stretch of the year. By hallowed tradition, the character-

istic calendar scene for January is a feast, doing double duty as a celebration of the Christmas season and a welcome to the new year. By far the best-known example today, found in a thousand posters and postcards, is the splendid banquet for the Duke de Berry in his Très Riches Heures. Nothing but the best was good enough for such an occasion—the finest linens and the most sumptuous serving dishes the household could muster, to satisfy its lord, and stun his guests. In a great establishment, the tableware was kept under lock and key and put on show only at times of high festivity. At the court of Edward IV in England, during the 1470s, a groom in the "Offyce of Picherhouse and Cuphouse" was appointed to care for the plate: "to waysshe and wype and gader home the plates of sylver and peauter [pewter] into the office dayly."[7] A rare January view (Fig. 2-4) takes us away from the magnificence of the feast itself and shows us just such a servant hard at work behind the scenes, polishing a great metal bowl.

The really grand feast is a rarity in the calendar tradition, and the scene is usually much more intimate: one man, a small table, and that all-important ingredient, a blazing fire. In one particularly cozy example (Color Plate 6-6), a high-backed chair has been added to cut out the drafts, a small boy and a cat have sidled into the picture to share the fireside, the supper table is being laid and, through the open doorway, there is a glimpse of preparations in the kitchen. It is just possible to make out a pot hanging from a chain over the fire, and a little figure crouched on the hearth, perhaps in position to turn the roasting spit.

In pictures like these, winter's terrors have been tamed, and its charms acknowledged. A French poet of the thirteenth century, Colin Muset, put his finger on the pleasures to be derived from piquant contrasts at this season, when he wrote:

> Quant je le tens refroidier
> Voi, et geler,
> Et ces arbres despoillier
> Et iverner,
> Adone me vueil aisier
> Et sejorner
> A bon feu, lès le brasier,
> Et à vin cler,
> En chaude maison,
> Por le tens felon.
> Ja n'ait il pardon
> Qui n'aime sa garison!

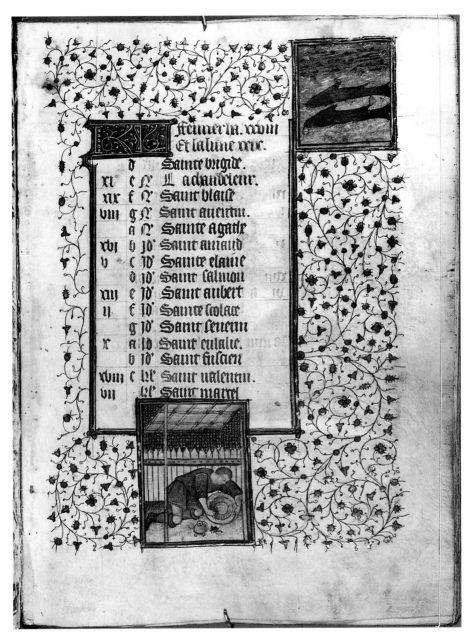

feuuier la. xxviii
Et la lune xxix.

	ð		Sainte brigide.
xi	e	Nª	La chandeleur.
xix	f	Nª	Saint blaise
viii	g	Nª	Saint auertui.
	a	Nª	Sainte agathe
xvi	b	Id'	Saint amand
v	c	Id'	Sainte elaine
	ð	Id'	Saint salmon
xiii	e	Id'	Saint aubert
ij	f	Id'	Sainte scolace
	g	Id'	Saint seuerin
x	a	Id'	Saint eulalie.
	b	Id'	Saint fulcien
xviii	c	kl'	Saint ualentin.
vii		kl'	Saint marcel

Fig. 2-4. January. Polishing the Silver. De Buz Book of Hours, French, early fifteenth
century. The Houghton Library, Harvard University, Cambridge, Mass., MS Richardson
42, fol. 1 recto. By permission of The Houghton Library.

[When I see the weather growing cold, and the frost coming, and the trees losing their leaves, and growing wintry, then I want to take my ease and stay in front of a good fire, beside the glowing charcoal, with clear wine, in a warm house, because of the bad weather. May he never be forgiven who does not care for his own comfort.][8]

When January's scene offers feasting of this intimate, domestic kind, it is hard to distinguish it from the characteristic scene for February, which shows an old man, still in his outdoor clothes, hunched by the fire, while supper in a stewpot simmers gently over the flames; see Fig. 2-5. This particular February man, like his countless cousins in the calendar convention, holds out one bare foot and one boot to dry, as he huddles on the hearth to warm his body through.

January and February were cold months, but their dominant zodiac signs made it clear that they would always be disagreeably wet ones as

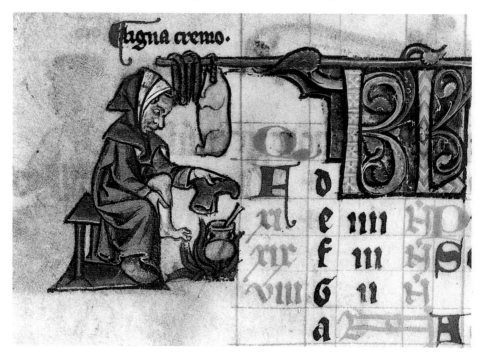

Fig. 2-5. February. Warming by the Fire. Calendar, English, late thirteenth century. The Bodleian Library, University of Oxford, in association with Corpus Christi College, MS Corpus Christi College 285.

well. In Fig. 2-2, February's fish (Pisces) are swimming in the waves, their natural element, and in Fig. 2-6 January's sign, Aquarius, is doing what every Aquarius likes best to do; he is pouring out the contents of his water-bottle on the ground beside his feet. The peasant was exposed to all kinds of weather throughout the year, but this particular season's chilling rains made life especially hard to bear. As a line in Langland's *Piers Plowman* points out:

> And yit is wynter for hem worse, for wete-shodde thei gange.
>
> [B. Passus XIV, line 161]

[And winter is even worse for them, because they walk in wet shoes.]

February's traditional image hints at the problem and provides the ideal solution, a never-failing, ever-cheering blaze.

These January and February figures, who never stop warming themselves by a roaring fire, yet never shed their mufflers, or their hats, or their

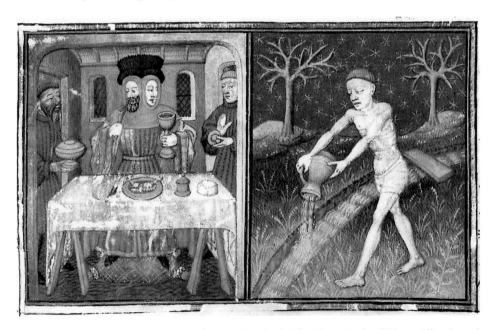

Fig. 2-6. January. Janus Feasting, and Aquarius, the Zodiac Sign. Book of Hours, illuminated in France for the English market by the Fastolf Master, c. 1440–50. The Bodleian Library, University of Oxford, MS Auct.D.inf.2.11, fol. 1 recto.

heavy overcoats, seem to be striking indictments of the medieval heating system. Even the members of a younger generation who make an occasional appearance in these scenes cannot seem to get enough of the fire's heat. The young woman in the February picture of the Très Riches Heures sits by the flames with her overskirt pulled up so that her knees will really feel the glow. And the flirtatious man in Fig. 8-5 toasts his back at a fire so hot that his companion holds up a screen to shield her cheeks from the blaze. In quite the most luxurious variation on February's theme (Fig. 2-7), the scene takes place in a bedroom, where a princely young man is being dressed by his attendants. As he sits on the end of his bed, and holds up one elegant leg, a page hands him an obviously custom-tailored stocking, ready-warmed and straight from the fireplace.

The youth of such figures goes against the grain of the season, whose characteristic image in the calendar world has evolved from a complicated skein of sad associations between winter and old age. In the medieval view of things, the whole stretch of time between January and March was shot through with contradictions. In many important ways, January marked the beginning of the new year, and was filled with tokens of good luck for

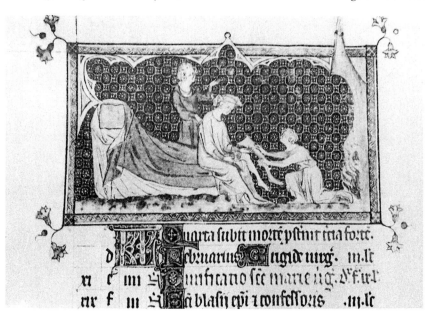

Fig. 2-7. February. Dressing by the Fireside. Queen Mary's Psalter, English, early fourteenth century. The British Library, London, Royal MS 2B VII, fol. 73 verso. By permission of The British Library.

the coming months—feasting, the drinking of toasts, the performance of certain ritual or symbolic acts. Indeed, it is thought that the fire itself, in the medieval calendar, is a descendant of the one onto which a Roman consul sprinkled incense as he took office on January 1, as part of a ceremony in which he prayed for the well-being of the state in the year to come, a rite actually chosen as the scene for January in a Roman calendar of the fourth century A.D.[9]

There are also many medieval examples in which the figure for January is the Roman god who is the guardian of gateways, two-headed Janus himself, drinking to the new year, and turning one head to see it come in through an open door. In Fig. 6-11 the new year actually arrives in the form of a new baby, presented by its nursemaid to an old man as he dines alone. This particular January figure has only one head, but the two horns on his cap are clues to his family ties with Janus. There can be no doubt at all that the robust diner wolfing down double helpings of every dish in Fig. 2-6 is indeed Janus, and the fact that he sits between the past year and the one about to begin is signified by his two profiles, one old and bearded, one young and clean-shaven.

When viewed in this light, January marks the turning point from winter into spring, and the seed of new life to come lies waiting, safely sheathed in snow and ice. Chaucer's contemporary, John Gower, in his *Confessio Amantis* [Book 7, line 1214], imagines Janus "with his double face" offering the world a very special present on New Year's Day, a token of rebirth:

> He yifth the first Primerole.
> [He gives the first primrose.]

In a similar way, those drenching rains of February that cause innumerable toes and boots to be dried by the fire and, in at least one instance, a wife to be shown vigorously toweling her husband's back as he huddles on the hearth,[10] can be presented in picture form as the necessary prelude to spring's awakening. There is a small family of refined and luxurious Parisian manuscripts of the fourteenth and early fifteenth centuries in which most of the calendar scenes are tiny landscapes without any human figures, and in this tradition February's rain pours down on bare branches which, in the months that follow, burst into leaf and blossom.[11]

However, in another, equally strong, tradition, the new year properly began with the spring equinox, in March. (For more on this, see also Chapter 6.) And so, according to this way of looking at the matter, Janu-

ary and February represent the very nadir of the year, the dregs, the last dying breath of the old. The conflict of associations is given striking expression in a carved stone calendar at Vézelay in France. There, in the February scene, an old man, fully clothed, crouches by the fire, while next to him there stands a young man, clothed on the side turned to the fire, and naked on the other, caught in the very act of stepping out of winter and away into spring.[12]

In extreme old age, the fire of life is dying down, and so the figure representing this stage is always cold, always heavily clothed, and always trying to get warm. Winter is the season of old age in the year, and the two threads of association are woven together to create the characteristic figure of winter as an old man, beside the fire, vainly stretching out for comfort. Winter is traditionally an old man, just as Spring is a jaunty young one. The January or February figure of the old man by the fire had in it originally elements of great weariness and sadness. The image imprinted itself on the imagination of Europe, and lingered on in the collective memory long after the calendar tradition had lost its vitality. On December 5, 1712, the twenty-four-year-old Alexander Pope, in the midst of a particularly trying stretch of ill health, chose it in a letter to describe his own dreary days: "I am just in the reverse of all this Spirit and Life, confind [sic] to a narrow Closet, lolling on an Arm Chair, nodding away my days over a Fire, like the picture of January in an old Salisbury Primer."[13]

Despite such gloomy overtones, a fire, by its nature, is a cheerful thing, and sitting beside one has many points in its favor. Indeed an anonymous Scottish poem, prompted perhaps by the rigors of a Scottish winter, lists with relish the advantages for old age in a comfortable seat by a roaring fire:

> Ane nap is nowrissand eftir none,
> Ane fyre is fosterand for my feit,
> With dowbill sokkis for my schone
> And mittanis for my handis meit.

> [A nap is sustaining after noon, and a fire is comforting for my feet, with double socks inside my shoes, and welcome mittens for my hands.][14]

Slowly, over time, it was this aspect of warming by the fire which was developed in the calendar tradition. The mood changes, from somber en-

durance to easy relaxation, and little touches of domestic detail are added to enhance the pleasure of the moment. And, at times, the temptation creeps in to put this passive figure brooding by the fire to more gainful employment, and to show him, if not actually cooking, then at least set to watch that fire do the work for him. (See Fig. 2-8.)

Whether depicted in action or at ease, the figure bent over the fire is, almost invariably, a man. Needless to say, there is an occasional exception and so, in Fig. 7-12, the familiar, heavily muffled character stirring a stew-

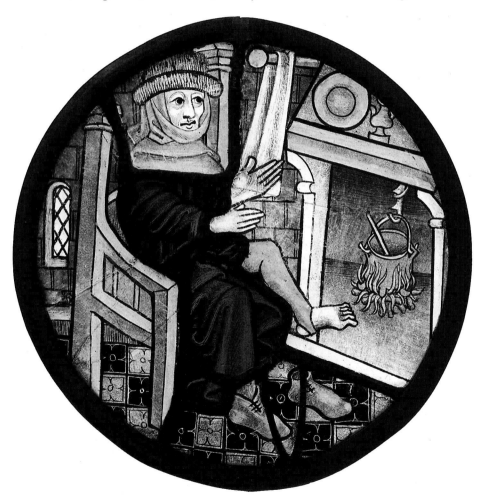

Fig. 2-8. February. Cheerful Old Man by the Fire. Stained-glass roundel, diameter 23.5 cm, English, late fifteenth century. Glasgow Museums, The Burrell Collection, 45/83.

pot turns out, on closer inspection, to be a woman. The choice is unusual but not unreasonable, and could have been easily justified by reference to an unimpeachable source. Just as winter was sometimes personified as a man "with his grey locks, feeble and old" so, from time to time, it was also portrayed as "a decrepit old woman to whom death draws near."[15] The image was used in *Secretum Secretorum*, a much-respected and much-consulted Arabic compendium of medical and moral advice that circulated widely in the West from the twelfth century onward and was translated into many languages.

A far more surprising variation is to be found in a surviving sculpture, made c. 1105–10 for the Cathedral of Santiago de Compostela, in which the February figure warming his foot by the fire is an endearingly chubby little boy; see Fig. 2-9. The rest of the cycle to which this fragment belongs has been lost, and it cannot now be known whether each of its other months was represented by the same kind of round, cherubic character. It

Fig. 2-9. February. Granite Sculpture, Spanish, 16½ × 10⅛ inches, 1105–10. Museo de la Catedral, Santiago de Compostela. Photograph courtesy of Lorna Walker and Anna Ross.

is just possible, though, that the choice of a boy as the personification of February was quite intentional. The month is the shortest one of the year, and an affectionate nickname for it in Spanish is "chico" ("youngster").[16]

Whenever they are included, any hints of food preparation in a calendar scene are small and slight, just touches of embroidery to refresh a faded old motif. Even so, within the confines of a very conservative tradition, several different kinds of techniques and equipment can be found. In Fig. 2-5 a cooking-pot with handles, standing on its own short legs, has been set in the midst of the flames. In Fig. 7-12 the same pot once more sits directly on the fire, but on the facing page is a much larger container placed on a portable metal stand which holds it safely above the flames and yet still close enough to them. Fig. 2-8 shows another method, a pot held in position on the fire by a hook and chain.

Management of the fireplace needed great skill, so that full use could be made of every kind of heat available, from the intense heat at the very heart of the fire to the gentle glow at the edge of the hearth, ideal for very slow cooking, or for keeping something warm. In some scenes, a closed pot has been placed where it will hold the heat for a long time; see Color Plate 6-6. Stewing is the method most favored by calendar cooks, but a rare January scene shows a bird being roasted, with a long pan set beneath the spit to catch the delicious drippings; see Fig. 2-10. In an early thirteenth-century stone relief on Amiens Cathedral, the February man is toasting a fish for his meal on a fire-fork.[17] The choice of fish in a February cooking scene is a witty allusion to the month's zodiac sign, Pisces. That zodiac sign is drawn into the picture in another illustration, where February's fish are being grilled on a gridiron set before the fire.[18]

Sausages and hams could be smoked and cured in the chimney, hung there through the long winter, perhaps to be used for the Easter feast. One whole pig and some sausage links hang behind the man warming his toes in Fig. 2-5. Details such as these are reminders of how closely one month is bound to the next in the year's cycle. For hams and sausages to hang in the chimney in February, a pig must be killed in December. And just as it is possible to look back to what has gone before, so it is possible to look forward. In one December scene, Fig. 7-2, a pig is already dead, and it is being jointed—the legs cut off for roasting now or, perhaps, for curing in the chimney through the long winter. In a November vignette, three stages are shown: the killing of the pig, the singeing of its bristles by fire, and the emptying of the intestines. These empty skins will then be cleaned and stuffed and turned into sausages, to be smoked by February's fire; see Fig. 2-11.

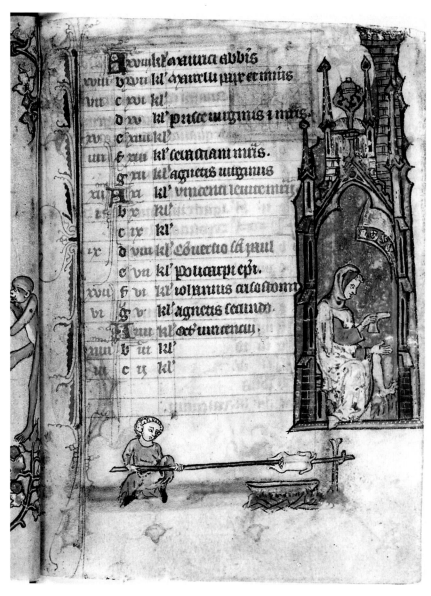

Fig. 2-10. January. Roasting a Chicken. Psalter, Flemish (Ghent), first quarter of the fourteenth century. The Bodleian Library, University of Oxford, MS Douce 5, fol. 1 recto.

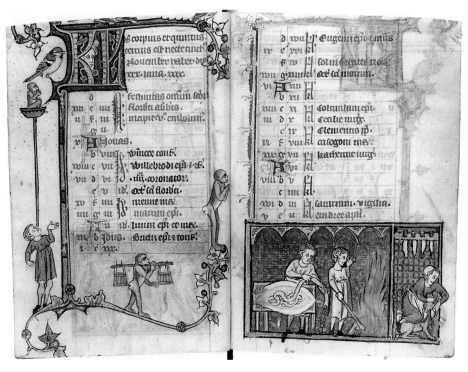

Fig. 2-11. November. Butchers at Work. Psalter, Flemish (Ghent), first quarter of the fourteenth century. The Bodleian Library, University of Oxford, MS Douce 5, fol. 7 recto.

In one February illustration (Fig. 2-2), there is a fully developed little drama. A cheerful old man is toasting his toes, with a contented cat beside him. One servant is blowing up the fire with bellows, and another brings in a fresh load of wood. In the fireplace, a stew-pot hangs from a chain, but it has its own short legs, so that it can also stand without support, in the fire or on the hearth. Many hooks have been set high up in the chimney, on which not just one but several cooking-pots could be hung. And up there among the hooks one can just make out the faint, shadowy outlines of plump little objects which may represent a cluster of sustaining sausages.

The servant figures occasionally found bustling about helpfully in these scenes may have been suggested by January's zodiac sign: Aquarius, the Water Carrier. Just as February's sign—Pisces, the Fish—at times helps to define the month's occupation, and is slipped into the scene to be caught by an angler or cooked on a grill, so Aquarius can play a part too, as a servant pouring out the wine, or the water for hand-washing before

dinner; see Fig. 6-12. And it seems quite possible that the idea of other servants, with other duties, may have sprouted from this seed. (See Fig. 2-6.)

When any trace of cooking shows up in medieval calendars, it is of the plain, basic kind, in keeping with the character of the cycle as a whole. A stew-pot, a grill, a spit, a bread-oven, provide simple, satisfying nourishment, to keep the haunting specter of starvation safely at bay. The "labors of the months" convention is concerned with the orderly pattern of work spread over the changing seasons, which ensures the survival of society. It is not the place for the demonstration of special, sophisticated cooking skills. Every rule requires an exception, and so in rare cases February is represented by two figures, a man frying pancakes and a woman beating the batter; see Fig. 7-4. Lucky friends wait expectantly nearby, ready for second helpings. This mouth-watering scene was appropriate for February, the month in which all dairy products had to be disposed of before the season of Lent began. In England, that tradition still lingers on in the delightful custom of serving lemon pancakes on Shrove Tuesday.

The addition of tiny cooking details was one means by which the twin terrors of winter and of death's approach were tamed. The tragic figure of Old Age, vainly stretching out hands to warm them at the fire of life, was modified, transformed into one of serene maturity. In pictures like these, we see not the agony and bitterness, but the privileges of age, and the pleasures of the season: the best seat in the house, a roaring fire, agreeable signs of supper in the making, respectful young attendants poised to answer every beck and call.

The note struck by such scenes has been made to chime with the one sounded by the calendar tradition as a whole. In that serene round of seasons and occupations, there are always duties but never disappointments. Satisfying tasks yield satisfying pleasures. Each month imposes its own rules, and each bestows its own rewards.

Chapter 2 Notes and References

1. T. Borenius, "The Cycle of Images in the Palaces and Castles of Henry III," *Journal of the Warburg and Courtauld Institutes*, vol. 6 (1943), pp. 40–50.
2. J. A. Burrow, *The Ages of Man* (Oxford: The Clarendon Press 1986), p. 29.
3. V. Pritchard, *English Medieval Graffiti* (Cambridge: Cambridge University Press 1967), p. 172.

4. E. Le Roy Ladurie, ed., *Paysages, paysans; l'art et la terre en Europe du Moyen Âge au XX^e siècle* (Paris: Bibliothèque Nationale de France and Réunion des Musées Nationaux, 1994), p. 48, item 15.
5. R. Klibansky, E. Panofsky, and F. Saxl, *Saturn and Melancholy; Studies in the History of Natural Philosophy, Religion*

and Art (New York: Basic Books Inc.; London: Thomas Nelson & Sons Ltd., 1964), pp. 204–7 and plate 40.

6. S. Lawson, trans., Christine de Pisan, "The Treasure of the City of Ladies" (Harmondsworth, Middlesex, U.K.: Penguin Books, 1985), p. 132.

7. A. R. Myers, ed., The Household of Edward IV (Manchester: Manchester University Press, 1959), pp. 183, 190.

8. B. Woledge, ed., Penguin Book of French Verse, vol. 1 (Harmondsworth, Middlesex, U.K.: Penguin Books, 1961), p. 163.

9. M. R. Salzman, On Roman Time; The Codex Calendar of 354 and the Rhythms of Urban Life in Late Antiquity (Berkeley and Los Angeles, and Oxford: University of California Press, 1990), pp. 79–83 and fig. 30.

10. February. Drying by the Fire. Book of Hours of Marguerite de Foix, France (northwest), c. 1470s. National Art Library, The Victoria and Albert Museum, London, Salting MS 1222, fol. 2 recto.

11. K. Morand, Jean Pucelle (Oxford: The Clarendon Press, 1962), pp. 43–44.

12. P. Mane, Calendriers et Techniques Agricoles (France-Italie, XIIᵉ–XIIIᵉ siècles) (Paris: Le Sycomore, 1983), fig. 89.

13. M. H. Nicolson and G. S. Rousseau, "This long disease, my life"; Alexander Pope and the Sciences (Princeton: Princeton University Press, 1968), p. 22.

14. W. A. Craigie, ed., "Old Age," item 59 in The Maitland Folio (Edinburgh: The Scottish Text Society, 1919).

15. Burrow (see note 2), p. 30.

16. The Art of Medieval Spain, A.D. 500–1200, Exhibition Catalogue, The Metropolitan Museum of Art, New York, 1993, item 94: "Personification of the Month of February," pp. 215–16.

17. Mane (see note 12), fig. 2.

18. February. Grilling Fish. The Belles Heures of Jean, Duke de Berry, French, Limbourg Brothers, c. 1408. The Metropolitan Museum of Art, New York, The Cloisters Collection, fol. 3.

3

Spring;
The Private Garden

At some point in the late fifteenth century, a touch of frivolity begins to brighten the calendar's sober sequence of activities for early spring. Little figures that for hundreds of years had been digging and plowing, pruning and chopping, in preparation for the year ahead are still hard at work, but now they are sometimes found in a new setting. Always before, they had been shown in featureless space, inside a decorative frame or, if given any hint of a realistic background, placed firmly on the farm. From this time onward there is a chance that they may be glimpsed, up in a stained-glass roundel or down on a manuscript page, exercising their age-old skills in the making of a private pleasure-garden.

Seen in the context of the time, the development is easy to explain. By this stage in the cycle's history, the convention had become comfortable. Ideas that had helped to shape it, of Adam's fall from grace and the work which was both the punishment and the path to salvation for all his de-

scendants, still justified its presence in a hundred forms and places, but they had long ceased to darken its tone. The calendar world was serene and, as we have noted, room had always been made for pleasure in its ordered round. As the centuries rolled on, pleasures came pressing in ever more boldly but, even so, there is still something curious about the foothold gained in the tradition by the garden theme. In the past, a strict distinction had been maintained between work and pleasure. Work was serious business, and peasants' relaxations were squeezed into moments off-duty; toes were toasted by the fire when winter had brought outdoor labors to a standstill, picnics enjoyed in the hayfield at the noontime break for dinner. Lords and masters were allowed more latitude but, while they might be presented as hunting in mid-winter or riding out to revel in the quickening new life of spring, their amusements did not interfere with the year's cycle of tasks and duties. Master and man lived parallel lives in the calendar convention, and there was rarely any intersection. The August scene in the Très Riches Heures (Musée Condé, Chantilly, MS 65, fol. 8 verso) shows in the foreground a courtly hawking party while, in the distance, the necessary, appropriate occupation for the month goes on undisturbed: harvesting the wheat.

When the garden scene makes its appearance, there is a change. Old tasks are performed in a new setting, for a new purpose, and old assumptions are modified by new aspirations. Skills slowly developed to prepare ground and plants alike for future harvest are now used to shape and trim a pleasure-plot. Lords and laborers no longer tacitly ignore each other; the area being cultivated is not for society in general but one household in particular, and the work often goes on under the watchful eye of an alert and interested proprietor.

Most striking of all, the garden is designed to satisfy appetites less basic than the one for food; it is an ornament, made for pride and pleasure, not necessity. This is a sharp break with the past. At the core of the calendar tradition lies the cultivated landscape, coaxed and groomed by human effort into harvest. Crops are raised, barns filled, hunger kept at bay. In such a scheme, the garden is at best an irrelevance, at worst a distraction from the task in hand. The heroes honored are plowmen and peasants, laboring for the common good. Their stalwart figures had been types of virtue at least since that day early in the eleventh century when Abbot Aelfric of Eynsham asked his pupils which was the most useful of human activities, and drew forth the right response: "Agriculture, because the Ploughman feeds us all."[1]

Although he shared with the farmhand many of the same skills, the gardener did not share the same respect. This remained true even though he had gained some honor by association, because Mary Magdalene had once mistaken Jesus for a gardener (John 20:15). Out of that moment of sadness and confusion on the morning of the Resurrection, an image of Jesus as a gardener had developed—one of the many roles he played in his relations with men and women, from fisherman to shepherd. The garden he toiled in was the human heart, and in that stony ground he struggled to grow fruit. In 1373 the mystic Julian of Norwich had a vision in which she saw God the Father sending out his Son to work in the world, and waiting to receive the crop: "And then I understood that he would do the greatest labor and the hardest travail that there is: he would be a gardener, delving and dyking and sweating, and turning the earth up and down: he would water the plants in season . . . and . . . make . . . noble plenteous fruit to spring forth. This fruit he would bring before the Lord, and serve him therewith to his liking."[2]

The image dignifies but cannot disguise; it underscores essential differences. In contrast to plowman and redeemer, the ornamental gardener neither feeds society nor saves its soul. Indeed, he does not serve society at all. He works for one master, and his job is to embody dreams and conjure up delight. Judged by the highest medieval standards, these are selfish aims, and the sudden entry of the gardener on the calendar scene marks a small but decided shift in society's attitude toward the garden itself as the Middle Ages drew to a close.

In every age, and in every society, it has been hard for human nature to set its face like flint against the solace of a garden. No matter how brutal the times, or how austere the code of moral values, some refreshment has always been found in that controlled variety which is the essence of a garden's charm: birdsong and blossom, sunshine and shadow, pattern and peace. The medieval centuries proved to be no exception to the rule. An appreciation of these pleasures runs like an underground stream through the whole period, from time to time bubbling to the surface of the written record in little murmurs of contentment and delight.

King Childebert I planted apple trees "magno amore" on his estate near Paris in the sixth century. In the thirteenth, Edward I's courtiers noticed that he had a special fondness for his garden at the Tower of London. Henry of Grosmont, Duke of Lancaster, confessed, in the devotional manual that he wrote for himself in 1354, that his nose was bewitched by the different smells of flowers and fruit. After Henry VII's death in 1509,

Bishop Fisher in his funeral sermon recalled that the king had loved the "galaryes of grete pleasure" from whose windows he could look down on the marvels of his new grounds at Richmond.[3]

The garden cast a potent spell and could become a dangerous addiction. At times a warning note had to be sounded. On a late twelfth-century drawing, "The Ladder of Virtue," little figures from different walks of life are struggling up, step by step, trying to reach the prize—the Crown of Life held out encouragingly at the very top. A hermit has almost reached the last rung, but is shown at the moment of ruin, fatally distracted from his prayers by the garden that he loves too much. He bends over to inspect a cherished plant, loses his balance, and falls right off the ladder. Expectant devils are waiting to seize him, far below.[4]

The fifteenth century saw not the dawn of an entirely new pleasure, but the steadily mounting awareness that an old pleasure could be enjoyed in new ways. Before this time, the emphasis had been on privacy. Those lucky enough to possess gardens liked to keep them to themselves, and there are many references in account books to the hedge-planting and wall-building planned to make privacy possible. At Odiham Castle in Hampshire, one of Edward III's properties, in the royal ledgers from 1331 to 1335, for example, there are notes on the making of a garden for the queen's use, with a board fence set round it, pierced by five doors.[5] Gardens were placed as close as possible to their owners' private quarters. An early thirteenth-century garden was planted outside King John's bedroom at Arundel; a century later, another was prepared at Langley Marish, right next to the queen's chamber.[6]

Slowly, fashions changed, as the idea of the garden as a prized possession began to form. Pride of ownership is nourished by the admiration of others, and a touch of envy never comes amiss. To be enviable, a garden must be seen, its beauties displayed for the eyes of the chosen few if not of the multitude. Those "galaryes of grete pleasure" which delighted Henry VII were used not just by the king but also by courtiers and visitors, who could gaze down from the windows on the patterns and colors of the beds below. In 1501, at the wedding of Catherine of Aragon and Henry's son Arthur, the festivities were deliberately planned to include a tour of inspection "through [Henry's] goodly gardeyns, . . . unto his galery upon the walles, apreparyd pleasantly for his highness."[7]

Ideas, like plants, need roots from which to grow, and this new appreciation of the garden as enviable property, laid out for public appraisal, was rooted in a long-established private pleasure. No matter how snug the retreat, it must be seen to be savored. Those early gardens planted close to

royal quarters were made to be enjoyed, if only by one pair of royal eyes. At Windsor in 1236, the queen's chamber had a window facing the herb garden, into which Henry III ordered glass panels to be placed, panels which could be made to open and shut, so that the garden could be viewed in comfort, whatever the weather.[8]

A sheltered viewpoint was the age-old answer to problems posed by searing sun and driving rain. The cloister walk, its side pierced and open to the courtyard it surrounded, was an architectural feature inherited by the monastery from the Roman villa, and in due course moved out once more into the secular world. In 1256 the sheriff at Guildford received instructions "to make a certain new cloister with marble columns in the king's garden."[9] Humble service-corridors, or pentices, were often built of wood and set against the outside walls of the apartments and offices which, together, made up the "rabbit warren" of a palace or a castle. Such corridors offered shelter, provided access to private rooms, and linked one building with another. Their function was severely practical, but pleasure always finds a way of breaking in, and in due course they too began to be brightened with windows. Those with time on their hands might then pause to enjoy a prospect, while even the most harried servant, hurtling from one task to the next, could catch a glimpse of freedom as he scurried by. In the early days, the windows were usually left open to the elements, but Henry III, a king with a well-developed taste for comfort as well as style, was quick to grasp the advantages of glazing. Perhaps it is significant that it was in that trying month, November, in the year 1240, that Henry took steps to ensure that at least the passage used most often by himself would be draft-proof. He ordered that in the corridors at Woodstock which linked his hall, his chapel, and his wife's apartment, the openings were to be partly boarded up, with "two white glass windows to be made in the same boards." Those windows looked out onto the garden.[10]

Such ingenious improvisations led, step by step, to permanent improvements. Throughout the fifteenth century, the pace quickened noticeably. Plain windows grew larger, and bay windows offered wider prospects; the simple pentice evolved into the handsome gallery. Each window and each gallery offered a view, and the favorite view was of a garden beyond. After the Duke of Gloucester's death in 1447, Queen Margaret took over his palace at Greenwich. Included in her vigorous program of repairs and rebuilding during the next five years was the construction of a gallery from which to look out over the garden.[11] A 1509 inventory appraising the contents of the London house which belonged to Henry VII's chief minister, Edmund Dudley, mentions "a long galerre agayn the

gardynne,"[12] while at Thornbury Castle, magnificently enlarged and improved by the Duke of Buckingham between 1511 and 1522, covered passages, with windows, were built around the gardens, to link the family apartments with the church.[13]

The bigger and better window is just one indication that, as the Middle Ages drew to a close, new ways were being found to satisfy the perennial human appetite for comfort and for status. Seen through English eyes, the fourteenth and fifteenth centuries together formed a tumultuous but not unprofitable period. Money could be made as well as lost during the Hundred Years' War with France, and during the Wars of the Roses within England, and home improvement was a favored form of conspicuous consumption. Great town houses were built, great castles were remodeled, and account books brim with notes on new chests and "riche coupbourdes" for display, "baynes to bath in" for private indulgence, and "Daunsyng chambres" for fun.[14]

Regrettably, few direct references to gardens have survived, but several hints suggest that they too were beginning to figure in ambitious daydreams. Of such hints the strongest occurs in a letter of no doubt unsolicited advice, written in 1480 by William Harleston of Denham in Suffolk, to his nephew, offering middle-aged caution to temper reckless youth: "And, syr, of on thyng that is tolde me, that ye do make a fayre newe garden. In the whiche I pray you for my sake to sette too herbis, the whiche ben Paciens [and] Tyme; And that theis too herbis be put in the potage that ye ete, so as ye may ete them dayly."[15] William Harleston feared, with good reason, that this new hobby would prove to be expensive. Eye-catching gardens swallow heart-stopping sums of money, and this fifteenth-century uncle would have nodded his head in agreement with the seventeenth-century proverb coined by George Herbert: "The charges of building and making of gardens are unknown."[16]

For anyone at the end of the fifteenth century who had garden ambitions in his heart, and money in his purse, support systems were already in place. When Cardinal Wolsey, in 1515, decided to develop the garden at York Place, in Westminster, he did just what other great magnates had done for centuries: he ordered his plants from a professional nurseryman, John Chapman of Kingston-upon-Thames.[17] As early as 1274, a certain William the Gardiner filled a bulk order for timber and rods to support grapevines in the royal garden at the Tower of London; the next year, he was able to supply the king with an assortment of fruit trees, lily bulbs, peony roots, and gooseberries.[18] In 1312–13, ten thousand turves were dug

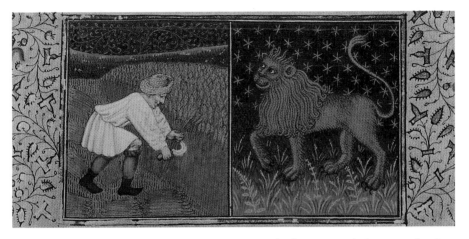

Color Plate 1-1. July. Reaping. Zodiac sign Leo. Book of Hours, made in France for the English market by the Fastolf Master, c. 1440–50. The Bodleian Library, University of Oxford, MS Auct. D.inf.2.11, fol. 7 recto.

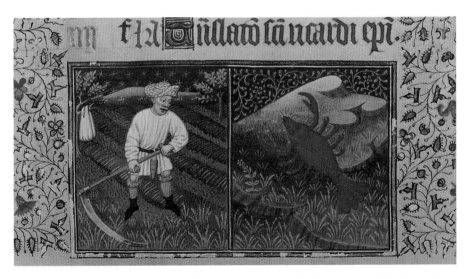

Color Plate 1-5. June. Mowing. Zodiac sign Cancer. Book of Hours, made in France for the English market by the Fastolf Master, c. 1440–50. The Bodleian Library, University of Oxford, MS Auct. D.inf.2.11, fol. 6 recto.

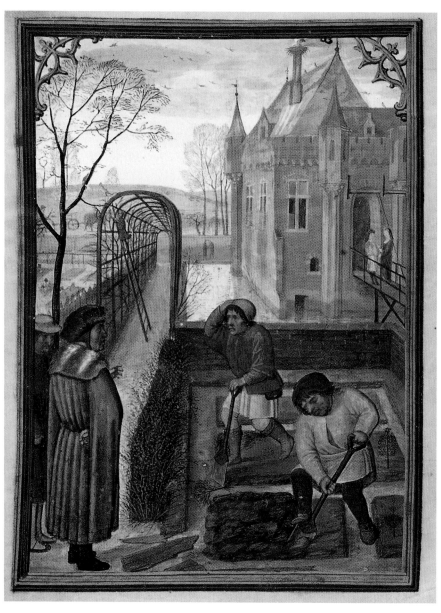

Color Plate 3-4. March. Gardeners with Their Master. Da Costa Hours, Flemish (Bruges), Simon Bening, c. 1515. The Pierpont Morgan Library, New York, MS M399, fol. 4 verso.

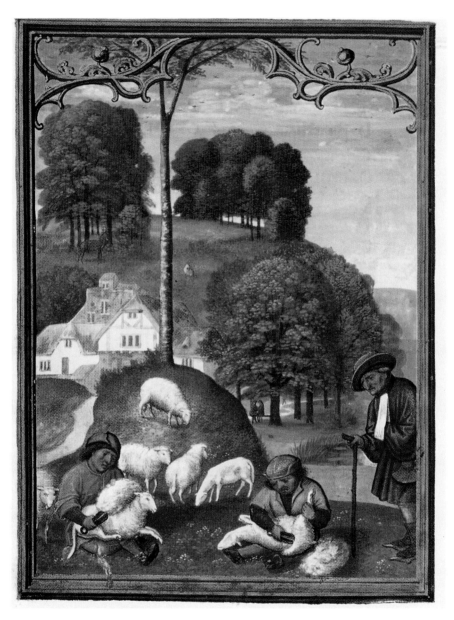

Color Plate 4-11. June. Sheep-shearing III. Da Costa Hours, Flemish (Bruges), Simon Bening, c. 1515. The Pierpont Morgan Library, New York, MS M399, fol. 7 verso.

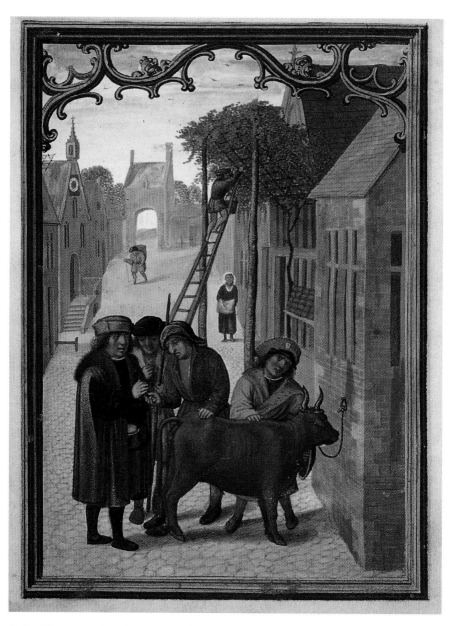

Color Plate 5-12. October. Cattle Sale. Da Costa Hours, Flemish (Bruges), Simon Bening, c. 1515. The Pierpont Morgan Library, New York, MS M399, fol. 11 verso.

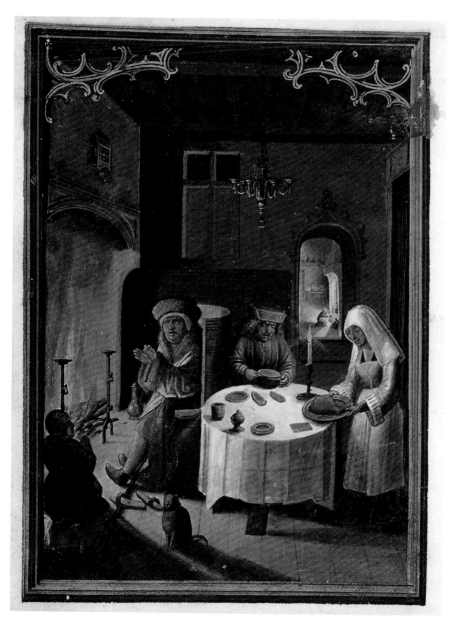

Color Plate 6-6. January. Supper by the Fire I. Da Costa Hours, Flemish (Bruges),
Simon Bening, c. 1515. The Pierpont Morgan Library, New York, MS M399, fol. 2
verso.

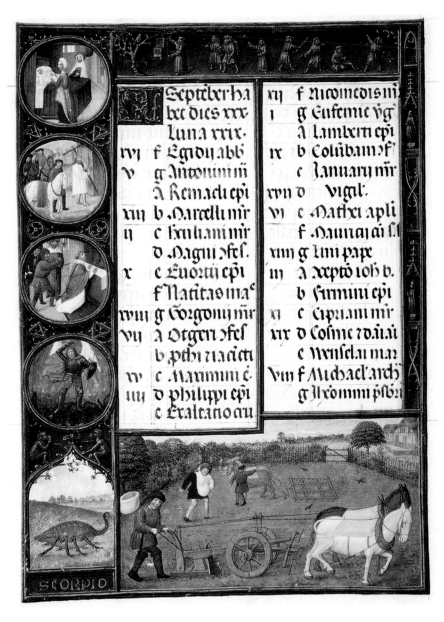

Color Plate 6-15. September. Plowing and Sowing. Bird-snaring (upper border). Spinola Hours (Use of Rome), Flemish (Ghent or Mechelen), Gerard Horenbout, c. 1515–1520. The J. Paul Getty Museum, Los Angeles, California, Ludwig MS IX.18, fol. 5 verso.

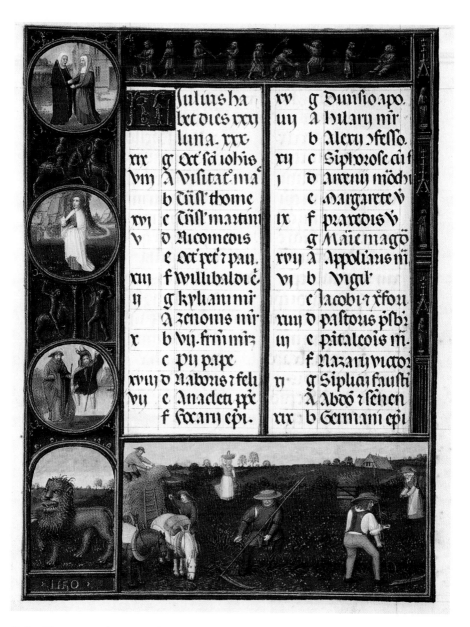

Color Plate 7-6. July. Haymaking. Spinola Hours (Use of Rome), Flemish (Ghent or Mechelen), Gerard Horenbout, c. 1515–1520. The J. Paul Getty Museum, Los Angeles, California, Ludwig MS IX.18, fol. 4 verso.

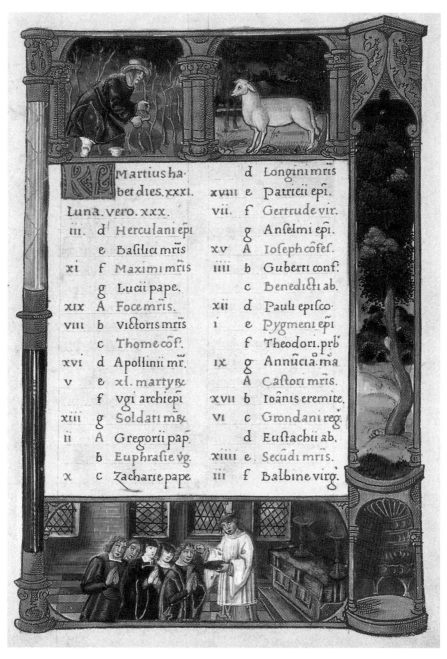

		Martius ha· bet dies. xxxi.		d	Longini mris	
			xviii	e	Patricii epi.	
	Luna. vero. xxx.		vii	f	Gertrude vir.	
iii.	d	Herculani epi.		g	Anselmi epi.	
	e	Basilia mris	xv	A	Ioseph cofes.	
xi	f	Maximi mris	iiii	b	Guberti conf.	
	g	Lucii pape.		c	Benedicti ab.	
xix	A	Foce mris.	xii	d	Pauli episco·	
viii	b	victoris mris	i	e	Pygmeni epi	
	c	Thome cof.		f	Theodori. prb	
xvi	d	Apollinii mr̄.	ix	g	Annucia. ma	
v	e	xl. martyr.		A	Castori mris.	
	f	vgi archiepi	xvii	b	Ioanis eremite.	
xiii	g	Soldati mr.	vi	c	Grondani reg.	
ii	A	Gregorii pap.		d	Eustachii ab.	
	b	Euphrasie vg.	xiiii	e	Secudi mris.	
x	c	Zacharie pape	iii	f	Balbine virg.	

Color Plate 7-14. March. Ash Wednesday. Book of Hours, French (Use of Rome), second quarter of the sixteenth century. The Bodleian Library, University of Oxford, MS Douce 135, fol. 3 recto.

in Fulham and brought to the palace at Westminster to make or renew its lawns and turf-topped benches.[19]

By the time Henry VII captured the throne, in 1485, conditions in England were encouraging for garden enthusiasts. The necessary skills and services were available, and a fine garden had become a source of pride. It was something to show an important visitor, as Edward IV did in 1472 when he gave the Burgundian ambassador a personal tour of inspection, to point out the best features of the royal grounds at Windsor.[20] A palace Henry built early in his reign both embodied and promoted current attitudes and trends. In 1497 the palace of Sheen burned to the ground, and Henry at once seized the chance to create a new phoenix from the ashes of the old. He named it "Richmond." The choice provoked many discreet jokes and fulsome compliments when the startling magnificence, not to mention stunning cost, of Henry's "Rich Mount" became apparent.

Richmond was raised in a hurry, and for a purpose. Begun early in 1498, it was barely ready in 1501 to form the splendid setting for the celebration of the wedding of the Prince of Wales to Catherine of Aragon. In the eyes of Europe, and of Henry's subjects, it was a symbol of the new Tudor dynasty, and a striking demonstration that, after a shaky start, the dynasty was firmly in control, a force to be reckoned with at home and abroad.

Every detail of the palace was intended to impress, and the gardens made their own contribution to the grand design. They were surrounded by a long covered gallery glittering with windows,[21] and, as has been mentioned, the wedding guests were allowed ample opportunity to make mental notes on every fashionable feature as they were conducted through the gardens and into the gallery.

Many great houses were built in the years that followed. Each signaled the power and status of its owner. Each brick, each sheet of glass, each length of tapestry, added its mite to the unmistakable message. The garden was seen as one more item in the total sum, an extension of the house, a place where the pleasure of scoring points had been added to the pleasure of setting seed. Flowers had long played a part in politics as family badges, from the broom of the Plantagenets to the red and white roses of Lancaster and York. It was Henry VII and his successors who first used the garden itself as a political emblem. Royal gardens soon bristled with painted, gilded rods and railings, topped with the heraldic beasts and devices that the Tudors claimed as their own.[22]

Such a display was part of a conscious plan to impress the majesty and authority of the new ruling family on the imagination of the country. The

idea proved to be a success for the Tudors and an inspiration for their subjects. It touched a responsive chord in a fiercely competitive era, when new families were thrusting to establish themselves while old ones battled to maintain their place. Other emblems in other gardens began to sprout throughout the country. Even in faraway Scotland, at some time early in the sixteenth century, George, Lord Seton, a man somewhat given to "voluptie and plesour," devised an ambitious garden scheme, pricked out with one hundred stakes, each painted "with dyvers hewis of oylie colouris," and each topped with not one but two large balls which had been "overgilt with gold."[23]

In England, Henry was a leader who set his stamp on the taste of his own generation and the next, but the ideas he promoted were already current in Europe. In that larger world, England was no pace-setter, just a small shrimp offshore in the North Sea. The model for Henry, as for his fellow monarchs, was Burgundy, that rich duchy whose sophisticated court had set fashions in Europe throughout the fifteenth century. Behind Burgundy stood Italy, where the art of garden design had already reached levels of subtlety and splendor not to be matched in northern Europe for many years to come. Italy was still very far away, her treasures only dimly perceived and half-understood. The example of Burgundy was closer to hand, and its artists and craftsmen were far more readily available. Even before Henry's reign, England had close business and political ties with the duchy; indeed, Edward IV's sister had married its duke in 1468. Throughout Henry's years on the throne, a steady stream of Burgundian scholars, musicians, and artists flowed to England to fill positions at his court, color its tone, and shape its attitudes.[24]

For some time, it had been the custom at the Burgundian court to use outdoor settings as delightful, and deceptively relaxed, stages for the transaction of ceremonial and diplomatic business. An English delegation sent over in 1464 to negotiate a commercial treaty with Philip the Good was first overawed by a conducted tour of the Duke's marvel-filled park at Hesdin before any discussion of awkward disagreements was permitted to take place.[25] Gifts were received, and courtesies exchanged, as easily in an outdoor room as under cover in a hall; one illustration in a manuscript pictures the presentation of the book itself to Charles the Bold as he strolls with his courtiers through one of his many elegant gardens.[26]

Burgundy's vast territories included the great centers of manuscript production in Bruges, Ghent, and other Flemish cities. In the late fifteenth and early sixteenth centuries, these dominated the international book market, and manuscripts made there were destined for many owners, in many

countries. Gardening scenes began to appear in calendar cycles devised in Flemish studios, or under Flemish influence. They were added in response to Burgundian tastes, which Burgundy's dominance had made acceptable elsewhere. A March gardening scene (see Fig. 3-8) was chosen for a book of private prayers in Latin and English, made in Ghent or Bruges circa 1500 for George Talbot, Earl of Shrewsbury.[27] Whether they turned the pages in England or in France, in Portugal or in Scotland, the owners who found such a scene inside a new book might puzzle over some unfamiliar Flemish detail, but they would not be baffled by the picture itself. The overall appearance of the garden depicted there conformed to every dictate of current fashion, and had been designed to evoke approving smiles and ambitious dreams.

In the medieval imagination, the garden was both setting and symbol of divine as well as human love. From the Paradise Garden to the allegorical Garden of the Rose, it was a place where the different beauties of bud and fruit, promise and fulfillment, existed together in exquisite harmony. The calendar garden is different. However neat, trim, and fashionable in detail, it is a garden rooted in the real world and has its real limitations. Inserted into the cycle as the scene for March, and pictured by artists living in northern Europe, it has the stripped, expectant air of a stage being readied before the play begins. Not very much is actually in bloom, for it is only in excited dreams that the flowers of summer can be made to flourish in the early spring. When Edward of York was fighting for the throne of England, he used as a badge his family emblem, a white rose. As one of his titles was "Earl of March," supporters celebrated his victory, when he marched in to London at the end of February 1460, as a horticultural miracle: "Let us walk in a new vine yard, and let us make a gay garden in the month of March with this fair white rose."[28]

The drawback to a portrait of the garden made in early spring is that it can offer only meager evidence of plant life. Manuscript borders brim with violets and pansies, pea-blossom and iris, set down together in ordered profusion, but the calendar garden is softened only here and there with hints of greenery. In compensation, the season's austerity lays bare the underlying structure, the pattern, the disposition of the elements, the underpinnings which support the show.

The calendar garden is always fenced and made secure, sheltered by the high walls of a courtyard (Fig. 3-1) or set out next to the house of its owner, in full view of the windows (Fig. 3-2). Trim beds, smooth paths, straight lines, give it an air of military precision. The formality of the design, with its closed, protected character and its artifice, demonstrates a

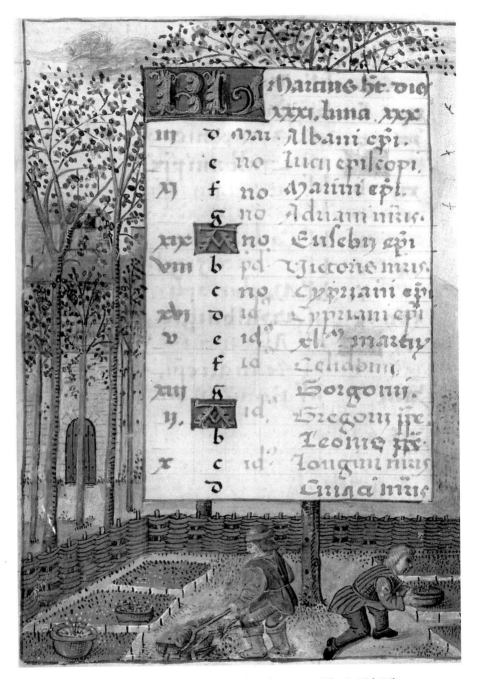

Fig. 3-1. March. Planting. Book of Hours, Flemish, c. 1490. The British Library, London, Add. MS 18852, fol. 3 verso. By permission of The British Library.

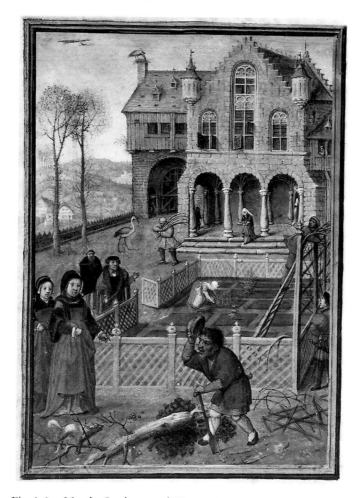

Fig. 3-2. March. Gardener and Woman Proprietor. Manuscript
fragment, Flemish, Bruges, illustrated by Simon Bening, early 1540s.
Bayerische Staatsbibliothek, Munich, Clm 23638, fol. 4 verso.

decided preference for a nature tamed and trained into order. In the world
at large, nature was unpredictable and uncomfortable; there was far too
much of it. Medieval society was still not sufficiently in control of its
surroundings to be able to afford the luxury of appreciating the beauty to
be found in difficulty and danger.

This dislike and distrust of nature in the raw only strengthened, in the
heart of the garden designer, some firmly held beliefs about the character

of art and the role of the artist. It was that artist's proud claim that he was a maker, and the pleasure he gave was in the display of workmanship and the refinements of technique. Art that conceals art was not a concept that appealed strongly to the medieval imagination, and so in gardening, as much as in cooking, or enamel work, or music, the emphasis was on the control and shaping of material by a master's hand.

The admired effect of visible design and intricate detail, the demonstration of undeniable skill, was hard enough to achieve on a jeweler's bench, let alone in the great outdoors, that wilderness of mud and weeds, drought and drenching storms. The only chance for the gardener was to concentrate all his effort on one chosen plot of land, and try to tame it. If a dictionary of medieval gardening terms were ever to be compiled, the two most important entries under the letter C would be control and containment. Even Paradise itself, that model for all earthly gardens, was always shown as meticulously enclosed, its perfection closely guarded.

In the everyday world, enclosure took many forms. One favorite was the wattle fence, made from osier willow shoots braided around upright stakes, a form of construction that was cheap, easy, and strong. (See Fig. 3-1.) Another was the simple wood fence, built from planks nailed together. (See Fig. 3-3.) Stone and brick were other possibilities, while a living hedgerow made an attractive boundary line. (See Color Plate 3-4.) The most elegant effects were achieved with ornamental iron or woodwork, formed into latticed fences of various patterns and topped with decorative balls and beasts. (See Fig. 3-2.)

The idea of containment was so firmly held that it affected not only the enclosure of the garden but also the presentation of the plants inside. Each neatly shaped bed was raised and crisply edged with brick or stone, wood or wattle. Demarcation lines were boldly drawn. The scene in Fig. 3-1 can be viewed as a series of ever-diminishing Chinese boxes. Set inside a large courtyard, protected by high stone walls, the small formal garden itself is enclosed with a wattle fence, its beds are edged with wood boards, and some special plants are being given pride of place in special pots.

Well-kept paths between the beds made their own contribution to the overall design. Many little details in household accounts reveal the care that went into their making and their maintenance. At Winchester College in 1394, the garden walks were laid out by men using lengths of rope and measuring-lines to keep them straight and true.[29] In 1359, a laborer worked for ten weeks on the paths in the Westminster Abbey gardens, and the accounts note an extra sum expended for the finishing touch: some fine, bright sand to spread over their surface. Gravel provided a more

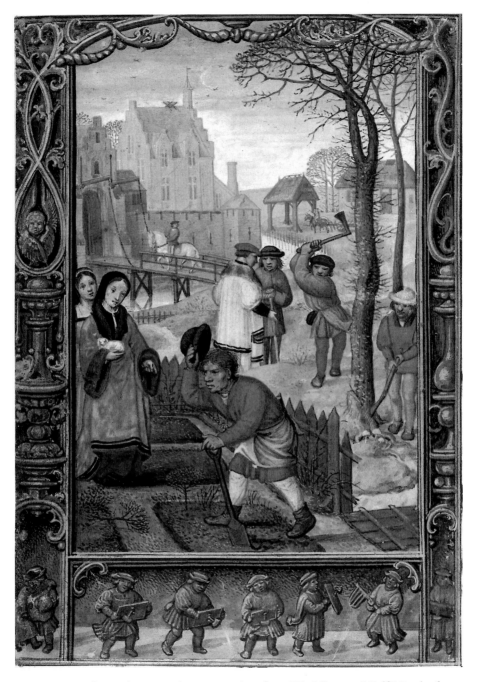

Fig. 3-3. March. Gardener Receives Instructions from His Mistress. "Golf" Book of Hours, Flemish, early sixteenth century. The British Library, London, Add. MS 24098, fol. 20 verso. By permission of The British Library.

durable, less comfortable alternative, and it was ordered by the cartload for Kenilworth Castle in 1440.[30]

Grass was chosen by George Cely, an English wool merchant, for his garden, in 1488. He paid a man called Laurence four shillings for mowing and for making "my alers gresse" ("turfing my alleys").[31] Grass is an aggravatingly unruly element, even when battled today with high-powered mowers, and its tendency to insubordination cannot have made it a prime favorite for any gardener armed only with a scythe. Fig. 3-5 offers a sensible compromise, a flower-strewn, informal meadow of grass for walking in, and a trim garden for show, set behind ornamental railings, its precise, straight paths unsullied by even a wisp of intrusive green.

There is a deceptive air of uniformity about the small, rectangular flowerbeds in the calendar pictures. At the time these were painted, it had become the fashion to overlay such beds with "knots," ingenious and varied designs grown in the bare earth. In this style, much loved and much admired throughout the sixteenth century, each plot was patterned with bands of greenery created from tractable plants like thyme, hyssop, or thrift, and coaxed and cropped into intricate traceries. The original intention may have been to use these as ornamental frames for flowers, but the patterns themselves gave such pleasure that flowers were often squeezed out of the picture, and the spaces between the curves and flourishes of the crisp design were left entirely bare. Nature abhors a vacuum, and dislikes discipline; the penalty for her displeasure was paid in nonstop weeding and tidying. At West Horsley Place in Surrey, in 1546, before a royal visit, men were specially hired for "picking and weeding out leaves out of the knottes of the privy garden."[32]

The inspiration for the fashion was drawn from the subtle linear harmonies which had long been achieved in embroidery, metal work, and calligraphy. By the end of the fifteenth century, the practice had become established; in 1519, one of the specimen sentences chosen for translation into Latin as a school exercise was: "Let us walke in to the knotte garden."[33] Hard work was needed to make and maintain such a style. In 1520 John Wynde, the Duke of Buckingham's gardener at Thornbury, was given a special reward of three shillings and fourpence "for his diligence working and making knotts."[34]

Hard work, however, was not enough. Judgment and skill, a sense of proportion, an ability to lay out the design and visualize the finished effect—all these were needed, and all were eagerly sought for by ambitious proprietors. On August 13, 1534, Thomas Warley wrote from London to

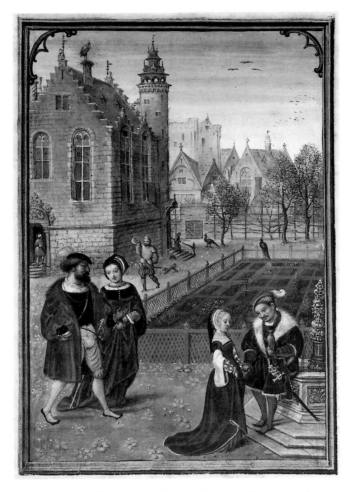

Fig. 3-5. April. Lovers Strolling in a Garden. Manuscript frag-
ment, Flemish, Bruges, illustrated by Simon Bening, early 1540s.
Bayerische Staatsbibliothek, Munich, Clm 23638, fol. 5 verso.

Lady Lisle, wife of the English governor of Calais, recommending to her
service a most promising find, a man of many parts: "Pleaseth it your
ladyship to understand that here is a priest, a very honest man. . . . And
these properties he hath: he writes a very fair secretary hand and text hand
and Roman, and singeth surely, and playeth very cunningly on the organs;
and he is very cunning in drawing of knots in gardens."[35] Such a treasure

might well be able to achieve that desired effect, the sharp intake of breath as a visitor gazed down from a window, compelled to marvel at "the Knots so enknotted it cannot be expres't."[36]

Of all this verdant filigree that fretted the gardens of Europe, nothing but faint traces show here and there in the calendar pictures, as in the hints of plain plant borders framing the beds in Figs. 3-6 and 3-7. No space was found within the confines of the manuscript scenes for the intriguing twists and turns of pattern that endeared the style to generations. It is only in one or two late and comparatively large-scale examples of the old tradition that the controlled exuberance of the convention can be clearly seen. One stained-glass roundel from a calendar cycle made in France during the late sixteenth century shows, for March, a garden scene, with the actual formation of a knot pattern taking place in the foreground, while a glass panel, made some fifty years afterward, in Switzerland, presents, for April, gardeners at work beside some highly ornamented beds.[37]

Discipline was imposed on the unruliness of nature in other ways. In the best-known of all the books of hours today, the Duke de Berry's Très Riches Heures, the April scene shows a trim line of fruit trees, espaliered and trained against a wall.[38] The only animals to be found in calendar gardens are privileged pets, in the arms or at the feet of indulgent owners (Figs. 3-6 and 3-2), but a sign of the gardener's uphill fight against the nibbling hordes of uninvited guests can be detected in a late fifteenth-century glass roundel from a calendar cycle at Brandiston Hall in Norfolk. There, the stem of each tree in the garden scene has been wrapped in a protective sheath, a shield against hungry rabbits.[39]

To clip a shrub into a special shape was an art with an irresistible appeal for the medieval imagination, satisfying as it did the two strong cravings for control and form. By the beginning of the Tudor period, topiary work had become an expected feature in the fashionable landscape, and Stephen Hawes, a groom of the chamber in Henry VII's household, took care to include some "Rampande Lyons . . . Made all of herbes," and "dragons of mervaylous lykenes, Of dyvers floures made full craftely," in the "gardyn gloryous" he described in his poem "The Passetyme of Pleasure" (1505).[40] Nothing so elaborate as a boxwood beast can be found in a calendar garden, but small bushes, sculpted with conscious elegance, are clearly visible in Color Plate 3-4 and Fig. 3-5, and an "estrade" tree, pruned into two tiers, is being planted out in Fig. 3-8. Even when the shrubs themselves have had no artificial form imposed upon them, their careful placement at the center and corners of the individual beds is an indication of the highly

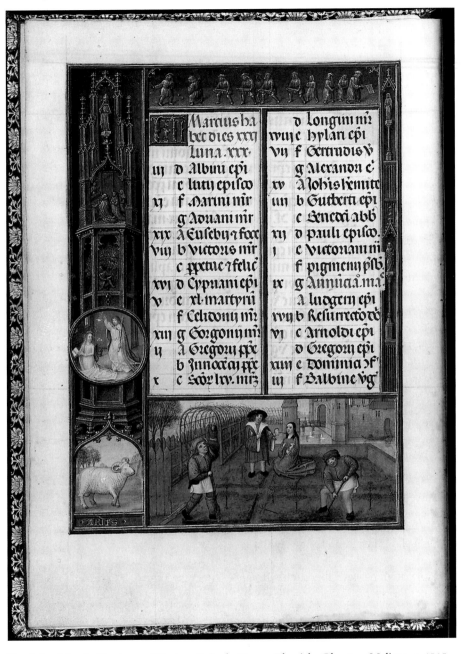

Fig. 3-6. March. Gardeners Digging. Spinola Hours, Flemish, Ghent or Malines, c. 1515. The J. Paul Getty Museum, Los Angeles, California, Ludwig MS IX.18, fol. 2 verso.

Fig. 3-7. April. Woman Gardener Planting, Watched by Her
Mistress. Book of Hours, Flemish, early sixteenth century. The
Walters Art Gallery, Baltimore, MS W425, fol. 4 verso.

developed sense of design which informed each detail of the admired gar-
den style. (See Figs. 3-2, 3-5, 3-6.)

Relaxation in such highly organized gardens took the form of gentle
strolls down manicured paths. The deck chair and the cushioned recliner
had not yet been invented, and could not have been approved; any sitting
down was done in the upright position, with the back straight and the
support firm. Benches and low walls of stone or wattle were used, and the
only concession to comfort was a soft, if sometimes damp, cushion of turf
planted on the top. A thin line of green indicates the presence of just such

Fig. 3-8. March. Tree-Planting. Book of Private Prayers written for George Talbot, Earl of Shrewsbury. English rubrics, Flemish decoration, c. 1500. The Bodleian Library, University of Oxford, MS Gough Liturg. 7, fol. 3 recto.

a cushion on the stone wall in Fig. 3-6, and there is a circular wattle bench, topped with turf, built around the trunk of an elaborately clipped, trained tree in the May scene of a French book of hours.[41] The provision of squares of turf to make or repair these seats was one of the outside services on which the owner of a grand estate had long come to rely. Hundreds of turves were brought to Windsor Castle in 1311, for the benches in the garden between the hall and the king's private apartments.[42]

In one way, the small, formal garden of the calendar cycle was very sheltered. It was private property, and screened off from the outside world. In another, its situation left it alarmingly exposed to scrutiny. Set out right under the main windows of the owner's house, it was intended to be enjoyed from those very windows. Unfortunately for privacy, this meant that it was all too easy to inspect from such vantage points. Something was needed, to add a touch of mystery, and even secrecy, to the garden; that element was supplied by latticework and trellises. These structures, covered with vines, creepers, and climbing plants, introduced new pleasures: striking patterns, the play of light and shade, the illusion, at least, that the stroller in their shelter was for a moment safe from prying eyes. They also provided new surfaces for the vertical display of flowers and foliage, and so increased the richness and variety of the garden's charms: "Aleys in gardens covered with vynes: and rayled up with stakis vaute [vault] wyse: do great pleasure with the shadowe in parchynge hete."[43]

The bare bones of such arbor-works can be seen quite plainly in these calendar gardens of early spring. Long, straight tunnels made from arched supports appear in several scenes with, here and there, a workman stretching from his ladder to prune a shoot, or tie a branch securely to a post. (See Color Plate 3-4 and Figs. 3-2, 3-6, and 3-9.) Thomas Hill, that fount of good advice for Elizabethan gardeners, states that ash and willow were the favorite woods for these frames. He himself preferred ash, on grounds of economy in effort as well as in expense: "Ashen poles . . . may well indure without repairing for ten years; but those framed with the Willow poles require every three years to be repaired."[44]

The covering of the frame depended on whim and circumstance, for anything that could be coaxed to climb was a potential candidate. Even that bane of the true gardener, the intrusive, indestructible bindweed, might tempt the unwary beginner with its moon-bright flowers. William Worcestre, the antiquary, made a special note in his journal of a charming effect that had caught his eye on one of his travels in the 1470s: "Bindweed, that twines round bushes in summer with white flowers like the

Martius habet xxxj

Luna xxx.

3	d	Albini epi		d	Longini m̄	
	e		18	e		
11	f		7	f	Patricij epi	
	g			g	Anselmi e:	
19	a		15	a	Joseph cōf.	
8	b		4	b		
	c	Thome te		c	Bñdicti abb	
16	d	Gerton̄ mj	13	d		
5	e		1	e		
	f	(martyr		f		
13	g		9	g	Annūciatio	
2	a	Gregorij p̄p:		a	(marie	
	b		17	b		
10	c		6	c		
				d		
			14	e		
			3	f		

Fig. 3-9. March. Inspection Tour by Woman Proprietor. Hours of the Virgin, Flemish, Bruges, school of Simon Bening, c. 1520. The Pierpont Morgan Library, New York, MS M307, fol. 2 verso.

little church bells called sacring bells."[45] Of all the possibilities, the grape-
vine was the universal favorite. In the cool summers of northern Europe,
its fruit might never ripen to full sweetness, but at least it always formed.
Members of the Grocers' Company in London valued their right to two
or three clusters a day in season from the guild garden.[46] Best of all, the
vine itself was obligingly easy to grow, and graceful in its habit: "A vyne
clevynge to his raylis with his twyndynge stryngis: and lette hangynge
downe his clusters of grapes: maketh a plesaunt walkynge aley."[47]

The work being done in these pictures is the same as that performed
for centuries in calendar scenes for early spring: digging, pruning, wood-
cutting. The only change is that now the old tasks have been transposed
into the fashionable new garden setting. Occasionally, a hint of other
farmwork traditional for the season is touched in somewhere in the back-
ground. In Color Plate 3-4, a plow can just be detected in a distant field,
and in Fig. 3-2 a bundle of long wands is being carried across the court-
yard, perhaps for use as stakes in an unseen vineyard. In some lavishly
laid-out calendars, two pages are allotted for each month and, when gar-
dening is chosen as the principal occupation, some work in a farm setting,
or in no setting at all, appears as the secondary scene. The garden of Fig.
3-3, for example, is followed by an illustration of plowing in an open
field. In the manuscript from which Fig. 3-10 has been taken, the order is
reversed: this garden is preceded by one which shows digging and trans-
planting. (See Fig. 3-11.) With such small, telling strokes, the artist paid
tribute to tradition even as he broke the mold.

Much digging and pruning goes on in these pictures, but most of the
myriad chores that filled the gardener's day failed to find footholds in the
scheme. Even watering is never shown, although the presence of a hand-
some fountain or a peaceful moat (Figs. 3-5, 3-6) is a reminder of how
necessary some convenient source of water is to the well-being of any
garden. The paths and beds are always spruce and trim but, perhaps for
that very reason, we are rarely permitted a glimpse of the equipment
needed to keep them in that enviable condition. There are many spades on
show, and several ladders (Fig. 3-2), but it is unusual to find a broom or a
wheelbarrow in use, and only an occasional basket (Fig. 3-8) or plant pot
(Fig. 3-1) hints at the ways in which materials were carried to and fro.

The development of the garden setting added only one new task to the
roster of early spring activities: the bedding out of plants. (See Figs. 3-1,
3-2, 3-7, 3-8, 3-10, 3-11.) This agreeable, and highly appropriate, occupa-
tion was introduced as soon as the scene began to take shape. It can be
found in the Turin Hours, whose calendar was illustrated at some time

Fig. 3-10. March. Pruning and Planting. Book of Hours, Flemish, probably
Bruges, c. 1500. The Fitzwilliam Museum, Cambridge, MS 1058-1975, fol. 3 verso.

Fig. 3-11. March. Digging and Tree-Planting. Book of Hours, Flemish, probably Bruges, c. 1500. The Fitzwilliam Museum, Cambridge, MS 1058-1975, fol. 3 recto.

between about 1450 and 1475[48] and, in another manuscript, made earlier in the century, the scene for April shows a "personnage plaçant des fleurs dans une caisse."[49]

Whatever the labor shown, the rules of the calendar game are always observed: each activity is proper for the season. The scenes present not fantasy, a medley of picturesque tasks plucked at random from the whole year, but sober reality, the jobs that had to be undertaken in the early spring, those long sanctioned by custom and conventional wisdom. The English schoolbook of 1519, mentioned earlier, offered for translation into Latin some instructions on pruning: "Vynes of pryce: that for pleasure shaddowe aleys shuld be lopped or cut about the xx day of march."[50] An elderly husband in late fourteenth-century Paris jotted down a long list of gardening instructions for his young wife.[51] Among his suggestions for March was one about bedding out practice. He advised that certain plants should be kept under cover indoors during the winter, and then set out at first not directly in the ground but still in their own pots, to bask in sunshine and fresh air for a few hours, before being carried back to shelter in the evening. (See Figs. 3-1, 3-8.)

Although, on the whole, the garden scene was built up, piece by piece, from old elements arranged in a new setting, it did contain one strikingly original ingredient: a marked emphasis on the relationship between master and man. However preoccupied medieval society may have been in general with knotty points of precedence and hierarchy, the relationship between the classes was rarely touched on in the calendar tradition. The cycle of the year's activities shows men at work, of their own free will, laboring in serene independence. No hint of the coercive power of bailiff or of landowner creeps in to darken or to sour the mood.

In contrast, the garden scenes often present owners and workers together and, with much doffing of caps and touching of forelocks, the gardeners pay obvious respect to their masters. The proprietor is an interested spectator, keenly attentive to the work going on around him, and he is not usually alone. Sometimes he looks on with his wife (Fig. 3-6), sometimes he and his wife go on separate tours of inspection, she with her ladies, he with one other man. (See Figs. 3-2, 3-3.) Sometimes no woman is present, and it is only the master and his companion who stand as onlookers in some corner of the scene. (See Color Plate 3-4.)

Economy was a watchword for the medieval artist, and these figures of the owner and his attendant were neatly lifted from another pictorial tradition which, already developed by Flemish artists, was conveniently at hand. The "Liber ruralium commodorum," a book of advice on agricul-

tural practice and estate management, was written sometime between 1304 and 1309 by a retired lawyer in Bologna, Piero de' Crescenzi. This collection of useful hints and firm instructions became very popular throughout Europe in the next century. It was translated from Latin into Italian and French, many manuscript copies were made, and at least fifty-seven printed editions, in Latin and assorted vernaculars, came out between 1478 and 1571. Charles V of France commissioned a translation in 1373, and Edward IV of England owned an illustrated copy in French, written in Flanders between 1473 and 1483. The book became a standard reference work in the library of any landowner.

In some of the sumptuously illustrated manuscript copies of the fifteenth century, made by Flemish artists for the international market, the twelve sections of the text contain pictures of an owner and his adviser surveying different parts of a great estate, from the orchards to the pleasure gardens. (See Fig. 3-12.) This is the detail which was borrowed for the calendar gardens painted early in the next century. The Crescenzi illustrations and the new scene in the labors cycle sprang from the same stock, a burgeoning pride of ownership, and it was only fitting that shared assumptions led to a shared motif.[52] Where the two differ is in atmosphere, for in the Crescenzi pictures the observers are not themselves observed. Invisible spectators, they watch as others work. No attention is paid to them, no respect is shown.

The two pictorial schemes part company on one other point: in the Crescenzi illustrations, the owner and the adviser are always men. By contrast, in the calendar pictures, not only does a wife sometimes appear with her husband (Fig. 3-6), but often she and her companions loom large in the foreground, while the two male figures, small and less significant, are set behind them somewhere in the middle distance. (See Figs. 3-2, 3-3.) At times, the woman appears alone, the sole source of authority. (See Figs. 3-7, 3-9.) To take matters even further, the gardeners busily at work under the eye of their mistress are sometimes women themselves. (See Figs. 3-2, 3-7, 3-8, 3-10.) The importance given to women here is noticeable in the calendar cycle, where by custom the principal actors are usually men (but see Chapter 7). The break with tradition brings a welcome breath of reality to the scene, for medieval women did indeed work in gardens, and their mistresses seem to have taken not just pleasure in the agreeable results of those exertions, but also a keen interest in the details.

The polychrome statues of a gardener and his wife, placed to charm the eye and close a vista in Sir John Danvers' garden at Chelsea during the 1620s, embodied a long tradition.[53] For centuries women had worked be-

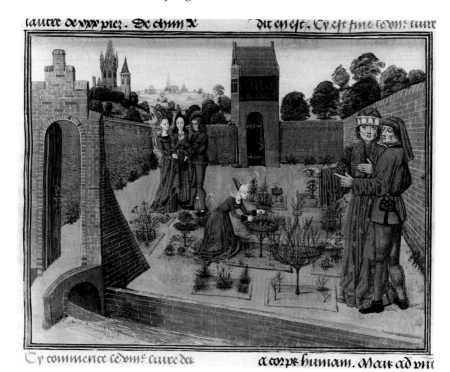

Fig. 3-12. The Pleasure Garden. Piero de' Crescenzi, *Livre des proffits ruraux,* Book VIII, Flemish, late fifteenth century. The British Library, London, Add. MS 19720, fol. 214 recto. By permission of The British Library.

side men, and had been used for all those garden tasks like planting out and weeding which demand deftness of hand, not to mention high tolerance of tedium, rather than sheer strength. In 1413, Winchester College paid the wife of William Bishop four shillings for what, judging from the size of the wage, must have been a herculean job of weeding. Twenty-two women were given three pence each by the day for a whirlwind of tidying in Wolsey's garden, about 1515, before one of Henry VIII's threatened descents for a little relaxation with his servant-friend.[54]

It was also acceptable for women to aspire to more challenging positions. In late fifteenth-century London, Richard Parys left twenty shillings at his death for "Eleanor, the woman who runs my garden across the Thames."[55] More than a century earlier, the head gardener on the Bishop of Ely's manor at Little Downham in Norfolk was called Juliana, and had been put in charge of a team of laborers drawn from the nearby village.[56]

From this precious fragment of information, lodged forever in the bishop's account book, it is easy enough to conjure up a tough, capable working woman, well matched to all those tough, capable ladies glimpsed for a moment in the pages of other records, in other places.

The mistress of any household, large or small, was urged to familiarize herself with every task performed by every servant, on the sensible ground that only in this way would she know what to ask for, and what to expect. When her husband was at home, her job was to provide the comfort of a smooth-running routine. When he was away, she had to step into the breach. It was a very old tradition. During the long years of Odysseus' absence, Penelope ran the estate, and turned for help in a crisis to the gardener who looked after her orchard (*The Odyssey,* book 4, lines 735–41).

In the helpful manual which an elderly husband wrote for his very young wife in late fourteenth-century Paris, the prologue opens on a beguilingly light-hearted note, an invitation to enjoyment: "And know that I am pleased rather than displeased that you tend rose-trees, and care for violets, and make chaplets, and dance, and sing."[57] After this sunlit introduction to the pleasures in store, the book gets down to business, and it must have been disconcerting for the bride to turn the pages of the garden chapter and begin to read. The author moves briskly through the year's endless round of jobs to be done and dangers to be averted: "Cabbage hearts be sown in March and transplanted in May. . . . After the Nativity of Our Lady in September let peony, dragonwort, lily bulbs, rose trees and currant bushes be planted. October: Peas, beans, a finger deep in earth and four inches apart. . . . Note that if you plant in summer in dry weather you should water the holes, but not so in damp weather. Note that if the caterpillars eat your cabbages, do you spread cinders beneath the cabbages when it rains, and the caterpillars will die."[58] On and on runs the list and, if the master plan worked just as the loving old man intended, the young wife would follow all the instructions to the letter, and slowly be transformed from a charming, feckless girl weaving garlands in a garden, into the capable, formidable manager of her second husband's household.

A few years later, in 1405, Christine de Pisan offered the same kind of practical advice to all wives: get up early, walk over the estate, give sensible orders and see they are properly carried out. Every member of the staff must be kept constructively busy: "She will employ her chambermaids to attend to the livestock, to feed the workmen, to weed the courtyards and work in the herb garden, even getting covered in mud."[59] A close and competent eye had to be trained on every detail, to forestall disaster. As a

seventeenth-century writer observed on a common garden catastrophe: "I advise the Mistress either to be present herself, or to teach her maids to know herbs from weeds."[60]

Some of the queens whose windows, as we have seen, opened on pleasant garden prospects took more than a casual interest in what went on out there. In 1280, Edward I's wife, Eleanor of Castile, arranged for grafts of the "Blandurel" apple tree to be sent from France to England, for the royal garden at King's Langley. Ten years later, her household accounts show a special payment, made to a team of gardeners from Aragon on their return to Spain after a spell of service at the same manor.[61] Aragon, with a large population of Moors, had long been influenced by the highly developed garden practice of the Arab world; it is impossible now to guess whether the little band of foreign experts managed to bring a touch of Eastern sophistication to the English garden, or went home defeated, baffled by problems of climate and conditions far different from those with which they had been trained to cope.

Rosemary was first brought to England by Philippa of Hainault, Edward III's wife, when she crossed over from Antwerp in the early 1340s. The cool, damp climate of an island in the North Sea is not ideally suited to the needs of a Mediterranean plant, but the venture had a happy ending. Besides the cuttings packed into her luggage, Philippa carried with her a present from her mother, an account of the medicinal properties of the herb. Over the next few years, the original text of the little treatise was not merely translated into English by a Dominican friar, Henry Daniel, but helpfully annotated and expanded with comments, drawn from his own hard-won success, on ways to protect and establish the tender plant in English conditions.[62]

Tiny hints, scattered here and there, suggest that an appreciation of gardening was shown not just by one or two eccentric individuals but by many women. It was, after all, to Lady Lisle, and not to her husband, that the talented priest "very cunning in drawing of knots" was recommended. A remark, in a treatise on health and diet which appeared in late fourteenth-century Italy, reveals that in one aspect of the art at least it is only time, not taste, which divides today's enthusiast from her medieval counterpart: "It is probably the delightful aroma of the marjoram plant that makes it so pleasing to women, nearly all of whom grow it and care for it diligently in the garden and in pots on the balcony or loggia."[63]

The seed of the idea to develop the traditional calendar activities for early spring into a full-blown garden scene may have been planted early in the fifteenth century by the Limbourg brothers, when they included

the corner of a garden in the April picture they designed for the Très Riches Heures.[64] No laborers are to be found there, but it is obvious that they have been busy, because the garden is in a state of enviable order. As the century unfolded, a garden scene alive with workmen began to be included occasionally in a calendar cycle.[65] By the time it drew to a close, the scene was chosen more often, as the idea became fashionable. (See Figs. 3-1, 3-8, 3-10.) The best-known of the calendar gardens appear in a cluster of early sixteenth-century Flemish manuscripts. They come from the workshops of Alexander Bening, his son Simon, and their colleagues, and the scenes themselves all show a strong family likeness. (See Color Plate 3-4 and Figs. 3-2, 3-3, 3-5, 3-6, 3-9.) The motif of the calendar garden, with its characteristic composition and components, continued to be used as a symbol of Spring itself throughout the sixteenth and seventeenth centuries, in picture series of the four seasons designed by Pieter Brueghel and his followers.[66] In such ways, the garden and its activities became detached from the dying calendar tradition, and absorbed into new decorative schemes. Drained of their original, sober strength, they lived on as delightful embodiments of the season, only to dwindle during the eighteenth century into the vapid prettiness of a gingerbread mold, the representation of Spring as a charming girl in a very large hat, refreshing her flowers with a very small watering-can.[67]

The garden scene found its foothold in the calendar because it touched a responsive chord in the viewer's heart. Its roots lay in the age-old, ever-renewed pleasures summed up so sweetly in the words of a riddle on a name: "Garden wayes and comfort of flowres" ("Alleys" and "Sun": "Alyson").[68] Those roots also tapped into new nourishment, the steadily intensifying pride of ownership. The calendar garden appeared not in a church, built for the community, but in personal property, as a picture in a book of hours laid on the lap of its reader, or a stained-glass roundel in a private dining hall.[69]

These small, controlled pleasure gardens allowed the imagination to feast not on fantasy but on high fashion. They tempted ambition with attainable luxuries, and whetted appetites for affordable beauties. Encouragingly, they showed a real world. In the season of early spring, masters and men alike are warmly dressed to face the rigors of a northern March. (See Color Plate 3-4 and Figs. 3-2, 3-6.) When hard work makes them hot, jackets are stripped off and left lying on the ground. (See Fig. 3-11.) It is, however, a gilded reality. The gardens displayed are in apple-pie order, touched here and there with emblems of prosperity and good fortune:

peacocks pace paths and perch on rails, cranes nest on rooftops. (See Figs. 3-2, 3-5.)

Only in one case does the mask slip. To look at the picture shown in Fig. 3-3, of a small, muddy plot, set beneath the cold sky of an uncertain spring, is to smile with rueful affection at the gulf that yawns between theory and practice, dream and reality. Even so, such bedraggled beginnings foreshadowed future splendors; the tiny enclosure, with its stout plank fence and a stunted plant or two, contained in embryo the principles of design which were to shape the great gardens of northern Europe for the next hundred years.

Chapter 3 Notes and References

1. G. N. Garmonsway, ed., *Aelfric's Colloquy,* 2nd ed. (London: Methuen's Old English Library, 1947), line 219.

2. J. Walsh, trans., *"The Revelations of Divine Love" of Julian of Norwich* (London: Burns & Oates, 1961), chap. 51, p. 139.

3. F. J. E. Raby, *A History of Secular Latin Poetry in the Middle Ages,* 2nd ed. (Oxford: The Clarendon Press, 1957), vol. 1, p. 134; R. A. Brown, H. M. Colvin, and A. J. Taylor, *The History of the King's Works* (London: Her Majesty's Stationery Office, 1963), vol. 2, p. 723, note 9, and vol. 4, p. 17; E. J. Arnould, ed., *"Le Livre de Seyntz Medicines" of Henry of Grosmont, Duke of Lancaster* (1354) (Oxford: Anglo-Norman Text Society, 1940), vol. 2, p. 13.

4. R. Green, M. Evans, C. Bischoff, and M. Curschmann, eds., *"Hortus Deliciarum" of Herrad of Hohenbourg* (London: The Warburg Institute, University of London, and Leiden: E. J. Brill, 1979), in *Studies of the Warburg Institute,* no. 36, 2 vols.; illustration, plate 124; text, vol. 1, p. 201.

5. *History of the King's Works* (see note 3), vol. 1, pp. 767–68.

6. Ibid., vol. 1, p. 80; vol. 2, p. 979.

7. Ibid., vol. 4, p. 17.

8. Ibid., vol. 1, p. 867.

9. M. Wood, *The English Mediaeval House,* 1st ed. (1965) (London: Bracken Books, 1983), p. 336.

10. Ibid.

11. *History of the King's Works* (see note 3), vol. 2, p. 949.

12. M. Howard, *The Early Tudor Country House: Architecture and Politics, 1490–1550* (London: George Philip, 27A Floral Street, 1987), pp. 116–17.

13. Ibid., p. 90.

14. K. B. McFarlane, *The Nobility of Later Medieval England* (Oxford: The Clarendon Press, 1973), pp. 92–101; Wood (see note 9), p. 31.

15. McFarlane (see note 14), pp. 112–13.

16. R. Blythe, *Divine Landscapes* (New York: Harcourt Brace Jovanovitch, 1986), p. 150.

17. J. Harvey, *Early Nurserymen* (London and Chichester: Phillimore, 1974), p. 30.

18. Ibid., p. 40.

19. J. Harvey, *Medieval Gardens* (London: B. T. Batsford Ltd., 1981), p. 112.

20. Ibid., p. 135.

21. G. Kipling, *The Triumph of Honour*

(Leiden: Leiden University Press, 1977), pp. 5–6.

22. *History of the King's Works* (see note 3), vol. 4, pp. 26, 138.

23. R. Maitland, *The History of the House of Seytoun, to the Year MDLIX* (Glasgow: Maitland Club, 1829), pp. 35–36. Thanks are due to Mrs. Priscilla Bawcutt for this reference.

24. Kipling (see note 21), pp. 1–10.

25. A. H. Van Buren, "Reality and Literary Romance in the Park of Hesdin," in *Medieval Gardens*, ed. E. B. McDougall (Washington, D.C.: Dumbarton Oaks Research Library and Collection, Trustees for Harvard University, 1986), pp. 123–24.

26. Harvey (1981; see note 19), fig. 56.

27. O. Pächt and J. J. G. Alexander, *Illuminated Manuscripts in the Bodleian Library, Oxford,* 3 vols. (Oxford: The Clarendon Press, 1963–73), vol. 1, item 390.

28. C. Ross, *Edward IV* (London: Methuen, 1983), p. 32 (1st ed. 1974).

29. Harvey (1981; see note 19), p. 110.

30. Ibid., p. 112.

31. A. Hanham, *The Celys and Their World* (Cambridge: Cambridge University Press, 1985), p. 335.

32. *History of the King's Works* (see note 3), vol. 4, p. 285.

33. W. Horman, *Vulgaria* (1519; reprint, Norwood, N.J., and Amsterdam: Walter J. Johnson Inc. and Theatrum Orbis Terrarum Ltd., 1975), p. 173.

34. Harvey (1974, see note 17), p. 35.

35. M. St. Clare Byrne, ed., *The Lisle Letters* (Harmondsworth, Middlesex, U.K.: Penguin Books Ltd., 1985), p. 98.

36. S. W. Singer, *The Life of Cardinal Wolsey* (Chiswick, 1825), vol. 2, pp. 10–11.

37. R. Mabey, ed., *Thomas Hill's "The Gardener's Labyrinth"* (1577) (Oxford: Oxford University Press, 1988), pp. 19, 120.

38. Espaliered trees can be found also in the April scene in *Turin Hours*, ed. A. Chatelet (Turin: Bottega d'Erasmo, 1967). The calendar scenes in this manuscript were made by Flemish artists circa 1450–75. The manuscript itself was destroyed by fire in 1904 and is known today only from photographs taken in 1902.

39. C. Woodforde, *The Norwich School of Glass-Painting in the Fifteenth Century* (Oxford: Oxford University Press, 1950), pp. 151–52, plate xxxiii.

40. W. E. Mead, ed., *Stephen Hawes, "The Passetyme of Pleasure,"* Early English Text Society, original series 173 (Oxford, 1927), lines 2012–16.

41. Harvey (1981, see note 19), fig. 47A: *The Hours of Queen Anne of Brittany (1501–1507),* by Jean Bourdichon, Bibliothèque Nationale, Paris, MS lat. 9474, fol. 8.

42. Ibid., p. 112.

43. Horman (see note 33), p. 172.

44. Mabey (see note 37), pp. 45–46.

45. J. Harvey, ed., *William Worcestre, "Itineraries"* (Oxford: The Clarendon Press, 1969), pp. 125–26, n. 4.

46. S. Thrupp, *The Merchant Class of Medieval London* (Ann Arbor: Ann Arbor Paperbacks, University of Michigan Press, 1962), p. 136, n. 106.

47. Horman (see note 33), p. 172.

48. *Turin Hours* (see note 38).

49. V. Leroquais, *Les Livres d'Heures Manuscrits de la Bibliothèque Nationale* (Paris, 1927), vol. 1, p. 66: Heures à l'Usage de Paris, or Heures de René d'Anjou, Roi de Sicile, French, first half of the fifteenth century, Bibliothèque Nationale, MS lat. 1156A, fol. 4.

50. Horman (see note 33), p. 172.

51. E. Power, trans. and ed., *The Goodman of Paris* (London: George Routledge & Sons Ltd., 1928), pp. 196–97.

52. R. G. Calkins, "Piero de' Crescenzi and the Medieval Garden," in *Medieval Gardens* (see note 25), pp. 157–73.

53. R. Strong, *The Renaissance Garden in England* (London: Thames & Hudson, 1979), p. 178.

54. Harvey (1974; see note 17), pp. 26, 30.

55. G. Hindley, *England in the Age of*

Caxton (London: Granada Publishing, 1979), p. 158.

56. T. McLean, *Medieval English Gardens* (New York: Viking Press, 1980), p. 219.

57. Power (see note 51), p. 42.

58. Ibid., pp. 199–201.

59. S. Lawson, trans., *Christine de Pisan, "The Treasure of the City of Ladies"* (Harmondsworth, Middlesex, U.K.: Penguin Books, 1985), chap. 10, p. 132.

60. W. Lawson, *The Country Housewife's Garden* (1617; reprint, London: Breslich & Foss, 1983), chap. 9, p. 34.

61. Harvey (1981; see note 19), p. 78.

62. Ibid., p. 118.

63. J. Spencer, trans., *The Four Seasons of the House of Cerruti* (New York and Bicester, U.K.: Facts on File Publications, 1984), p. 43.

64. The Très Riches Heures of Jean, Duke de Berry (1413–16), Musée Condé, Chantilly, MS lat. 1284, fol. 4 verso.

65. For examples, see notes 38 and 49.

66. K. J. Hellerstedt, *Gardens of Earthly Delight: Sixteenth and Seventeenth Century Netherlandish Gardens* (Pittsburgh: The Frick Art Museum, 1986), pp. 8–9.

67. A. Walzer, *Liebeskutsche, Reitersmann, Nikolaus und Kinderbringer: Volkstümlicher Bilderschatz auf Gebäckmodeln, in der Graphik und Keramik* (Stuttgart: Jan Thorbecke Verlag Konstanz, 1963), p. 189, fig. 272.

68. C. and K. Sisam, *The Oxford Book of Medieval English Verse* (Oxford: The Clarendon Press, 1970), p. 567, no. 332. The riddle is dated c. 1450.

69. For example, in Brandiston Hall, Norfolk (see note 39).

4

Summer;
Sheep and Shepherds

 Sheep, and the shepherd, have been figures in the land-
scape of the world for a very long time. Archaeological
discoveries suggest that, by at least 9000 B.C., people in
northeastern Mesopotamia were already making use of domesticated sheep
and goats.[1] So old, and so familiar, is the work of the shepherd that, at the
spectacular discovery of the body of a Late Stone Age man in a glacier
high in the Tyrolean Alps, in the autumn of 1991, the first confident spec-
ulations by experts assumed that he was a herdsman who had perished
after leading his flock to summer pastures in the mountains.[2]

In later centuries, it was the wool and cloth trade that drove the econ-
omy of western Europe. The importance of wool in the medieval scheme
of things is indicated by one of the sculptural programs designed for
Chartres Cathedral. There, sometime after 1224, the left door of the North
Portal was decorated with six figures representing what was called the
"Active Life." Each one is engaged in some stage of wool production.[3] For

the lucky, wool meant wealth. Splendid churches and handsome houses still bear witness to their builders' sound investment of substantial profit. One fifteenth-century wool merchant, John Barton of Holme beside Newark, made no bones about the matter, and inscribed this cheerful tribute in the window of his fine new premises:

> I thank God, and ever shall,
> It is the sheep hath paid for all.[4]

Not only was the shepherd an essential figure in the economy of Europe, he was also presented as an exemplary one in both the Old Testament and the New. From Abel to Abraham, Jacob to Moses to David, the pages of the Bible are filled with the lives of good shepherds; the shepherd as the comfort and protector of his block is one of the best-loved and most familiar images in the teaching of Jews and Christians alike.

According to a Jewish commentary on the Scriptures, it was when God noticed how careful and conscientious Moses had shown himself as a herdsman that He decided this was the right man to lead the Israelites out of Egypt.[5] With the simple words "Feed my sheep," Jesus entrusted to Peter the care of his fellow disciples and all their future followers (John 21:16–17). The moment is engagingly pictured in a copy of Saint Anselm's *Prayers and Meditations*, made circa 1130 at St. Alban's Abbey, where Jesus and Peter are shown towering above two sweet and woolly members of the flock (Bibliothèque Municipale, Verdun, MS 70, fol. 68 verso). Jesus also spoke of himself as the "good shepherd," and was often represented as such in early Christian art. Following this example, bishops, his representatives on earth, carry as the badge of authority and emblem of commitment a pastoral staff in the form of a shepherd's crook. Character and circumstance shaped the term of every bishop in a hundred different ways, but each man was measured against the same symbolic yardstick. To be memorialized as the faithful guardian of the flock was the only tribute that really counted.[6]

Despite the key part he had to play in the affairs of the workaday world, and in the teachings of the Church, the shepherd found it surprisingly hard to gain a foothold in the pictorial scheme of the medieval calendar. He is glimpsed, from time to time, in individual examples, but it is not until the late fifteenth and early sixteenth centuries that he begins to show up with any regularity. Moreover, the traces of his work that can be detected in the calendar tradition by no means indicate the range of the

shepherd's responsibilities, or the sheep's economic importance in the life of the community.

The calendar does not concern itself with the shepherd's duties in the lambing season, or the skills he needed to doctor his flock. It shows no interest in the production of vellum from sheepskin. Until the last years of the Middle Ages, books were made not from paper but from animal skins, and the vital part sheep played in the process is implied in a story about Henry II's visit to the Carthusian community at Witham, in Somerset, sometime in the early 1180s. The statutes of the Order forbade Carthusians to eat meat, but permitted them to herd sheep and to copy books. This particular foundation, however, the first of its kind to be established in England, was so new, and so small, that it had no flock and, in consequence, no library of its own. The king came to the rescue with a present of ten silver marks, to make possible the purchase of some ready-made vellum, on which to start the long labor of patient copying and composition.[7]

The calendar offers no hint that the sheep was prized for its milk, its mutton, and its manure. When Bishop Grosseteste, around 1240, offered the Countess of Lincoln some advice on managing her household and estate, he reminded her in his twenty-seventh rule: "The return from cows and sheep in cheese is worth much money every day in the season."[8] On the Irish estate of Robert Bigod, Earl of Norfolk, in County Wexford, at the end of the thirteenth century, the accounts show that sheep were kept not only for their wool and meat, but also for their manure, which was spread on the fields to improve the crop.[9] Not one of these products or activities finds a place in the calendar scheme.

As the calendar cycle pictures developed into small, self-contained landscapes, it became possible to include extra details in the background of a traditional scene. Occasionally these hint at the shepherd's work, even though the shepherd himself is not a leading character. In the February scene of the Très Riches Heures (1415) made for the Duke de Berry (Musée Condé, Chantilly, MS 65, fol. 2 verso), the emphasis is on the characteristic, centuries-old occupation for the month—toasting toes by the fire—but a sheep pen can be seen in the farmyard, packed with sheep which, like their masters, are huddling together to keep warm. In the next month, March, from the same cycle, a plowman dominates the foreground, but in the distance there is a shepherd, bringing some forage for his sheep to supplement the meager grazing to be found in a hard, close-cropped meadow at the end of winter. And in a November scene, from another manuscript, where cattle are driven to market, one disconsolate

sheep is plodding along beside them (Fig. 4-1). It is rare, indeed, for any calendar to hint in this way that the sheep was ever thought of as part of society's food chain.

Touches like these are incidental embroideries, tiny details added to enrich and enliven a familiar scene. Only at two points in the traditional cycle did the shepherd have a place as a principal player: early spring and high summer. For April, the start of spring was sometimes marked by a scene in which flocks were released from winter quarters and driven out to pasture (Fig. 4-2). And in June or July, the customary task of haymaking was at times displaced, and sheep-shearers stepped to center stage. (See Fig. 4-3.) In the real world, the shepherd himself usually sheared his lambs, and left the full-grown sheep to the skill of a professional.[10] Occasionally, in the late, elaborated calendar scenes, a division of labor is indicated, and the shepherd can be seen taking his ease while the shearers are hard at work (Fig. 4-4). In the small, simplified calendar world, however, there is usually no room for specialists, and one figure stands for all.

Although these two scenes begin to appear with any regularity only in later examples, each has long roots, reaching back into antiquity. Shepherds and springtime had been linked together in the classical world. In a

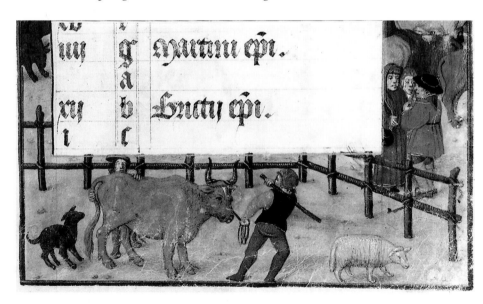

Fig. 4-1. November. Cattle and Sheep Taken to Market. Book of Private Prayers written for George Talbot, Earl of Shrewsbury. English rubrics, Flemish decoration, c. 1500. The Bodleian Library, University of Oxford, MS Gough Liturg. 7 (s.c. 18340), fol. 10. Detail.

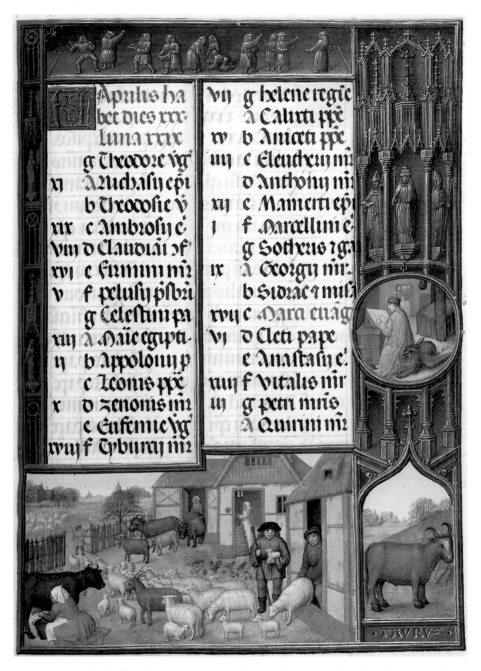

Fig. 4-2. April. Flock Led Out to Pasture. The Spinola Hours, Flemish, Ghent or Malines, c. 1515. The J. Paul Getty Museum, Los Angeles, California, Ludwig MS IX.18, fol. 3 recto.

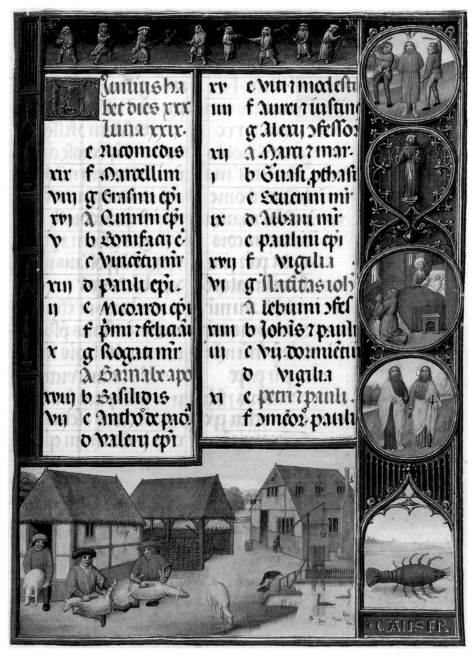

Fig. 4-3. June. Sheep-shearing I. Boys with windmills and hobbyhorses in upper border. The Spinola Hours, Flemish, Ghent or Malines, c. 1515. The J. Paul Getty Museum, Los Angeles, California, Ludwig MS IX.18, fol. 4 recto.

Fig. 4-4. June. Sheep-shearing II. Calendar page by Simon Bening, Flemish, probably Bruges, c. 1540. The British Library, London, Add. MS 18855, fol. 109. By permission of The British Library.

Roman calendar of A.D. 354, the month of March is represented by a young shepherd holding a goat. March was the month in which the god Mars was honored, and the shepherd figure here may represent Romulus, a young man who happened to be the son of Mars, the founder of Rome, and, indeed, a shepherd as well for good measure. His work as a shepherd was often pictured in Roman art, and a shepherd hut, claimed (though not, alas, by eyewitnesses) to have been used by him, still stood on Rome's Palatine Hill in the fourth century.[11]

For medieval calendar artists, the association between shepherds and spring may have been strengthened by the fact that the zodiac sign which influenced late March and much of April was Aries, the Ram. Indeed, in an early fourteenth-century English manuscript, Queen Mary's Psalter (The British Library, London, Royal MS 2B VII), there is a witty embodiment of the sign in the zodiac scene devised for March: shepherds watch over their flock while two rams butt each other in the foreground. (See Fig. 4-5.) In an earlier, twelfth-century stone carving, on the west doorway of the Autun cathedral, the scene for April shows goats which have been let out to browse on fresh green leaves.

In the earliest surviving English calendar, made in the eleventh century, before the Norman Conquest, room has been found for some shepherds in springtime, but the picture's theme and its position in the cycle are both unusual. The month is May, and the shepherds are already out in the open fields with their charges.[12] The illustration of this particular aspect of a shepherd's work never did find general favor. It was the moment when the animals were released after the long winter which slowly but surely became a popular motif for April in late calendars. In this type, artists often combined two kinds of work which, together, represented spring's promise of new life and abundance; sheep are let out to pasture, while cows, and an occasional goat—but never sheep—are milked, or butter is churned. (See Fig. 4-6. See also Figs. 4-2 and 4-10.)

Sheep-shearing also made an appearance in the Roman calendar world. It is, for example, the subject of one of the medallions which show the work of the year on a triumphal arch, built in Gaul in the third century A.D.[13] The theme was treated, occasionally, in the sculpture or mosaic of the earlier medieval period, noticeably in places which had strong connections with classical or Byzantine traditions,[14] but it is not until the thirteenth century that it begins to find a place in manuscript cycles.[15] Needless to say, there must always be at least one exception to prove any rule, and an elegant forerunner, a mid-twelfth-century example, appears in an English calendar.[16] From the thirteenth century onward, there is a

Fig. 4-5. March. Shepherds with Flock, Rams Butting (zodiac scene). Queen Mary's Psalter, English, early fourteenth century. The British Library, London, Royal MS 2B VII, fol. 75 recto. By permission of The British Library. (N.B.: The first line below the picture reads, in part, "XVII KL Aprilis," meaning the seventeenth day before the Kalends of April, i.e., March 16. See Appendix.)

trickle of manuscript examples, and this trickle slowly gathers force until, by the fifteenth century, the subject has become quite a popular alternative to the conventional haymaking or harvest scenes for summer, although it never entirely displaced them.

Even though sheep and shepherds slipped in and out of the calendar tradition over the centuries, they did not manage to win an absolutely predictable place there, and we are faced with two intriguing, interlocking questions: why was it so hard, for so long, for the two to be accepted, and why was there a perceptible increase in their popularity in the calendars of the late Middle Ages?

One reason for the reluctance to use the shepherd may lie in the gulf between theory and practice. In the Bible, the shepherd is the ideal representative of the good man; in the story of Cain and Abel it is Cain, the farmer, who is the murderer, and Abel, the shepherd, who is the innocent victim. As Francis Bacon, like many other commentators, pointed out:

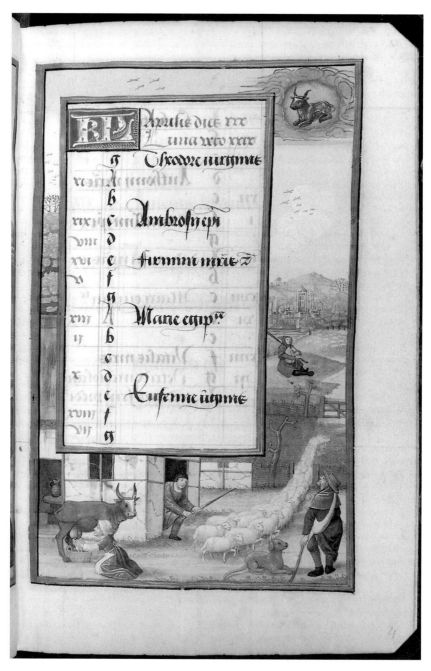

Fig. 4-6. April. Flock Led Out to Pasture. Book of Hours, Flemish, probably
Bruges, c. 1500. The Fitzwilliam Museum, Cambridge, MS 1058-1975, fol. 4 recto.

"We see again the favour and election of God went to the shepherd, and not to the tiller of the ground."[17] It is also true that the part played by sheep and shepherds in the economy of Europe, and in the economy of the individual village, was of central importance. Nevertheless, in the everyday world of everyday encounters, the shepherd's life set him a little apart from his fellows; he was often viewed with suspicion, and sometimes with downright dislike.

There were two main kinds of shepherd in the Middle Ages. One guarded large flocks on mountain pastures, and guided them over great distances to important markets. This type did not enter at all into the calendar. The other was the village shepherd, closely tied to a particular community, a man who took care of his overlord's flock or, alternatively, of small numbers of sheep belonging to his neighbors. He was paid to look after the animals while the owners looked after their own work. This is the shepherd who stepped into the calendar pages, where he is always shown not out in the wilderness but very close to home.

Although his job was important to the community, and although his sheep made a vital contribution to its economy, the demands of the shepherd's work set him on a fault line which ran between the needs of his flock and the needs of his neighbors. While the village wanted sheep to pasture on fallow fields and enrich them with manure, smiles changed to frowns when sheep overstepped the bounds and proceeded to munch their way through tasty new crops. A never-ending crackle of complaints between shepherds and villagers rises from the pages of community records, nagging recriminations punctuated by violent eruptions of injury and even death.[18] However, a far more serious threat to the whole community was posed when the lord of the district decided that sheep would bring more profit than arable farming, and proceeded to enclose an area of his land for pasture, for then many villagers lost their homes and their livelihood. The shepherd was not responsible for the catastrophe, but he was the most visible, and the most vulnerable, target for hostility.

Even when pleasant harmony prevailed, the shepherd's life followed a different rhythm from that of his neighbors. His hours were odd, and he spent long stretches of time with his flock, away from normal human contacts. In the lambing season, he often stayed out in the fields beside his sheep, sheltered from the worst of the cold in a hut on wheels, which could be hauled from place to place as need arose.[19]

For any and all of these reasons, the shepherd was viewed as something of an outsider, and this seems to have been recognized from the first. The society of ancient Mesopotamia in the third millennium B.C. harvested ce-

reals and was proud of its vast, protected grain stores. It is not surprising that in *Gilgamesh*, the Sumerian epic created in that world, shepherding is presented as a mere way-station in the progress of human civilization from life among the wild beasts to life in a city, "strong-walled Uruk."[20] In the earliest literary treatment of the work cycle, Hesiod, writing in central Greece during the eighth century B.C., composed a poem on the farmer's year, in which the focus is on the agricultural round of plowing, sowing, and harvesting, with only a rare, stray reference to sheep throughout the entire composition.[21] Virgil finished his own poem on farm life, the *Georgics*, in 29 B.C. This does, indeed, deal with sheep farming, but Virgil keeps the matter strictly apart from agriculture proper by covering the subject of animal husbandry in a separate section.[22]

The medieval calendar cycle is a celebration of the agricultural round. Once it had set into this mold, it was hard for any new element to insert itself into the pattern, because each month's compartment had long since been filled. It is a measure of the ever-growing importance of sheep-farming that it managed to thrust its way in at all, over the barriers of custom and convention. Even when a spot was found for it, this was often done not by displacement but by distancing; a traditional occupation was pushed into the background, to clear the stage for sheep. In the Très Riches Heures, the July scene has been appropriated by the sheep-shearers, but just behind them the reapers are still at work, cutting the wheat crop.

Another shadow fell across the shepherd's path. In the minds of those who speculated about the nature of the world, there was a tug-of-war between the rival charms of two models shaped by revered authors in antiquity. The vision of a golden age, lost in the mists of time, in which nature was benign, the earth was fruitful, and the living was easy,[23] battled with a vision of the earth groomed into beauty by the conscious effort, constant toil, of men and women.[24] The dream of a golden age never lost its magic, but it was the image of the cultivated landscape as testimony to the well-regulated society which best fitted the realities and the aspirations of the Middle Ages.

By many, the pastoral life was regarded as more primitive than that of agriculture and settlement. The shepherd and his flock seemed to accept conditions, the farmer created new ones. He carved out space and tamed the wilderness. Countries like Scandinavia and Ireland, which were considered, by those privileged to live in the middle of the continent, to lie on the fringe of Europe, and therefore on the fringe of civilization, were sometimes criticized for their backwardness, their unreformed pastoral ways.[25] In the late twelfth century, that confident, caustic visitor to Ire-

land, Gerald of Wales, wrote of the inhabitants: "They have not progressed at all from the primitive habits of pastoral living. While man usually progresses from the woods to the fields, and from the fields to settlements and communities of citizens, this people despises work on the land. . . . They use the fields generally as pasture, but it is pasture in a poor state."[26]

It is part of the humor in the human condition that, when just about everybody lives in the country, the city becomes the place to be. Heaven, in the book of Revelation, is pictured as the ideal city, the glittering, bejeweled New Jerusalem, a setting as far removed as possible from the muddy, muddled realities of the everyday world (Revelation 21). On such a scale of values, when the city is placed at the top, the lonely life of the shepherd, with only his flock for company, may well seem close to the bottom.

Over the centuries, however, there have been many visions of heaven, and the one that was offered in the late thirteenth century, in the continuation of that most influential of medieval poems, the *Roman de la Rose*, was not a city at all. Instead, Paradise is presented there as the perfect meadow, on which white sheep and their shepherd move in soft sunshine over fresh green grass.[27] Perhaps it is significant that this was the image chosen by a poet just at the time when attitudes were starting to change. Certainly, in the next century, the fourteenth, and from then onward, it became fashionable to dwell on the hollow splendor of life at the top, and to contrast the corruption and cruelty of the court with the wholesome delights of the country.[28] The courtier's nagging anxiety about advancement, his nightmare of insecurity, were compared, unfavorably, with the placid pleasures of the peasant, who worked hard, enjoyed each day as it came, and slept soundly every night. Not one of the sophisticated poets who played with the theme had any intention of changing his own lifestyle, but the artificiality of the dream only added to its charm.

From time to time there was even, in courtly circles, a faint stirring of interest in actual rural affairs. In 1379, Charles V of France commissioned a short book on the training and duties of the shepherd, and this was not written by some armchair theorist, but by Jean de Brie, a real, dyed-in-the-wool shepherd.[29] Shortly afterward, in the first years of the next century, two sumptuously illustrated manuscripts of Virgil's *Eclogues* and *Georgics* were prepared for members of the French court, with idealized and irresistible scenes of country pleasures.[30]

To an attentive eye, calendar pictures of this later period offer many hints of contemporary sheep-farming practice, from the use of a goat as a bellwether, or leader of the flock (Fig. 4-7), to the methods of securing

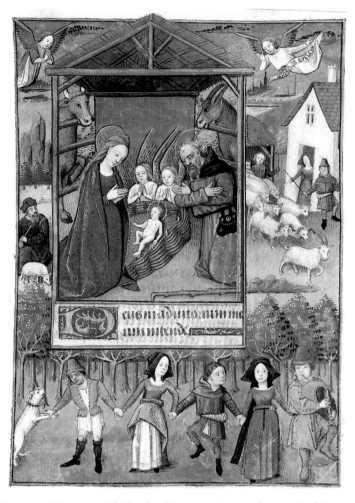

Fig. 4-7. Nativity, with Shepherd Scenes in the Border. Book of Hours,
attributed to Robinet Testard, French, Poitiers, c. 1475. The Pierpont
Morgan Library, New York, MS M1001, fol. 44.

sheep and storing wool at clipping time (Figs. 4-3, 4-4).[31] Such tiny, telling
details are precious to the historian, but enthusiasm is fanned into flame
by fancy rather than by fact, and their presence is a symptom, not a cause,
of an awakened response. For the style-conscious, peasant ways had be-
come high fashion, and of all kinds of peasant occupation, it was the shep-
herd's life which seemed by far the most congenial. Viewed from a safe

distance, his work appeared to consist mainly of sitting in meadows, watching over docile flocks, and whiling away the hours with a little music or a little flirtation. (See Fig. 4-7). Undemanding, undeniably picturesque, the shepherd's world became a dream world for society. In the late fourteenth and the fifteenth centuries, the most unlikely court entertainments were presented in the trappings of pastoral. King René of Anjou arranged a delightful tournament in June 1449, in which the two champions prepared to fight against all comers were dressed as shepherds, and the object of their devoted defense, the king's wife, appeared as a shepherdess holding a crook which was six feet long and made entirely of silver.[32]

It pleased the great and the wealthy to surround themselves with enticing simulations of the simple life. So, Germolles, a manor which belonged to Margaret of Flanders, wife of the Duke of Burgundy, in the last twenty years of the fourteenth century, was decorated on the inside with tiles and tapestries, furniture and bedspreads, all generously sprinkled with sheep and shepherds in every possible combination. More, the mansion was ornamented on an outside wall with a large stone sculpture, which showed a flock of sheep in the shelter of an elm tree, set between the heraldic devices and imposing figures of the duke and the duchess.[33]

Such an exceptionally elaborate response to a current enthusiasm required exceptional resources, but it was possible to bow to fashion with more modest means. The set of tapestries, showing "shepherds and their wives," purchased by Sir John Fastolf for his own pleasure in the mid-fifteenth century,[34] could be matched by any number of variations on the same theme in the master bedrooms and parlors of Europe throughout the next hundred years.

The idealized shepherd was seen as the personification of the good life, and of all this world's blessings: love, harmony, peace, prosperity. As such, the shepherd even came to be chosen as an appropriate ornamental motif for a political document. The peace settlement between France and England in 1527, known as the Treaty of Amiens, had been hammered out by hard-eyed politicians with very little peace in their hearts, but the official record of its terms was decorated with a promising scene of pastoral tranquillity.[35]

Not only was this ideal figure regarded as a symbol of the good life, he was also venerated as a good man. Having been ennobled over the centuries by association with the virtuous and famous shepherds of the Bible, he now began to be seen as the personification of every good and faithful workman in the world. He played the part to perfection because, of all the kinds of laborers, it was the shepherd, and only the shepherd, to whom

angels brought the news of the miraculous birth at Bethlehem. Shepherds were the first representatives of the human race to reach the stable and pay homage.

A masterly retelling of the Gospel story, *Meditations on the Life of Christ*, appeared in the late thirteenth century, and proceeded to shape the devotional landscape of Europe for the next two hundred years. This book, by an unknown Franciscan writer, wove together the biblical text and an inspired selection of scholarly commentaries into one seamless narrative, whose tone was so gently persuasive that it determined the viewpoint and colored the response of succeeding generations.

In his account of the Nativity, the author included this observation by an earlier authority, Saint Bernard of Clairvaux: "To the shepherds who watched is announced the joy of the light, and to them it is told that the Savior is born; to the poor and to those who work hard, and not to you who are rich."[36] The highlighting of Bernard's words gave them a new prominence, and from this seed grew a new devotional respect for the poor in general, and the shepherd in particular. It was in the fourteenth century that two scenes in the Nativity account—the annunciation to the shepherds, and their visit to the stable to pay homage—were elaborated by artists and added to the familiar pictorial re-creation of the story.[37] The two movements, pastoral and devotional, fed on each other and became entwined. Often a devotional scene of shepherds listening to the angels, or kneeling at the manger, is set in the midst of a pastoral world, where good news of any kind is celebrated with song and dance. (See Fig. 4-8. See also Fig. 4-7.)

The shepherd, as the simple man who is wiser than the wise, was a figure that took on a life outside the confines of the gospel story. At the very end of the fifteenth century, in Paris, he was given a calendar of his own. In 1491, the first edition was published of a work which went on to enjoy great popularity in many countries throughout the next two hundred years: *Le Kalendrier des Bergiers*.[38] In this, an omniscient shepherd lectures his readers on everything, from the ages of man through the seasons of the year to the movements of the stars and planets. Indeed, he has so much to say, on so many subjects, that in one sixteenth-century Scottish version his wife feels impelled to step forward briskly and stop him in mid-stream, when the tedium of his ruminations threatens to become interminable: "I pray the to decist fra that tideus melancolic orison."[39]

The establishment of such an authority figure, in a world where real shepherds were rarely asked for advice on any subject but real sheep, speaks volumes about the power of ideas to shape assumptions. The same

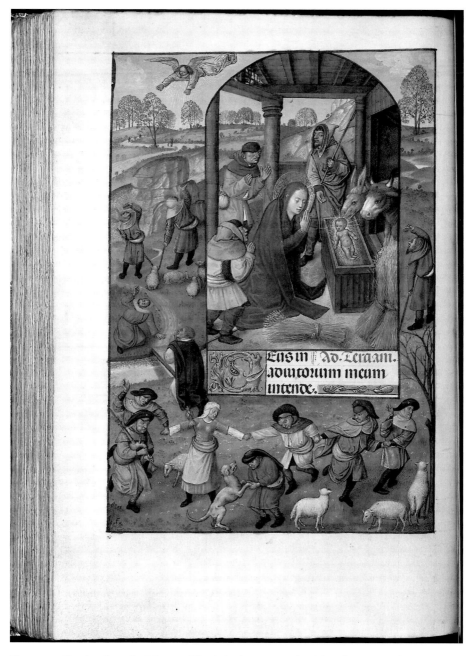

Fig. 4-8. Shepherds at the Manger. The Spinola Hours, Flemish, Ghent or Malines, c. 1515. The J. Paul Getty Museum, Los Angeles, California, Ludwig MS IX.18, fol. 125 verso.

Iunius ha‑
bet dies.xxx.
Luna vero. xxix.

	e	Secundi mr̃is	xv	e	Viti mr̃is.
xix	f	Erafmi mr̃is	iiii.	f	Diogenis mr̃is
viii	g	Pergentini.		g	Auiti confef.
xvi	A	Quirini epĩ.	xii	A	Marcellini mr̃.
v	b	Bonifacii epĩ	i	b	Geruafii epĩ
	c	Marcellini ep.		c	Siluerii pape.
xiii	d	Pauli epĩ.	ix	d	Ianuarie virg̃
ii.	e	Medardi epĩ.		e	Paulini epĩ.
	f	Primi mr̃is	xvii	f	vigilia.
x	g	Getulli mr̃is	vi.	g	Natiuitas ioã.
	A	Barnabe apo·		A	Eligii epĩ.
xviii	b	Bafilid'mr̃is	xiiii	b	Ioãnis & Pau
vii	c	Antonii côfef	iii.	c	Crefcentii epĩ.
	d	Helifeipphẽ		d	Vigilia.
			xi	e	Petri & Pau.
				f	Cõmeoro Pauli.

Fig. 4-9. June. Upper Border: Shepherdess Shearing Sheep; Lower Border: Wedding Procession. Book of Hours, French, early sixteenth century. The Bodleian Library, University of Oxford, MS Douce 135, fol. 4 verso.

pressures came to shape the sober calendar world. There, from time to time, everyday work is softened by touches, borrowed from the pastoral dream, of work presented as pure pleasure. A shepherd has enough time to watch a huntsman ride by;[40] a shepherd couple and a courtly couple enjoy a spring landscape together (see Fig. 1-11); a particularly decorative shepherdess shears her sheep (Fig. 4-9). The real strength of fashion, however, reveals itself not so much in this tracery of incidental details as in the actual addition of the shepherd figure to the calendar's cast of characters. The pincer movement of devotional and pastoral forces pressed the old calendar tradition, and pushed the shepherd into place within its cycle. His very presence there in the late medieval period is a testament to their power. Every now and then, the design of some composition hints at the cross-currents of influence at work. One late fifteenth-century French manuscript page shows an "Annunciation to the Shepherds," set within a border borrowed from a calendar scene for April, in which the sheep are driven out to pasture while a goat is being milked. Picture and frame are quite separate in subject, and yet interlocked. They are two sides of one coin; the idealized shepherd's life. (See Fig. 4-10.)

One other thread wove the shepherd figure into the calendar tapestry. In the late Middle Ages, the motif appears in calendars created not for churches but for manuscripts, not for public but for private settings. The books of hours in which these calendars occur were produced for an international market. They were made for the well-to-do, designed for the landowner, not the laborer. In the eyes of such readers, sheep-farming and wool represented economic health, growth, and profit. To underline the point, in some cases a bailiff, the master's representative, is present in the picture, to check the work in hand. (See Color Plate 4-11.) For men of property, in this period, the shepherd had become a central figure in the scheme of things, made acceptable by fashion and essential by circumstance. The ancient division between the agricultural and the pastoral worlds had been bridged, and the shepherd's presence in the calendar is one clue to the change.

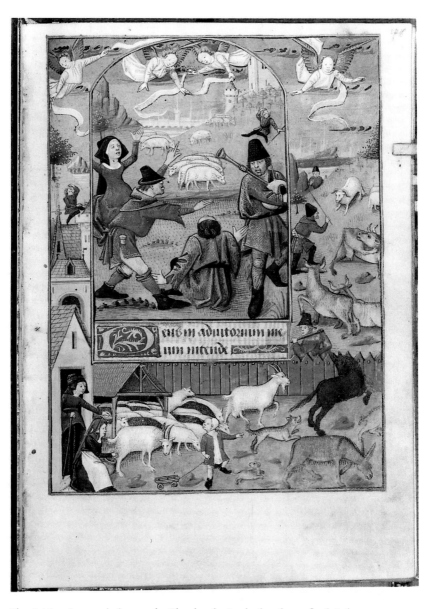

Fig. 4-10. Annunciation to the Shepherds. In the border, a flock is let out to
pasture. Book of Hours, attributed to Robinet Testard, French, Poitiers, c. 1475.
The Pierpont Morgan Library, New York, MS M1001, fol. 48.

Chapter 4 Notes and References

1. M. L. Ryder, *Sheep and Men* (London: Gerald Duckworth & Company Ltd., 1983), p. 22.

2. B. Fowler, "Man in Glacier," *New York Times*, July 21, 1992, p. C1.

3. H. Kraus, *The Living Theatre of Medieval Art* (Bloomington and London: Indiana University Press, 1967), p. 100.

4. E. Power, *Medieval People* (Garden City, N.Y.: Doubleday Anchor Books, Doubleday & Company Inc., 1954), chap. 5, p. 145.

5. D. Goldstein, *Jewish Mythology* (London: Hamlyn Publishing Group Ltd., a division of The Octopus Publishing Group, 1987), p. 86.

6. R. W. Hunt, "Verses on the Life of Robert Grosseteste," *Medievalia et Humanistica*, n.s., no. 1 (1970), pp. 241–51.

7. C. de Hamel, *A History of Illuminated Manuscripts* (Boston: David R. Godine, 1986), p. 84.

8. E. Lamond, ed., *Walter of Henley's Husbandry* (New York and London: Longmans, Green & Company, 1890), Robert Grosseteste's *Rules*, on p. 145.

9. T. O'Neil, *Merchants and Mariners in Medieval Ireland* (Dublin: Irish Academic Press, 1987), p. 59.

10. M. T. Kaiser-Guyot, *Le Berger en France aux XIVᵉ et XVᵉ siècles* (Paris: Éditions Klincksieck, 1974), pp. 35–36.

11. M. R. Salzman, *On Roman Time; The Codex-Calendar of 354 and the Rhythms of Urban Life in Late Antiquity* (Berkeley and Los Angeles, and Oxford: University of California Press, 1990), pp. 106–8.

12. The British Library, London, Cotton MS Julius A.VI, fol. 5, Calendar and Hymnal in Latin and Anglo-Saxon, English, probably Christchurch, Canterbury, early and mid-eleventh century.

13. J. Le Sénécal, "Les occupations des mois dans l'iconographie du moyen âge," *Bulletin de la Société des Antiquaires de Normandie* (Caen), 35 (1924), pp. 1–218; this reference is to p. 22.

14. P. Mane, *Calendriers et Techniques Agricoles (France-Italie, XIIᵉ–XIIIᵉ siècles)* (Paris: Le Sycomore, 1983), pp. 230–32, figs. 208, 210.

15. P. Mane, "Comparaison des thèmes iconographiques des calendriers monumentaux et enluminés en France, aux XIIᵉ et XIIIᵉ siècles," *Cahiers de Civilisation médiévale* 29, no. 3 (July–September 1986), pp. 257–64; this reference is to p. 262.

16. The Bodleian Library, University of Oxford, Series B.1099, MS Auct.D.2.6, fol. 4 recto. Romanesque calendar, St. Albans, 1140–58.

17. H. Cooper, *Pastoral: Medieval into Renaissance* (Totowa, N.J.: Rowman & Littlefield; Ipswich, U.K.: D. S. Brewer Ltd., 1977), p. 90, Francis Bacon, quotation from *The Advancement of Learning* (1605), 1.6.7.

18. Kaiser-Guyot (see note 10), pp. 115–18.

19. An example of such a hut on wheels can be seen in an "Annunciation to the Shepherds" in The Huntington Library, San Marino, California, MS HM.1173, a Flemish book of hours, written in Latin. The miniature was painted by Simon Marmion. Valenciennes, c. 1460.

20. N. K. Sandars, trans., *The Epic of Gilgamesh* (Harmondsworth, Middlesex, U.K.: Penguin Books Ltd., 1960), sec. 1, "The Coming of Enkidu," pp. 61–67.

21. M. L. West, trans., Hesiod, *"Theogony" and "Works and Days,"* The World's Classics (New York and Oxford: Oxford University Press, 1988).

22. L. P. Wilkinson, trans., Virgil, *The Georgics* (Harmondsworth, Middlesex,

U.K.: Penguin Books Ltd., 1982), book 3, part 2, deals with sheep and goats.

23. N. Cohn, *The Pursuit of the Millennium* (London: Mercury Books, 1962), pp. 195–201; M. M. Innes, trans., Ovid, *The Metamorphoses* (Harmondsworth, Middlesex, U.K.: Penguin Books Ltd., 1961), book 1, p. 33; book 15, pp. 366–67.

24. R. E. Latham, trans., Lucretius, *On the Nature of the Universe* (Harmondsworth, Middlesex, U.K.: Penguin Books Ltd., 1951), book 5, lines 1361–78, p. 213.

25. R. Bartlett, *Gerald of Wales, 1146–1223* (Oxford: The Clarendon Press, 1982), pp. 158–63.

26. J. J. O'Meara, trans., Gerald of Wales, *The History and Topography of Ireland* (Harmondsworth, Middlesex, U.K.: Penguin Books Ltd., 1982), pp. 101–2.

27. E. Langlois, ed., Guillaume de Lorris and Jean de Meun, *Le Roman de la Rose*, Société des anciens textes français (Paris: Didot & Champion, 1914–24), lines 19931–20000.

28. B. Woledge, ed., *The Penguin Book of French Verse* (Harmondsworth, Middlesex, U.K.: Penguin Books Ltd., 1961), pp. 216–18, Philippe de Vitry (1291–1361), *Franc Gontier*; pp. 218–20, Pierre d'Ailly (1350–1420), *Le Tyran*; pp. 327–29, François Villon (1431–c. 1460), *Les Contredis Franc Gontier*.

29. Kaiser-Guyot (see note 10), pp. 12–13.

30. M. Meiss, *The Limbourgs and Their Contemporaries*, 2 vols. (New York: George Braziller and The Pierpont Morgan Library, 1974), pp. 60–61, 303–4.

31. Ryder (see note 1), p. 7. For calendar scenes of sheep-shearing, see Wilhelm Hansen, *Kalenderminiaturen der Stundenbücher: Mittelalterliches Leben im Jahreslauf* (Munich: Verlag Georg D. W. Callwey, 1984), pp. 150–52.

32. G. Wickham, *Early English Stages, 1300–1660* (London: Routledge & Kegan Paul, 1959), vol. 1, pp. 22–23.

33. K. Morand, *Claus Sluter: Artist at the Court of Burgundy* (Austin: University of Texas Press, 1991), pp. 370–73.

34. A. Hanham, *The Celys and Their World* (Cambridge: Cambridge University Press, 1985), p. 213.

35. D. Starkey, ed., *Henry VIII: A European Court in England* (London: Collins & Brown, in association with The National Maritime Museum, Greenwich, 1991), pp. 9, 77–78.

36. I. Ragusa and R. B. Green, trans. and eds., *Meditations on the Life of Christ* (Princeton: Princeton University Press, 1961), pp. 36–37.

37. Meiss (see note 30), p. 152; Millard Meiss and E. H. Beatson, eds., *La Vie de Nostre Benoit Sauveur Ihesucrist et la Vie de Nostre Dame* (New York: New York University Press, for the College Art Association of America, 1977), introduction, p. xii.

38. E. Dal and P. Skårup, *The Ages of Man and the Months of the Year* (Copenhagen: The Royal Danish Academy of Sciences and Letters, 1980), p. 14.

39. J. A. H. Murray, ed., *The Complaynt of Scotland*, Early English Text Society, Extra Series 17 (1872), pp. 42–66; the wife's interruption is on p. 62.

40. Shepherd Watching Huntsman Ride By. Hennessy Hours, Flemish (Bruges), Simon Bening, c. 1530–35, Bibliothèque Royale, Brussels, MS II.158, Plate 12 (April).

5

Autumn; The Harvest

 Harvest is the heart of the calendar year, its high point and its purpose—but not every kind of harvest. In the tradition's streamlined survey of the farming scene, there is no space for cabbages or parsnips, lettuces or leeks. An assortment of fruits is picked from time to time in cycles either made in Italy (for example, in the August labors chosen for the 1278 Fontana Maggiore in Perugia), or touched by Italian influence but, by and large, few crops win a place on the severely selective short-list deemed worthy of attention: hay, wheat, grapes, and livestock.

In the calendar world the rules are simple, and so are the rewards. The right steps taken at the right time ensure the right result. The yield is just right in quality, just right in size. Little figures, isolated in each month's compartment, cut one sheaf of wheat or tread one vat of grapes; the job is done, and attention swings to the next task in the seamless story of the seasons' round. In the real world, as even the most inattentive gardener

becomes aware, Nature is never so precise in her measurements. Harvests are always too big or too small, and each kind poses its own problem. Either surplus stock has to be disposed of, or supplements must be found. However simple the society, the ebb and flow of exchange, barter, or trade begin, and commerce is born.

Moreover, the calendar world is a self-sufficient and entirely agricultural model, in which every task performed, every skill required, has something to do with the raising of crops. The viewer is encouraged to believe that its inhabitants first produce and then consume their own harvest. There are no leftovers, and no links with the wider world that lies beyond the frame. The facts of life in medieval society were far more complicated, with farmers in need of buyers, and ever more varied kinds of consumer in search of supplies. The elaborate household of a bishop or a lord had to be provisioned, either from local farms under its authority or from markets. Townspeople, whether wealthy goldsmiths or struggling shoe-makers, could grow at best a mere fraction of their daily requirements, and went shopping for a joint of meat or a sack of flour, a basket of eggs or a handful of cress.

Acknowledgment of this sustaining web of need that bound producer and customer together was expressed occasionally in picture schemes that lay outside the calendar tradition. The most famous example is the fresco completed by Ambrogio Lorenzetti in 1340 for the Sala dei Nove in the Palazzo Pubblico of Siena. There the art of Good Government is embod-ied in the representation of a secure city, set in a secure countryside. Har-mony and order reign inside the city walls, and in the fruitful, carefully cultivated landscape that lies outside them. Citizens and peasants go about their daily tasks and, to emphasize the necessary connection between the two, there are parties riding out of the city into the country, and figures that head back toward town. One drives a pig, another brings a load of grain, both to be sold in the busy marketplace inside the gate. The system is in perfect working order, and a bloom of contentment lies over city and country alike.[1]

In a less familiar example, a *Life of Saint Denis* presented to Philippe V of France in 1317,[2] the bottom borders display thirty tiny, vivid scenes of everyday life on a bridge in Paris. Wine casks and firewood are brought up by river to the city gates, grain is ground into flour in watermills se-cured beneath the arches of the bridge; sheep and oxen plod through the streets to market, and sacks of goods are trundled by wheelbarrows, car-ried by porters, or hauled to their destination with ropes and sled-runners.

Diminutive dramas between buyers and sellers are acted out in every scrap of picture space.

Such a vision of variety, such a celebration of commerce as the pulsing lifeblood of community, has no place in the calendar world, that serene embodiment of the unity that comes from common tasks and common purpose. However, even a tradition that satisfies for centuries runs the risk of being touched and colored by the changing times. And so, every now and then, a calendar scene is opened up to show a hint or two of economic complexity. It is not surprising that traces of such interest are most often found in the later medieval period, when the traditional, almost feature-less, compartment designed to display a month's allotted occupation was at times transformed into a little landscape, with room and need for inci-dental embroidery.

In the Très Riches Heures (1415) of the Duke de Berry, that manuscript made known to modern readers by a thousand reproductions, the scene for June shows peasants gracefully cutting and raking hay on one bank of the Seine, while just across the water rise the city walls of Paris. In Septem-ber, grapes are picked in a vineyard laid out in the shadow of the duke's great castle at Saumur. The link between harvest and household is hinted at in the actions of two figures: a woman with a basket of grapes on her head is walking up to the castle, while a mule with emptied panniers makes its way down from the gateway to the workers below. In October, once again, townspeople strolling by the Seine on a path outside the walls of Paris can easily watch work in progress as a field is sowed with seed on the opposite bank. The same October scene was adopted a hundred years later in the Grimani Breviary (c. 1517–18), and elaborated to include some commercial river traffic behind the sowing that still continues in the fore-ground. Boats loaded with provisions are being pulled or poled up to the city gate, where tax officials sit to check the cargo and assess the duty.[3] In pictures like these, the closeness of city to country, castle to farm, vividly conveys the closeness of the ties that bound them in mutual dependence.

Occasionally, an artist with a witty turn of mind would play with one of the zodiac signs and give it a part to play in a scene of its own. The sign for September, the month that crowns the harvest season, is Libra, the Scales, a perfect emblem for measure and marketing. In Fig. 5-1a, from a mid-fifteenth-century French book of hours, a merchant uses a balance to weigh goods in his office, while in Fig. 5-1b, from the early fourteenth-century Queen Mary's Psalter, one man holds a pair of scales heaped with grain, while two others are enjoyably engaged in driving a hard bargain.

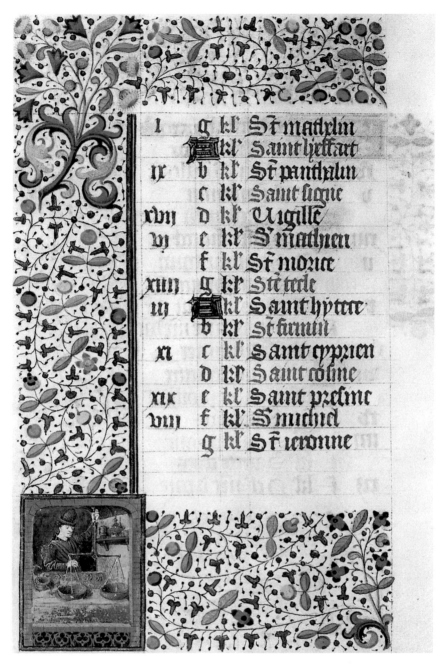

i	g	kl'	St mattelin
		kl'	Saint hettart
ir	b	kl'	St pantalin
	c	kl'	Saint signe
rbiy	d	kl'	Vigille
bi	e	kl'	S' mathieu
	f	kl'	St morice
riiy	g	kl'	Ste tecle
iy		kl'	Saint hyperte
	b	kl'	St farmin
ri	c	kl'	Saint cyprien
	d	kl'	Saint cosine
rir	e	kl'	Saint præsine
biiy	f	kl'	S' michiel
	g	kl'	St ieromne

Fig. 5-1a. September. Libra Sign: A Merchant Weighs Goods in His Office. Book of Hours, French (Angers?), 1460s. The Walters Art Gallery, Baltimore, MS W274, fol. 9 verso.

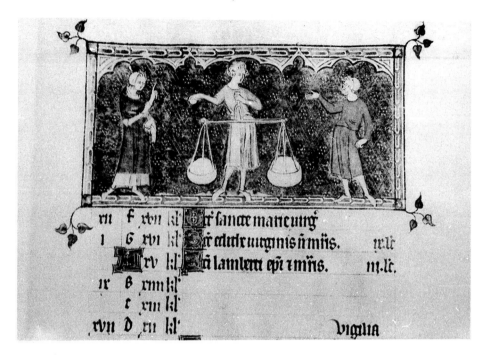

Fig. 5-1b. September. Libra Sign: The Sale of Grain. Queen Mary's Psalter, English, first
quarter of the fourteenth century. The British Library, London, Royal MS 2B VII, fol. 81
recto. By permission of The British Library.

Haymaking, a job for June and July, opens the harvest season in the
calendar year. Hay's main use was as winter fodder for horses and other
livestock. It was a valuable crop, needed in quantity but, like all organic
matter, it could rot as well as ripen, and care had to be taken to dry and
keep it properly during easygoing summer, ready for the harsh, demand-
ing months ahead. As a winter food supply for valuable animals, hay was
precious. Obviously, the greater the yield, the greater the satisfaction, but
a bumper crop was also a bulky one, and raised inevitably the question of
storage. This problem is rarely addressed in the calendar scenes. In most
cases hay is scythed, or raked into neat little heaps; that is the end of the
story, and the spotlight swings to the next month and the next labor. The
pictorial convention betrays no hint of trouble ahead in the handling of
the harvest.

The one clue to the size of the job is the occasional presence of a large
wagon, waiting in the background while the mowers work, already piled
high with hay, and with a ladder set against the load to ease the task of

tossing even more on top (Color Plate 7-6). Just a few late examples show the hay actually being stored away, and it is only in the illustration of this stage that the viewer is given any idea of the bulk and weight involved, and of how unmanageable is the precious load that has to be maneuvered into safety. The problem is compounded by the fact that hay keeps best when air can circulate around it, and so it is stored off the ground whenever possible. In Fig. 5-2 it takes three men to steer an awkward mass into the appointed resting place. The bundle has been tied to one end of a rope that runs through an iron pulley ring fixed high up on the outside wall of a building. Two men on the ground tug on the other end, and haul the hay up to the window of a loft, where a third member of the team stands ready to catch the prize and swing it inside. The same method is demonstrated in Fig. 5-3, a rare calendar scene in which trade has brought the country right into town, as a wagon delivers a load of hay in a city street. Crop has become commodity.

Hay always held its value, but wheat, the next crop to be harvested, in July or August, was the real prize. From hay came food for horses; from wheat was made that staple of the human diet, the loaf of bread. At this point it is best to clarify one small semantic confusion that may puzzle both English and American readers. In English usage, "corn" is a term that covers all kinds of cereal grains, including wheat, whereas in North America today it is the common name for one particular grain plant, Indian maize. For this reason, "wheat" is the word used here, even though, for a medieval poet, August is the month

> Quen corne is corven with crokez kene.
>
> [When corn is cut with sharp sickles.][4]

In wheat, the edible grains form in the ear at the top of the plant's stem. Before they can be ground into flour, they have to be detached from the husk, or chaff, that surrounds them. In medieval practice, this was done in two stages, by threshing and by winnowing. The ears were first thrashed with flails—or, in some Italian calendars, trampled by horses or other draft animals[5]—to make a coarse division, and then a fan or sieve was used to cause the fine chaff to float away from the heavier seed. This grain was the all-important harvest, the precious pearl found in the dust of the threshing-floor. The careful separation of grain from chaff was not only a familiar sight in everyday life; it was also a familiar image of the separation of the saved souls from the damned, because it had been used in the Bible as a metaphor for the Last Judgment: "[He] will gather the wheat into his

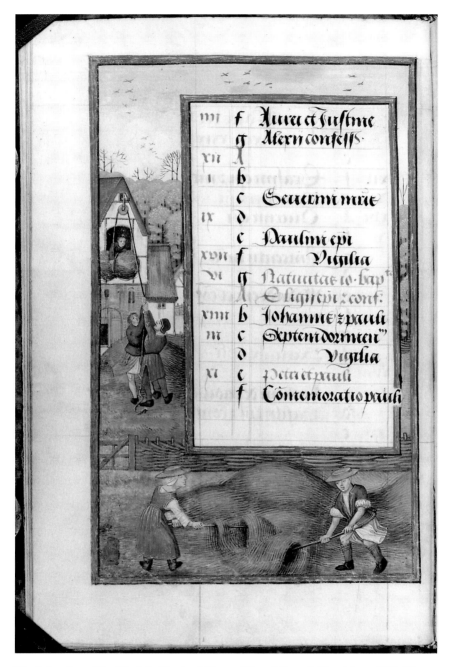

Fig. 5-2. June. The Hayloft. Book of Hours (Use of Rome), Flemish, c. 1500. The Fitzwilliam Museum, University of Cambridge, MS 1058-1975, fol. 6 verso.

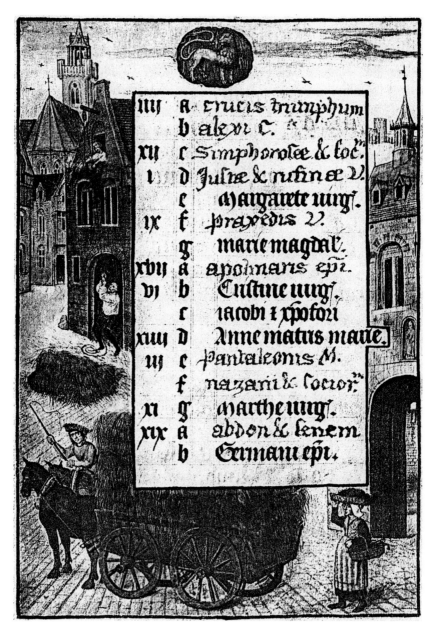

Fig. 5-3. July. Hay Delivery in Town. Calendar page in a Flemish Book of Hours, early sixteenth century. Reproduced in Paul Durrieu, *La Miniature Flamande au Temps de la Cour de Bourgogne, 1415–1530*, 2nd ed. (Paris and Brussels: Librairie Nationale d'Art et d'Histoire, 1927), plate lxxvi. Special Collections, Rare Books Room, Pattee Library, The Pennsylvania State University, University Park, Pennsylvania.

garner; but the chaff he will burn with fire unquenchable" (Luke 3:17).
The somber words paint a powerful but misleading picture, having been
spoken by John the Baptist, a prophet who, living in the wilderness exclu-
sively on locusts and wild honey, was no farmer, and had at best a shaky
grasp of farming practice.

In real life, it was just because the whole plant could be put to good use
that wheat was a specially valued crop. No part was utterly worthless.
As Mischief, a provoking little devil's advocate in the English Interlude
Mankind (c. 1470), points out, the biblical text is not correct. Nothing is
thrown away after threshing, for the simple reason that

> The chaff to horse shall be good provender.
>
> [Chaff is good food for horses.][6]

Moreover, once the grain had been collected from the ears, the long, left-
over stalks were dried and, as straw, became useful in a host of different
ways. Strewn on the floor, stuffed into a mattress, twisted into a rope,
reached for as kindling, straw had a hundred parts to play in the day-to-
day management of any household.

Wheat's versatility was always appreciated, but its value as a food was
the aspect that won it a place at the heart of the calendar tradition. This
being so, it comes as some surprise to find no reference to bread in the
pictures for the high harvest season. Perhaps there was simply no room at
this, the most demanding time of the agricultural year to show the reason
and reward for all the hard work or, indeed, to show anything but the
cutting of the wheat (Fig. 7-7) and the extraction of the grain. On the
Fontana Maggiore in Perugia, for example, the two compartments allotted
to July display one man swinging a flail, and another tossing grain into the
air, to separate it from the chaff.[7] If any baking does take place in a calen-
dar, it is done in the dead of winter (Fig. 7-1 and Chapter 2). Bread and
harvest were linked together by the Church of England, in the ancient fast
of Lammas ("Loaf Mass") on August 1, when loaves of bread made from
the first ripe wheat were blessed, but no direct acknowledgment of such a
link is to be found in the usual calendar scheme. Only in a handful of
exceptions can any hint of the connection be detected.

It has been said that the July scene on a fifteenth-century misericord in
the Church of St. Mary at Ripple, Worcestershire, represents a village
oven, under guard against theft on the eve of Lammas,[8] but it is difficult
to have complete confidence in the claim. There are indeed two men in the

picture, but they stand beside two ill-defined shapes that may or may not
represent the mouth of an oven, with a large loaf suspended in space
below. The design is clear, but for today's viewer the meaning is clouded,
either by the passage of time or by the carver's incompetence. Another
reason for hesitation is that the calendar tradition concerns itself with the
high points of the farming year, not with those in the Church's annual
round, and any such allusion to Lammas would be quite out of character.
It is always important to bear in mind the possibilities of local idiosyn-
crasy; even so, until the theory can be buttressed with more evidence it
seems best to handle it with caution.

Two other examples, however, make the connection between crop and
cook with reassuring clarity. In one late French book of hours (MS 134,
Bibliothèque, Angers), a woman on the August page peers into an oven
and draws out some loaves.[9] In another French book of hours, c. 1500
(Bibliothèque Nationale, Paris, MS Lat. 1171, fol. 4 verso), a man stands
in the occupation compartment for August, separating grain from chaff
with a sieve in the proper, usual way, but the border of the entire page is
bejeweled with enticing latticework tarts. It is a surprisingly frivolous de-
sign for the sober calendar tradition, but an appropriate one, for there can
be no fine pastry without fine wheat flour.

In the established calendar convention, no special emphasis is placed on
the size of the harvest. It is, quite simply, sufficient, and one or two
sheaves represent its abundance. Only in the late medieval period is there
any attempt to indicate the sheer quantity desired and needed by a hungry
society. The same clue as that used to mark the size of the hay yield can
sometimes be detected, in the form of an already heavily laden wagon,
with its patient horse, waiting in the background as a field of wheat is cut
(Fig. 7-7). The bulk of a bumper crop is also implied in the rare scene of
wheat being tossed for safe-keeping into a loft (Fig. 5-4). It was the custom
to store grain in the ear of the plant until the time came to thresh it,[10] and
in this particular illustration care has been taken to show the beautiful
feathery heads on their neatly bundled stems, each sheaf secured by that
indispensable by-product of the harvest, a twist of straw.

After it has been beaten out of the ear, grain may surface one more time
in the calendar, as food for the future. It can sometimes be seen in Septem-
ber or October, scattered as the seed from which the next year's crop will
spring (Fig. 1-3). The customary emphasis falls on growth and harvest,
not on consumption. Wheat is not presented as food for the present, a
precious source of nourishment for the here and now. It is rare indeed to
find any acknowledgment of an appetite for grain beyond the boundaries

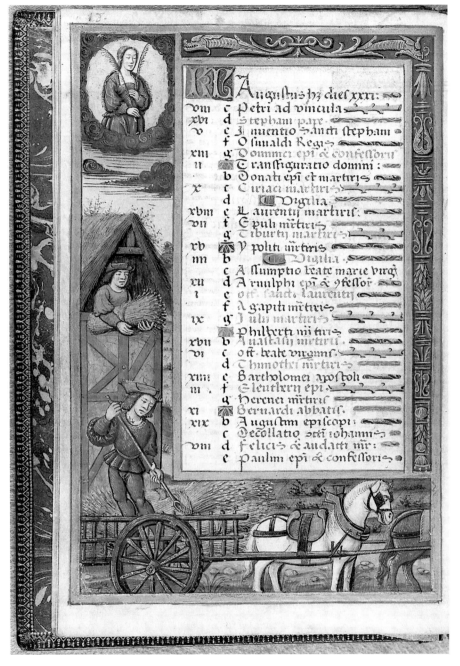

Fig. 5-4. August. Storing Wheat. Book of Hours, French, early sixteenth century, with miniatures added in Bourges(?), c. 1535–37. The Walters Art Gallery, Baltimore, MS W451, fol. 7 verso.

of the farm. Just occasionally, though, there is a late scene in which the viewer is made aware of market forces, of supply matched by demand. In Fig. 5-5 the occupation for August is the transportation of grain by boat to town. On the quayside stands someone who quite literally is keeping score of work in progress; he checks off the sacks as they are first filled on board, then unloaded and at last carried up the steps and delivered to their destinations. And Fig. 5-6, another August scene, shows the conclusion of an actual business deal. Plump bags, all the same size, are lined up in ordered rows, ready for sale. Most are already securely tied, but one had only just been filled; its contents are still being leveled off with a stick, to make sure that they will be neither overweight nor underweight, and will satisfy sharp-eyed buyer and seller alike. Two men shake hands over a sack of grain that stands open for inspection, and a horse with a half-filled cart waits for the signal to haul away the purchase.

A sheaf of wheat can be cradled in the arms, but anything more than a handful of grain needs to be stored somewhere for safekeeping. The sack is the usual container of choice, and may often be found standing beside the sower in the field (Fig. 1-3), or waiting to be filled with the treasure of the threshing-floor.[11] Although so necessary to the proper conduct of the work in progress, the sack is never singled out for special notice. It is simply a detail in the picture, a useful prop in the unfolding drama. Very different is the treatment of another kind of container, the barrel that holds the next calendar crop, the wine made from the grape harvest.

The barrel was first invented by the Celts and then adopted by the Romans, who recognized that it was far more robust than the breakable amphora and, because it could be rolled, far easier to maneuver and transport.[12] The part it played in the making and marketing of wine is acknowledged in the calendar cycle with a particular mark of respect. Unlike the plow or the scythe, the basket or the bag, the barrel is the one manufactured object that is sometimes given pride of place as the focus of a month's activity.

Because it was needed to hold the wine, a new barrel had to be made, or an old one repaired, before the grape harvest began. This simple fact of life is recognized in many calendars of the earlier medieval period; the sculpted examples in Arezzo and Verona, both produced in the first half of the thirteenth century, choose barrel-making as the job for August, and picking grapes as the one for September.[13] Space is at a premium in the cycle, however, and room could not always be found for barrel-making on its own. Logic had to be set aside, and the task was often squeezed

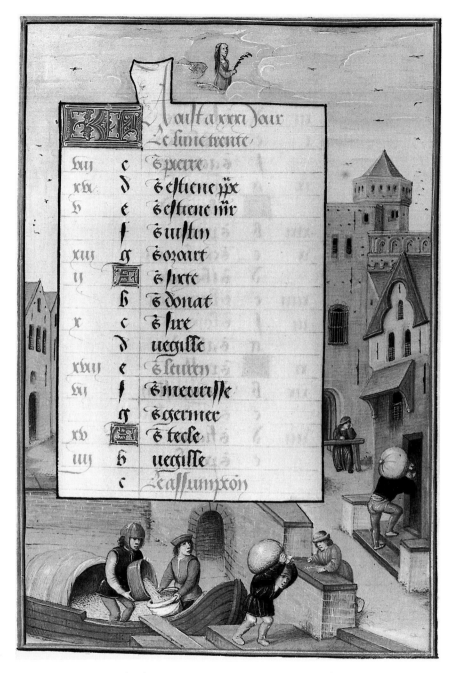

Fig. 5-5. August. Unloading Grain at a Town Wharf. Book of Hours, French, early sixteenth century. The British Library, London, Add. MS 15677, fol. 8. By permission of The British Library.

Fig. 5-6. August. Grain
Market. Book of Hours,
Flemish(?), early sixteenth
century. Unidentified
manuscript, known only in
greeting-card reproduction.

with other stages of wine production inside the confines of a single month. The late thirteenth-century Fontana Maggiore in Perugia shows for October one barrel being filled and another being made.

Even when it has to share the spotlight, cooperage is treated with the respect due an indispensable craft. In Fig. 5-7, a page for September, four men are busily engaged. One brings in a load of grapes, another treads the fruit in a vat, a third pours wine into a barrel, and a fourth, firmly planted in the foreground, closes and secures a row of casks. Each barrel, from time immemorial, has been built from staves, bound tightly together with hoops of iron or of wood. In Fig. 5-8 one hoop is being shaped and sized by an apprentice before it is judged ready to be slipped into place around the body of a cask. Such hoops became a familiar and much appreciated symbol of the bond between the barrel and the wine trade. A single specimen was often hung up outside a tavern as a sign and a welcome to the thirsty passerby. One is displayed for this very purpose in the early thirteenth-century Lubinus window in Chartres Cathedral that shows various aspects of the wine business, including a most important one, courting the customer.[14]

Acknowledgment of the part played by the barrel in the trade can be found in one truly remarkable calendar scene for October; see Fig. 5-9. The picture, made in the early 1540s by the Flemish master Simon Bening, does not concern itself with any work in any vineyard. Instead, it sets before the viewer's eyes a business deal, a sale concluded in the heart of town—and not just any, generic town, but a recognizable one, the city of Bruges, that great international trading center where Bening had his studio. It shows the site of the wine market, the Place de la Grue, with the Pont de Flamande behind it. In the foreground, a merchant offers his

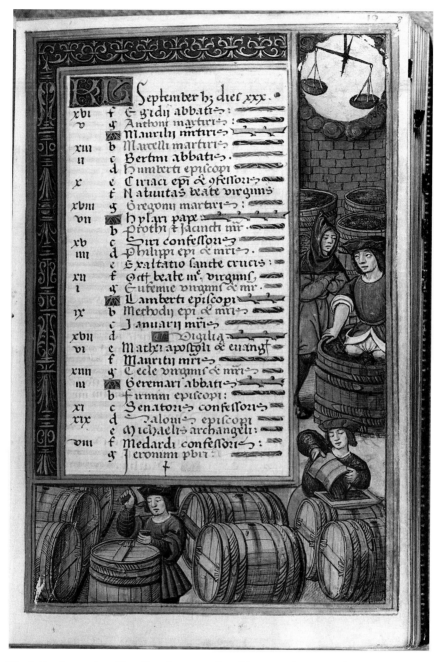

Fig. 5-7. September. Treading Grapes and Making Barrels. Book of Hours, French, early sixteenth century, with miniatures added in Bourges(?), c. 1535–37. The Walters Art Gallery, Baltimore, MS W451, fol. 8 recto.

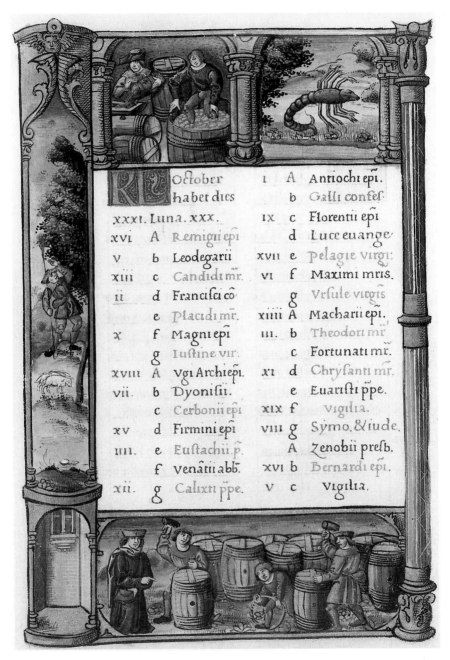

		October habet dies	i	A	Antiochi epi.
				b	Galli confef.
xxxi.		Luna. xxx.	ix	c	Florentii epi
xvi	A	Remigii epi		d	Luce euange
v	b	Leodegarii	xvii	e	Pelagie virgi.
xiii	c	Candidi mr.	vi	f	Maximi mris.
ii	d	Francifci cō		g	Vrfule virgis
	e	Placidi mr.	xiiii	A	Macharii epi.
x	f	Magni epi	iii.	b	Theodori mr.
	g	Iustine vir.		c	Fortunati mr.
xviii	A	vgi Archiepi.	xi	d	Chryfanti mr.
vii.	b	Dyonifii.		e	Euarifti ppe.
	c	Cerbonii epi	xix	f	vigilia.
xv	d	Firmini epi	viii	g	Symo. & iude.
iiii.	e	Euftachii.p.		A	Zenobii prefb.
	f	venatii abb.	xvi	b	Bernardi epi.
xii.	g	Calixti ppe.	v	c	vigilia.

Fig. 5-8. October. Treading Grapes and Making Barrels. Book of Hours, French (Use of Rome), second quarter of the sixteenth century. The Bodleian Library, University of Oxford, MS Douce 135, fol. 6 verso.

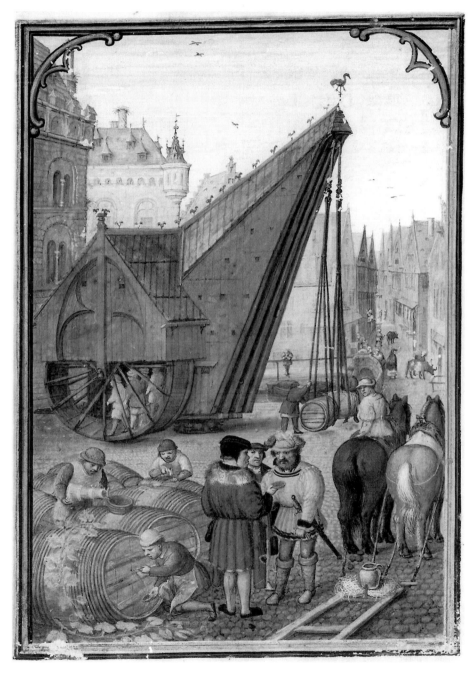

Fig. 5-9. October. The Wine Market at Bruges. Book of Hours, Flemish, Simon Bening, early 1540s. Bayerische Staatsbibliothek, Munich, MS Clm 23638, fol. 11 verso.

client a sample of wine while a gigantic crane, moving on a pivot and worked by a man-powered treadmill, hoists and swings the purchased barrels from the marketplace onto a waiting barge.[15] The massive structure, made for very serious business, has one endearing touch in the design; it is edged and crowned with the very birds whose striking profile and action first inspired its name. The makers must have loved their monster very much. For anyone at all familiar with the calendar convention, the sheer scale of the operation shown here comes as a shock. The compressed shorthand of the tradition conveys the essence, not the extent, of any labor. Here is a rare instance where, instead, there is revealed something of the complexity and range of commerce, the ingenuity and enterprise that forged the links connecting crop to customer.

Almost invariably, the grape harvest is represented by the picking of grapes, the pressing of grapes, or a combination of the two. Each stage made heavy demands on human labor, the grapes being first gathered by hand and then trodden by foot until the juices flowed. Occasionally, however, in a few late variations on the theme, the scene is dominated by another massive piece of machinery. In Fig. 5-10, a customer, or perhaps the owner of the vineyard, tastes the vintage, while barrels stand ready to receive the stream of new wine squeezed out by a gigantic screw press. Its presence in the picture is almost as much a surprise as that of the crane in Fig. 5-9. The ancient, accepted motif for the harvest is the figure of a man treading grapes in a vat and, although the introduction of a machine to do the work might seem to be a natural elaboration of the image, in real life the use of such equipment never won complete approval. The *vin de presse* extracted by mechanical means was always considered inferior to the *vin de goutte*, which flowed from beneath the treader's foot; it was usually sold separately, and at a lower price.[16] Nevertheless, the equipment justified its cost, because it did noticeably increase the yield, and hence the return, from the crop. The addition of such a feature to the scene is a silent admission of an interest in surplus, sales, and the possibility of profit.

The press, the crane, and the pulley for hoisting hay, shown in Figs. 5-2 and 5-3, appear in Flemish manuscripts of the late medieval period, a time when Flemish workshops dominated the international book trade. The artists in those studios are admired today for their meticulous simulation of the material world on the manuscript page. Their border designs are loving celebrations of reality, decorated with precisely observed and fully rendered objects, from butterflies to mussel shells, rosary beads to pilgrim badges, while their principal scenes, whatever the subject, are marked by a fascination with the way things look and work in the contem-

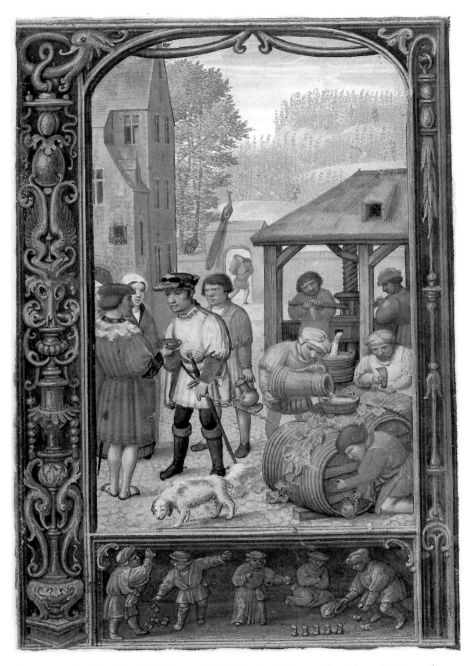

Fig. 5-10. October. The Wine Press. "Golf" Book of Hours, Flemish, early sixteenth century. The British Library, London, Add. MS 24098, fol. 27 verso. By permission of The British Library.

porary landscape.[17] The choice of such equipment as press, crane, or pulley for inclusion in a calendar picture was prompted in part by this heightened appreciation in art of the marvels to be found in everyday life.

It was also one more expression of an awakened acknowledgment by artists of the satisfaction to be gained by solving everyday problems. Centuries before, Virgil had claimed, in the *Georgics*, that human ingenuity was a response called forth by human drudgery. The burden of unceasing toil forced the mind to find ways to ease the pressure and avoid the pain, "care sharpening the wits of mortals."[18] There is a touch of this belief in the late calendar cycles, and the occasional presence there of heavy-duty equipment shows how even the calm surface of a conservative tradition could be stirred by ripples from a renewed interest in resourceful invention and ambitious schemes.

For the presence of the wine press, there may be one additional point to be considered. Devotional images and practice leave scarcely a trace on calendar scenes, nothing more than such stray allusions to Candlemas or Ash Wednesday shown in Fig. 7-13 and Color Plate 7-14; nevertheless, they left a deep impression on the daily lives and thoughts of the artists who made those pictures. Wine for them was important not simply because it was delightful but because of its role in the Mass, the heart of Christian worship. The wine press is used in the Bible as an image of the Last Judgment (Isaiah 63:1–7; Revelation 14:19), and there was also a popular devotional image, developed in the later Middle Ages, in which the press of the world's sins squeezed Christ himself, and his blood flowed out to redeem the faithful. Because of these solemn associations, the wine press had long held a place in the iconographical vocabulary of religious art,[19] and for artists the familiarity of the object in such contexts may have helped to ease its entry into the calendar scheme when the time was ripe.

All this is speculation, but certainly the grape harvest, the Mass, and its wine are mentioned in the same breath in some muddled lines about October that appeared in the *Kalender of Shepherdes,* an English version of an extraordinarily successful best-seller, first published in France in 1491, and internationally popular throughout the next century and a half (for more on this book, see Chapters 4 and 6):

> Among the other October I hyght
> Frende unto vynteners naturally
> And in my tyme Bachus is redy dyght
> All maner wyne to presse and clarify
> Of which is sacred as we se dayly

The blyssed body of Cryst in flesshe and blode
Which is our hope, refeccyon and fode.

[Among the rest I am called October, by nature a friend of the wine-makers. And in my days Bacchus is ready to press and purify all kinds of wine, including a sacred one, as we see day by day, the blessed body of Christ in flesh and blood, which is our hope, refreshment and food.][20]

Another large screw press can be found in Fig. 5-11, standing under cover, far in the background, at the end of a street; already the task it represents has been relegated to the status of "last month's occupation." By now, in this October scene, grapes are no longer the center of concern. Instead, the problem of the winter meat supply has come to the fore. This major preoccupation is usually allotted two slots in the calendar scheme; pigs are fattened up with acorns in November (Fig. 1-10), and some animal is killed in December. In the present illustration, that slaughter takes place at one side while, more in the center, a commercial transaction is in progress, as buyer and seller look over a possible purchase. Such an appraisal, once again taking place on a town street, is the principal subject of another October picture (see Color Plate 5-12), although in the background lingering traces of the grape harvest can still be detected.

The business side of the meat supply enters the tradition late in the day and never becomes a fixture, but occasional hints of its importance in the real world squeeze their way into the confines of convention. Sheep and cattle are being driven to market on an autumn day in Fig. 4-1, and a livestock sale is in progress in Fig. 7-9. Another sale is completed in Fig. 1-12, where the actual moment of exchange is captured, as a coin is handed over for the chosen pig. December is always the favored calendar month for the animal "harvest," and in almost every case the butchering takes place either inside a formalized, featureless compartment or on a farm. From time to time, though, in late examples, the work is done on a street in town.[21] The necessary, unpleasant operation was carried out quite regularly, of course, in such a context in real life, although it was kept away as far as possible from the more desirable residential areas. In fourteenth-century Paris, the slaughterhouse district was on the Right Bank, outside the heart of the city; even so, there was a steady rumble of complaint about the obvious disadvantages of smell, noise, and mess.[22] The town setting for this particular winter occupation defies not the facts of life but the force of tradition.

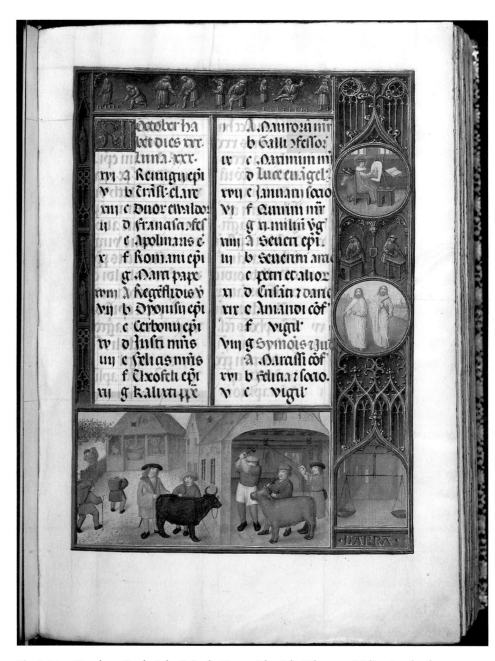

Fig. 5-11. October. Cattle Sale. Spinola Hours, Flemish (Ghent or Malines), calendar pages possibly by Gerard Horenbout, c. 1515. The J. Paul Getty Museum, Los Angeles, California, Ludwig MS IX.18, fol. 6 recto.

While seen on the hoof, in the process of being fattened, sold, or slaughtered, an animal remains recognizably an animal, but in a few late instances it is no longer itself, merely a food product, and the winter task of securing the meat supply has been turned into a shopping expedition. The official occupation for November or December becomes nothing more strenuous than a visit to the marketplace, where neat joints of beef or pork are offered by stall-holders and paid for by customers; see Figs. 6-5 and 7-3.

In one particular November market scene (Fig. 5-13), a housewife accompanied by a very small page, bowed down by the weight of a very large basket, is making her leisurely inspection of a row of meat stalls on a cobbled quayside in town, while, just around the corner, is shown the delivery of another winter necessity: bundles of firewood are being unloaded from a barge onto a long-handled wheelbarrow that stands ready to trundle off on its appointed round.

Once again, this rather sophisticated presentation of firewood as an item on a winter shopping-list has its root in a venerable calendar occupation, the chopping and gathering of sticks to make a heartening blaze against the bitter cold. The task was never a constant element in the tradition, but it was included from time to time. The figure for December in a tiny, twelfth-century calendar roundel is a man with a load of faggots on his back.[23] In that case, at least the tiring job has been completed, but in Fig. 6-1, a January scene, a woman is on her knees, picking up sticks in a frozen farmyard, while in Fig. 7-5 another scrabbles on the ground for twigs, as trees are trimmed on a bleak February day. The calendar's view of life and its demands has already been radically changed when it begins to include the idea that a seasonal labor can be commuted to a simple commercial exchange.

Whenever any market scene appears, one can sense a slight acknowledgment of how important the town was for the country, as a place where crops could be disposed of for a price. There are hints too of the complexity of the process. Transportation had to be devised, and goods displayed, before buyer and seller could come to terms, whether the transaction involved several barrels of wine or a single joint of meat. Many stages and many people were involved in the bringing of goods to market, and this tissue of connections was suggested by the inclusion of more than one action in a single frame. Appraisal comes before slaughter in Fig. 5-11; grain has to be unloaded before it can be delivered, in Fig. 5-5. Farmwork is no longer showcased in splendid isolation, but is shown in relation to the society that needed and sustained it.

Although never widely used, the town setting for a calendar scene be-

Fig. 5-13. November. Meat Market and Firewood Delivery.
Calendar page in a Flemish Book of Hours, early sixteenth century,
reproduced in Paul Durrieu, *La Miniature Flamande au Temps de
la Cour de Bourgogne, 1415–1530*, 2nd ed. (Paris and Brussels:
Librairie Nationale d'Art et d'Histoire, 1927), plate lxxvi. Special
Collections, Rare Books Room, Pattee Library, The Pennsylvania
State University, University Park, Pennsylvania.

came acceptable in the later Middle Ages. In rare cases, an actual place can be identified; the Paris skyline, seen from the banks of the Seine; the wine market in the center of Bruges. Far more often, it is just the suggestion of a town that is sketched in with one or two stage props: a street, a gateway, a cluster of houses. Once the idea had caught on, a town might serve as a backdrop for any number of activities. Sheep are sheared in Fig. 4-3 on a street, not in an open meadow; winter sports are enjoyed in Figs. 1-2 and 7-10 within a city's limits, not outside its gates. December's occupation in Fig. 6-4 is just a stroll through quiet streets, under softly falling snow.

This uncharacteristic taste for towns in the calendar world is just one example of a fashionable preoccupation that shows its influence in other genres and other picture worlds during the same period. When the Flemish artist Robert Campin (active 1418–1444) painted a triptych, *The Annunciation, Donors, and Saint Joseph in His Workshop* (Metropolitan Museum of Art, New York), he included a view, seen through an open window, of an animated town street, with church and houses, passers-by, and a workman caught in the act of climbing a ladder. Another town can be glimpsed in the background of *Saint Luke Painting the Virgin* (Museum of Fine Arts, Boston), by Rogier van der Weyden (1399/1400–1464). In a Last Supper altarpiece (1517), now in the Museum der Stadt Regensburg, the maker, Albrecht Altdorfer, shows through a window behind the head of Jesus the facade of the Minoritenkirche in Regensburg, the church that had commissioned the work. One artist, famous for his calendar scenes (for example, Fig. 5-9), was at home in many different genres. Simon Bening (1483–1561), the great Flemish master of manuscript illumination, in the course of his long career received a dazzling variety of commissions for devotional as well as secular pieces.[24] When he came to paint his last self-portrait (1558), now in the Metropolitan Museum of New York, he positioned himself with his back to a window, through which can just be detected the shadowy skyline of Bruges, his own city.

One last, late autumn crop is an unexpected addition to the harvest roster. In Fig. 5-14, flax is being hackled, a step in the long process whereby the fibers were separated from the woody stems and made ready for use. The occupation appears from time to time as a job for November in manuscripts of the fifteenth and sixteenth centuries that were created by Flemish workshops, or produced elsewhere under Flemish influence.

What makes the calendar choice of flax surprising is that by no stretch of the definition can the plant be classified as a food. Flax was important not because it could be served at table but because it might be made into the fabric of the tablecloth. Its invaluable contribution to the cloth trade

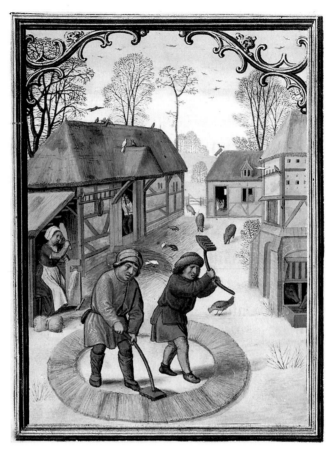

Fig. 5-14. November. Preparation of Flax. Da Costa Hours,
Flemish (Bruges), Simon Bening, c. 1515. The Pierpont Morgan
Library, New York, MS M399, fol. 12 verso.

is underlined in the occasional scene where finished lengths of material are
shown pegged out on the ground to be bleached by the action of sun and
air, the last stage in their manufacture.[25]

The value of the crop in the medieval economy is a fitting topic with
which to close this survey. Flax was versatile, and its thread was used for
more than tablecloths and bed linen, the paraphernalia of domestic life. It
had an important role to play in the wider world of trade and labor, a part
in the sustaining web of connections between crops and commerce that
has been the present theme.

The thread spun from flax was fine but very strong, and this toughness made it ideal for heavy-duty fabrics, intended to withstand rough use and rough conditions. From this thread could be woven the sails that transported goods over long distances, and gave wings to cargoes. Pliny the Elder pointed out the link between travel, trade, and flax in his *Historia Naturalis,* written in the first century A.D. and known and copied throughout the Middle Ages. He marveled at the potency "of so small a seed [from which] springs a means of carrying the whole world to and fro."[26] Flax was also tough enough to make sacks, those all-important containers without which grain and a hundred and one other crops could not be stored or handled. The indispensable contribution they made at the crown and climax of the farming year is implied in a fifteenth-century English description of the goddess of harvest, Ceres herself, who is pictured

> . . . in a garment
> Of sak clothe . . .
> Embrowderyd with sheves & sykelys bent.

[. . . in a dress made of sack cloth, embroidered with sheaves and curved sickles.][27]

Chapter 5 Notes and References

1. R. Starn, *Ambrogio Lorenzetti; the Palazzo Pubblico, Siena* (New York: George Braziller, 1994).
2. V. W. Egbert, *On the Bridges of Mediaeval Paris; A Record of Early Fourteenth Century Life* (Princeton: Princeton University Press, 1974).
3. M. Salmi and G. E. Ferrari, *The Grimani Breviary, Bibl. Marciana, Venice, MS Lat. XI.67 (75331)* (London: Thames & Hudson, 1972). October.
4. E. V. Gordon, ed., *Pearl* (Oxford: The Clarendon Press, 1953), p. 2, line 40.
5. P. Mane, *Calendriers et Techniques Agricoles (France-Italie, XIIᵉ–XIIIᵉ siècles)* (Paris: Le Sycomore, 1983), pp. 165–166, fig. 147.
6. G. Wickham, ed., *Mankind* (c. 1470), in *English Moral Interludes* (London:

J. M. Dent & Sons Ltd., 1976), p. 8, line 60. See also M. Collins and V. Davis, *A Medieval Book of Seasons* (New York: Harper Collins Publishers, 1992), p. 100.
7. Mane (see note 5), fig. 194.
8. G. L. Remnant, *A Catalogue of Misericords in Great Britain* (Oxford: The Clarendon Press, 1969), p. 169. The misericord is illustrated in J. C. D. Smith, *A Guide to Church Woodcarvings* (Newton Abbot, London, North Pomfret [Vt.], and Vancouver: David & Charles, 1974), p. 35.
9. S. Fox, *The Medieval Woman; an Illuminated Book of Days* (Toronto: Key Porter Books, 1985). The August picture is used as an inset detail on the page for January 13–18.

10. D. Hartley, *Lost Country Life* (New York: Pantheon Books, 1979), p. 184.

11. For example, the August scene for threshing and winnowing in The Playfair Hours, made in France (Rouen) for the English market, late fifteenth century. London, The Victoria and Albert Museum, MS L. 475–1918.

12. H. Johnson, *Vintage: The Story of Wine* (New York and London: Simon & Schuster, 1989), p. 83.

13. Mane (see note 5), figs. 131, 217.

14. J. W. Williams, *Bread, Wine, and Money; The Windows of the Trades at Chartres Cathedral* (Chicago and London: University of Chicago Press, 1993), pp. 82–83, color plate 2.

15. T. Kren, *Simon Bening and the Development of Landscape in Flemish Calendar Illumination* (Lucerne: Faksimile-Verlag, 1988), pp. 294–97.

16. Johnson (see note 12), pp. 124–25.

17. M. Smeyers and J. Van der Stock, eds., *Flemish Illuminated Manuscripts, 1475–1550* (Ghent: Ludion Press, 1996), pp. 13–21.

18. L. P. Wilkinson, trans. *Virgil, The Georgics* (Harmondsworth, Middlesex, U.K.: Penguin Books Ltd., 1982), book 1, line 124.

19. For the depiction of a wine press in an early fourteenth-century scene from the book of Revelation, see *The Cloisters Apocalypse* by Florens Deuchler, Jeffrey M. Hoffeld, and Helmut Nickel (New York: Metropolitan Museum of Art, 1971), vol. 1, p. 66; vol. 2, fol. 29 recto. For the devotional image "Christ in the Wine Press," see E. Duffy, *The Stripping of the Altars; Traditional Religion in England, c. 1400–c. 1580* (New Haven and London: Yale University Press, 1992), p. 253. An early fifteenth-century German woodcut example of the image is noted in *An Introduction to a History of Woodcut,* by Arthur M. Hind (New York: Dover Publications Inc., 1963), vol. 1, p. 123.

20. Duffy (see note 19), pp. 50–51.

21. An example of a pig-killing in a town street can be found in the December calendar picture in The Playfair Hours (see note 11).

22. Egbert (see note 2), p. 50 and n. 69.

23. The roundel is illustrated in *English Romanesque Art, 1066–1200,* ed. G. Zarnecki, J. Holt, and T. Holland (London: Arts Council of Great Britain, and Weidenfeld & Nicolson Ltd., 1984), p. 98, item 23: Calendar St. Isidore, Homilies, etc., c. 1120–40, perhaps made in Worcester Cathedral Priory, now Cambridge, St. John's College, MS B.20.

24. Smeyers and Stock (see note 17), pp. 27–28.

25. W. Hanson, *Kalenderminiaturen der Stundenbücher: Mittelalterliches Leben im Jahreslauf* (Munich: Verlag Georg D. W. Callwey, 1984), p. 146, fig. 239. The linen-bleaching scene for November appears in a Flemish book of hours of the first half of the sixteenth century, now in Sibiu/Hermanstadt, Brukenthal Museum, Inv. Nr. I, fol. 6.

26. J. I. Whalley, *Pliny the Elder, "Historia Naturalis"* (London: The Victoria and Albert Museum, 1982), book 19, p. 28.

27. H. N. MacCracken, ed., *The Minor Poems of John Lydgate,* vol. 1, Early English Text Society, Extra Series 107 (1911), p. xxxv. The poem, "The Assembly of Gods," once attributed to Lydgate, was written down "without ascription" in a manuscript "of not earlier than 1463." The text quotation appears in the *Oxford English Dictionary* under "sackcloth."

6

The Calendar Child

 Educational theory in the Middle Ages laid heavy emphasis on the danger of sparing the rod and spoiling the child. A baby arrived in the world already marked with the stain of original sin, and had to be battered into virtue as vigorously as possible. Needless to say, a gulf yawned between principle and practice, and this dark view of human nature was brightened, in daily life, by an instinctive response to the charm of childhood. Medieval parents pampered as well as punished, cherished as well as chastised. Childish behavior was often observed with an attentive eye, and recorded with amused affection:

> But a none, aftyr as thou hast bett him, then schewe to him a feyre flowre or ellys a fayre redde appull; then hathe he forgeton all that was done to him before, and then he wyll come to the, rynnyng, withe his clyppyng armys, for to plese the and to kysse the. [But

straightaway, after you have beaten him, show him a pretty flower or a fine red apple, and then at once he forgets everything that was done to him before. He will come running up, with his arms outstretched to hug you, to please you and to kiss you.][1]

Linked to the medieval world by this common bond of sympathy, modern viewers feel not surprise but pleasure as their eyes catch a glimpse from time to time of a child in a calendar picture. And yet, the small figure is an unexpected intruder on the scene, a new arrival in an old tradition. In the "occupations of the months" calendar, there is no place either for the cradle or the deathbed. The cycle is concerned with life at full flood, not with its source, nor with its ebb-tide. It is rare to find a child in any calendar before the fifteenth century; one in a handful of exceptions to the rule is on the page for May in the Saint Blasien Psalter (German, c. 1230–35), where a boy at play with a stick and ball is standing in the margin.[2]

Because examples cluster ever more thickly at the end of the period, in the fifteenth and early sixteenth centuries, it is probably true to say that the addition of a child to a scene is one more demonstration of an ever-strengthening impulse to depict the surface details of the everyday world. The decision may also have owed a minor, less obvious debt to the influence of a new kind of calendar tradition, which was catching the popular imagination at much the same time. Since antiquity, it had been a philosophical pastime to construct a portrait of human life painted, as it were, by numbers. Progress from birth to death was defined as a series of stages, that varied according to the system favored by the writer of the moment.[3] Of all the numbers that ingenuity played with in this game, and there were many, from three to seven to fifteen, one that proved easiest to handle, and remember, was four, a figure which made possible a straightforward equation of the seasons of life with the seasons of the year: spring, summer, autumn, and winter.

At some time in the fourteenth century, a comparison between the human life-span and the twelve-month cycle began to circulate. In this plan, it was assumed that the age of seventy-two marked the proper end of life, and so each month represented one six-year chapter in the story. The earliest known expression of this scheme is in a luxurious manuscript that may once have been a volume in the library of Charles V of France, but the idea did not stay trapped there.[4] It escaped, to become a commonplace in the course of the next century. Proof of its popularity, and guarantee that it would remain familiar to generations to come, was its inclusion in the runaway best-seller that burst on the scene in 1491, *Le*

Grant Kalendrier et Compost des Bergiers. (See also Chapter 4.) This rather eccentric medley of information on life, medicine, morals, and astrology was first printed in Paris by Guy Marchant, and from then onward appeared in new editions and translations in France and in many parts of Europe, well into the seventeenth century. A calendar with a comparison between the twelve months and the twelve stages of life was always the first item in the list of contents.[5] The scheme became so universally accepted that it found its way into many places besides the *Kalendrier*, including the hundreds of printed books of hours that flooded the market in England and France during the early sixteenth century.[6]

Such a comparison, between human life and the calendar year, seems simple enough, but perception of the months' progress was clouded by the confusing fact that the medieval year actually had two starting points. As in Roman times, New Year's Day fell on January 1 and, in images of the months, two-headed Janus continued to sit at table, with one face looking back at the old year, and the other turned to greet the new. (See Chapter 2.) By another reckoning, the year began on March 25, Lady Day, the feast which commemorated the Annunciation, and the moment when Jesus was conceived in Mary's womb. Many rents and contracts came due then and, indeed, the name and number of the year changed not in January but in March, more or less at the vernal solstice.[7]

A year which begins in spring, with a surge of energy and renewal, ends in exhaustion in the depth of winter. The warmly wrapped figure feasting by the fire in the January or February scene of a traditional calendar is not a child but an old man. (See Chapter 2.) Although springtime today is pictured as a season bubbling with babies of every kind, the medieval spring was presented as a time not of infancy but of youth, of life coming into flower, approaching its peak. This being so, an awkward link had to be forged between babyhood and those months which stood at the start of one kind of year's cycle and at the end of another: January and February. The little verse that accompanied the January picture in the new "ages of man" calendar offered the limp, official explanation of the pairing:

> The fyrst .VI. yeres of mannes byrth and aege
> May well be compared to Janyuere.
> For in this monthe is no strength no courage
> More than in a chylde of the aege of. VI. yere.

[The first six years of human life may well be compared to January, for there is no more strength or spirit in that month than there is in a child up to the age of six.][8]

The influence of this increasingly popular comparison between human life and the months of the year can be detected in the older "occupations" calendar tradition, once children start to make an occasional appearance there, although the use of the new theme is very selective. While January, for example, in the "ages" cycle, is the month representing the very young, under six years of age, February covers the next span, from six to twelve. Life becomes sterner at this stage, and schoolboys are shown being briskly beaten into knowledge by their teachers. No hint of such a scene ever appears in the "occupations" cycle, which is supremely indifferent both to education and to punishment. It is also true that ideas for the use of children, as will be shown, may have been found in the image for one month and applied to another. Nevertheless, there is some ground for believing that a current of influence passed between the two traditions. The correspondence is not exact, but the comparison is intriguing. At the very least, it is plausible that the fresh way of looking at the year offered artists a path down which to lead the figure of the child into the old picture frame.

Whatever else was borrowed by the old convention from the new, it was certainly not tone. The sunlit serenity of the seasons' cycle in the occupations calendar is never darkened by the "ages of man" view of life's progress, which is consistently grim from start to finish. In one "ages" calendar, the picture for January shows a mother nursing her baby, while the husband heats a little soup for supper. The scene is appealing, but the verse that accompanies it merely draws a bleak parallel between the state of the newborn and the state of the season:

> Froit, nu, impotent, miserable
> Cy est nostre commencement.
>
> [Cold, naked, helpless, miserable,
> That is our beginning.][9]

By contrast, the baby cradled in its mother's arms in Fig. 6-1 is just one of many tiny details in this traditional calendar scene which show that winter's terrors have been tamed. Snow lies on the ground, but logs are being chopped and gathered to keep the cottage cozy. Bright fire, warm clothes, and a substantial meal on the table add to the air of snug well-being. Small comforts, sensible strategies, cushion life against the shocks of January's weather.

In the "ages of man" convention, it is more usual for the first six years

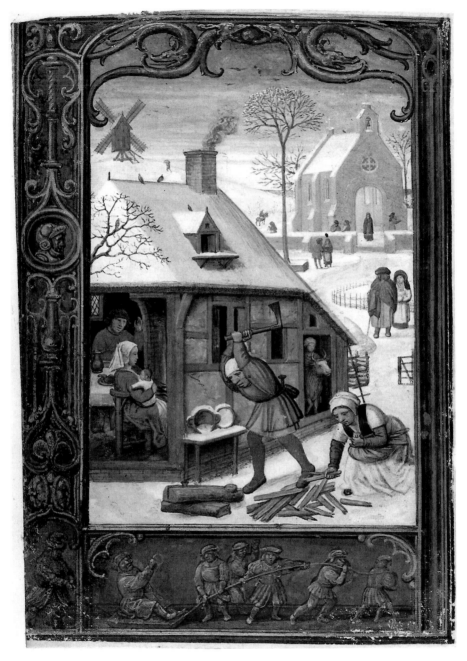

Fig. 6-1. January. Chopping Wood for the Cottage Fire. Children Tobogganing in Lower Border. "Golf" Book of Hours, Flemish, early sixteenth century. The British Library, London, Add. MS 24098, fol. 18b. By permission of The British Library.

of life to be represented by a January scene filled not with babies but with young children at play. Their toys and games are many, but the prime favorites, the ones that appear again and again, are massed in the foreground of Fig. 6-2: the hobbyhorse, the windmill, and the whip and top. Each of these was an image of youth's frivolity and foolishness, used for centuries by moralists to drive home a lesson.[10] When John Bunyan in 1686 published his *Book for Boys and Girls, or Country Rhymes for Children*, the little story in it on "The Boy and His Hobby-Horse" is still the same old warning about the dangers of racing to win the worthless prizes of a fickle world.[11] Viewed with a more indulgent eye, such toys and pastimes could also be seen as badges of childhood, emblems of its fleeting charm, its innocence rather than its folly. As such, they are used on the late medieval Lady Altar at Ranworth in Norfolk, which shows the three daughters of Saint Anne: Mary holding the baby Jesus, and her two sisters with their own small sons, of whom one holds a toy windmill, and another is blowing bubbles from a pipe.[12]

Fig. 6-2. January. Children with Tops. Prymer of Salisbury Use, Paris, François Regnault, 1529. The Folger Shakespeare Library, Washington, D.C., MS STC 15961-5. By permission of The Folger Shakespeare Library.

¶ The fyrst. vj. yeres of mannes byrth and aege. ¶ May well be compared to Janpuere. ¶ for in this moneth is no strength no courage. ¶ More than in a chylde of the aege of vj. yere.

The link between infancy and play created tempting images for artists but, as neither children nor games could claim a rightful place in the occupations tradition, it proved hard to fit them into the main picture. The problem was solved by putting them in its frame. As already mentioned, there is an early example of this, the boy with bat and ball, in the margin of the thirteenth-century Saint Blasien Psalter, but it was in the first decades of the sixteenth century that the stray impulse became a steady fashion. For a number of years, the margins of many Flemish and French books of hours, made for an international market, were filled with lively little figures, busily enjoying themselves.

The range of amusements is wide, from walking on stilts to knocking down skittles. In Fig. 6-3, boys are playing hockey. The frames may border any month of the year, and there is not often any obvious connection between the featured pastime and the featured occupation. Sheep are sheared in a village street in Fig. 4-3, while in the upper border boys are clutching windmills and galloping on hobbyhorses. At times, however, there does seem to be a conscious effort to make the game suit the season. The snowy January scene in Fig. 6-1 is set above a frame where children are tobogganing, while in Fig. 1-2 the January border shows a boy skating, and whipping his top on the ice. Both examples are from Flanders, a region in which winter sports had been popular for a long time as decorative details in manuscript margins. Two tiny figures, possibly children, are skating and sledding in the border of a February page (Fig. 8-1) in an early fourteenth-century psalter from Ghent.[13]

Toboggans and skates need snow or ice for best performance, but tops can be enjoyed on any firm surface, in any season. Easy to carry, easy to use, they were treated by writers and artists alike as essential equipment

Fig. 6-3. Border detail. Playing Hockey. Book of Hours (Salisbury Use), Paris, Nicolas Hihman for Simon Vostre, c. 1520. The Pierpont Morgan Library, New York.

for an active childhood. Alexander Barclay, a prolific and much patronized poet in the early years of Henry VIII's reign, squeezed out a line or two on the fun of spinning them on the street, in the cold days of early spring:

> Eche time and season hath his delite and ioyes,
> Loke in the stretes beholde the little boyes . . .
> In Lent is eche one full busy with his top.[14]

So familiar was the plaything that it was the one chosen to be carried by the character Infans in the Tudor morality play, *Mundus et Infans* (c. 1520). Infans, who represents all children, demonstrates his skill with a top, which represents all toys, as he addresses the audience:

> Lo, my top I drive. . . .
> See, it turneth round![15]

Once established, the association between childhood and winter, which may have been suggested by the "ages of man" convention, took on a life of its own in the other tradition. When the story of human life is pictured as a progress through the months of the year, if January is always the month for babies, there must be an inevitable and depressing correspondence between December and deathbeds. By contrast, in the more cheerful world of the occupations cycle, there was no inherent reason to hesitate before coupling life's start with the year's end, and so at times a place could be found for an infant even in the depths of December. In Fig. 6-4, a woman with a small child walks through town, in a softly falling snowstorm; in Fig. 6-5, which shows another December scene, a woman shops in a market while her inquisitive little boy reaches up to touch something on the stall that has caught his eye. The impulse is instantly recognized, instantly understood, in every age. As one thirteenth-century writer remarked about children: "They desire all things that they see, and pray and ask with voice and with hand."[16]

Fire and food together form a powerful magnet on a winter day, so it seems only natural to find, from time to time, a child curled up on the hearth at the feet of an old man, waiting expectantly with him for the table to be laid and supper to appear; see Color Plate 6-6. To the modern eye, there is nothing remarkable about the cozy scene, and yet in fact only one of the actors had a long-established right to play a part in it. For centuries, the old man by the fire had been the traditional figure for January or February (see Chapter 2), but the child is a new member of the cast. Such

Fig. 6-4. December. Winter Walk in Town. Book of Hours (Use of Rome), Flemish, c. 1500. The Fitzwilliam Museum, Cambridge, MS 1058-1975, fol. 12 verso.

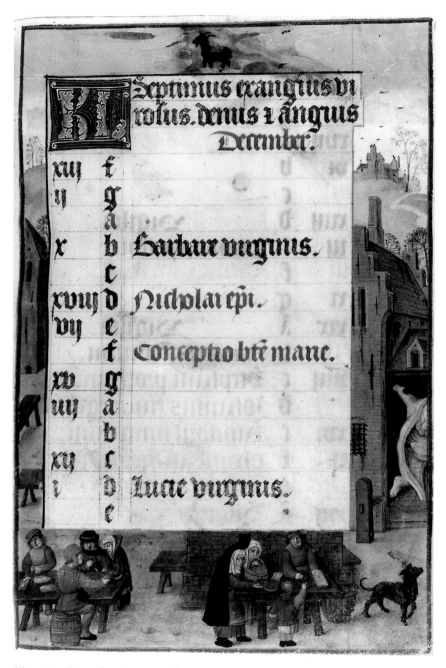

Fig. 6-5. December. Street Market. Book of Private Prayers for George Talbot, Earl of Shrewsbury, Flemish (for English client), c. 1500. The Bodleian Library, University of Oxford, MS Gough Liturg. 7, fol. 112.

a touch, added occasionally to calendars late in the period, doubtless owes its presence, in the main, to the painter's newfound, newly indulged delight in the details of domestic life. Medieval artists, however, always liked to have a model to justify a pleasant fancy, and it is possible that the hint to authorize the impulse may have been found, once again, in the "ages of man" sequence, not actually in the winter stretch of the year but in the autumn. In that tradition, October symbolized harvest time, the crown of achievement in life's span, and the month was represented by a well-dressed couple seated with their children at a well-laid table, ready to enjoy the bounty that their own hard work and prudence have provided, a well-earned feast. (See Fig. 6-7.) The January scene in Fig. 6-8 comes close to this "ages" model by including a prosperous woman in the contented little party seated around the fire as the meal is served.

Children love to be where the action is, and at a very tender age learn that there are almost as many possibilities of pleasure in the preparations for dinner as in dinner itself. In the December border of the Grimani

Fig. 6-7. October. Family Feast. Prymer of Salisbury Use, Paris, François Regnault, 1529. The Folger Shakespeare Library, Washington, D.C., MS STC 15961-5. By permission of The Folger Shakespeare Library.

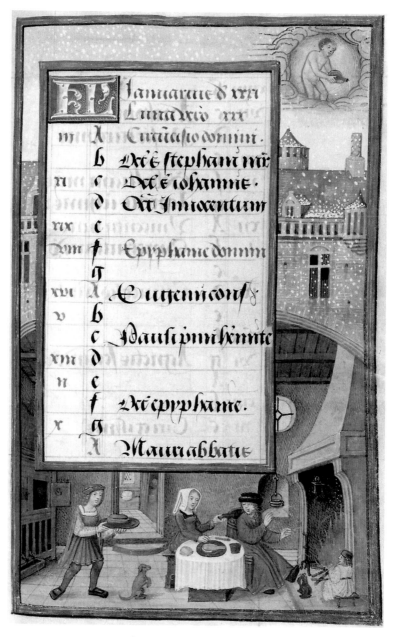

Fig. 6-8. January. Supper by the Fire II. Book of Hours (Use of Rome), Flemish, c. 1500. The Fitzwilliam Museum, Cambridge, MS 1058-1975, fol. 1 recto.

Breviary (c. 1518), a child holds up its hands to warm them at a bright, hot oven while the mother bakes a batch of bread, and older boys watch with rapt attention as the bristles of the dead board are singed away before the carcass is cut up into portions.[17] Alexander Barclay puts into words the vision forming in each excited, expectant little mind:

> They have great pleasour supposing well to dine,
> When men be busied, in killing of fat swine.[18]

Earlier in the year, on an August page, fruit-harvesting is the subject of a border scene in another calendar (Fig. 8-3). At the center of the picture, a woman stops for a moment to offer an apple to a tiny child who is with her while she works.[19] Apples and children were always paired together, and many a moralist sighed over the baby's pleasure in the shining red bauble. Although sometimes conceded to be charming, the innocent enthusiasm was considered a prime example of false values and flawed reasoning, as wrongheaded in its own way as a preoccupation later in life with the grosser treasures of the grown-up world: "They love an apple more than gold . . . and weep more for the loss of an apple, than for the loss of their heritage."[20]

In yet another example, the February illustration in the Hours of Turin (c. 1465), a child clings to the side of a woman as she walks along with a bundle of sticks on her shoulder.[21] To show children like this, on the fringes of adult activity, was an easy, effective way of introducing them into the calendar scene without making any change in its character or purpose. It proved more difficult to show them busy with their own jobs in the workplace. To judge from the records of everyday life, it would have been perfectly plausible to fit their efforts into the cycle's celebration of year-round tasks and duties. There is ample evidence of the child's contribution to the daily round. Even the very young helped in a hundred small ways, from collecting eggs to laying tables. As years passed, responsibilities grew; boys and girls played their part in fetching and carrying, housekeeping and harvest.[22]

There was, however, an invisible, intellectual barrier hindering any easy entry of the child into the calendar scheme. Childhood, whether considered with an eye benign or baneful, was so associated with the idea of play that it was hard for reality to reshape the image, and break through preconception to find a place in art. Some child, somewhere, could be seen at work on any day of the year, but in only a handful of instances throughout the long history of the tradition can one be found who is engaged in

any kind of useful activity in a calendar scene. In truth, to compile a list of any length at all it is necessary at times to stretch the definition both of children and of work to cover some enigmatic variations on the theme.

One French example, remarkable for its date, appears in the decorative scheme that surrounds the early thirteenth-century doorway on the west front of the church of Notre Dame in Mimizan (Landes). There, in the scene for March, a peasant is pruning while a small child stands on the other side of the vine.[23] Whether the boy is actually working with the man or merely accompanying him is not clear, but in an image carved at this time, long before it had become fashionable to soften the traditional emphasis on labor with extraneous domestic detail, it seems permissible to regard him as a helpful assistant, not a helpless appendage.

The significance of a figure's size is sometimes hard to gauge. Is smallness an indication of youth, or of unimportance? In the February scene of a mid-fourteenth-century prayerbook (Fig. 2-2), the flames of a cheerful fire are encouraged to burn brightly by a tiny figure energetically pumping a pair of bellows.[24] The artist may have made this servant small because he is only a boy, or small because he is only a bit player in the action.

Other small figures probably represent not children but boys approaching manhood, because the work they are doing demands at least strength, and often strength and skill combined. In a late fifteenth-century stained-glass roundel from Lincoln Cathedral, two boys haul a large log through the snow, heading for a castle. Over the years, the original series of twelve calendar roundels to which this picture once belonged disappeared, but it is likely that the log is intended as a contribution to the good cheer of the Christmas season.[25] Another survivor from a vanished roundel series has the name of its month, "Octobris," considerately painted on the glass, and shows a boy guiding a horse-drawn harrow over a plowed field.[26] For such a job, far more than for dragging logs, some muscle and a judgment born of experience were essential, and the task must have been beyond the capacity of any child. Nonetheless, there is something grand about the ability to control large horses and heavy equipment, and children dreamed of the day when they too would be in charge of such a team. In the fourteenth century, Froissart, in his poem, "L'Espinette Amoureuse" (c. 1370), listed many games he had enjoyed as a little boy, and among them was play with a make-believe harrow.[27]

A sixteenth-century woodcut for December shows a bakery bustling with activity. (See Fig. 6-9.) As the master baker thrusts his loaves into the oven, a much shorter figure stands beside him, shaping balls of dough for the next batch. This assistant would have been identified by his contempo-

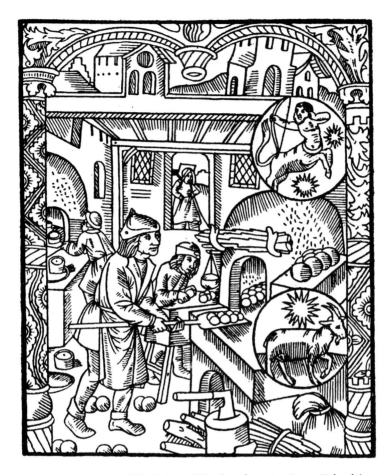

Fig. 6-9. December. The Bakery. Woodcut from Le Grant Kalendrier
et Compost des Bergiers, French (Troyes), 1541. Department of Printing
and Graphic Arts, The Houghton Library, Harvard University,
Cambridge, Massachusetts. By permission of The Houghton Library.

raries as a youth of at least sixteen years old because, by the late medieval
period, that was the generally accepted age at which to enter into an ap-
prenticeship.[28]

Much younger children are making themselves useful in two other pic-
tures, both Flemish, and both of the sixteenth century. In a January scene,
a small boy picks up sticks as a man chops firewood,[29] while in a calendar
page for April, another leads a flock of sheep from the farmyard, out to
spring pasture. (See Fig. 6-10. See also Fig. 4-2.) Surprisingly, such respon-

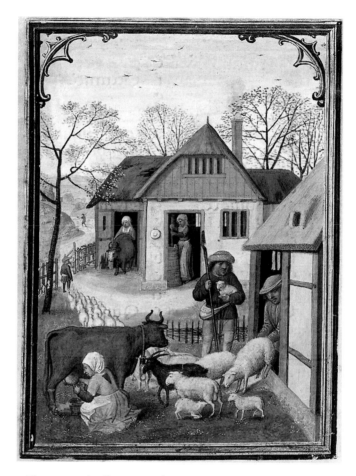

Fig. 6-10. April. Farmyard in Spring. Da Costa Hours,
Flemish (Bruges), Simon Bening and others, c. 1515. The
Pierpont Morgan Library, New York, MS M399, fol. 5 verso.

sibility was often entrusted to children before they reached the age of
ten.[30] The work was not without its dangers, when animals or circum-
stances got out of control, but diminutive guardians of docile flocks were
familiar figures in the landscape of art:

> And many flowte [flute] and liltyng horn,
> And pipes made of grene corn,
> As han [have] thise lytel herde-gromes,
> That kepen bestis in the bromes [amongst the broom].[31]

Rash though it may be to draw conclusions from this meager harvest, it is interesting that, of the seven examples discussed, six are found in calendar scenes for the autumn and winter months, from October to March, even though in real life there was plenty of work for any child to do throughout the year.

Sometimes the winter season and the adolescent boy were bound together by a link forged from a witty fancy. The zodiac sign that dominated the period from late January to late February was Aquarius, the Water Carrier. From antiquity, the sign had been depicted as a man, naked or lightly clothed, who was not merely carrying water in some container, but pouring it out, dashing it down on the ground. This traditional figure can be found in a roundel on the right margin of the page shown in Fig. 6-11. Because feasting and warming by the fire were the typical calendar occupations for January and February, it took only a small step of the imagination to visualize the sign of the season occasionally not as a wild water spirit but as a smartly dressed attendant, serving at a feast. (See Fig. 6-12.) With just one more step, he was pulled inside the calendar scene itself, and set down there, ready to pour out water, or something considerably stronger, at his master's signal. And every now and then, he is presented as a page, noticeably younger than the other actors in the drama. (See Fig. 6-13.)

Sightings of children at work in the calendar cycle are few and far between, but it is possible to extend the list a trifle by including a handful of cases in which children are doing something enjoyable that could, at a stretch, be claimed as useful too. In Fig. 6-14, which shows the lower border of a November page, two young men are playing some kind of handball, while a small boy crosses between them, in the middle of the court. The game itself may be either "palm," or the earliest form of tennis. Both became popular in the fifteenth century, and in both the ball was struck by hand.[32] What the little boy contributes is unclear. Is he an irritating distraction, another player, or, just possibly, a medieval prototype of the Wimbledon ballboy?

Children seem to have been inordinately fond of bird-snaring, an activity described with disagreeable relish by the character "Boy" in John Heywood's *Play of the Wether* (1533):

> All my pleasure is in catchynge the byrdes. . . .
> O . . . to here the byrdes how they flycker theyr wynges
> In the pitfale [trap in the form of a pit], I say yt passeth all
> thynges.[33]

Fig. 6-11. January. Presentation of Newborn Baby. Book of Hours of Margaret de Foix, France (northwest), c. 1470s. The Victoria and Albert Museum, London, Salting MS 1222, fol. 1 recto. Courtesy of the Board of Trustees of The Victoria and Albert Museum.

Fig. 6-12. Zodiac Sign, Aquarius, the Water Carrier.
Woodcut from *Astrolabium,* by Johannes Angelus, printed
by Erhard Ratdolt, Augsburg, 1488. Location no. A-624/
Goff. no. A-711. The Walters Art Gallery, Baltimore.

In one stained-glass roundel that has become separated from a calendar
set, a boy is kneeling beside a caged decoy bird;[34] another child, in the
upper border of a September page, waits expectantly for a bird in a tree to
fly into his trap. (See Color Plate 6-15.)

Bird-snaring, though entrusted here to boys, was serious business. It
was both a sport and a hunt, a pastime with a purpose. Hunger hardens
the heart, and nagging anxiety about the food supply ensured that the
theft of grain from newly seeded fields was regarded not as a charming
caprice but as a capital crime.

The battle of wits took place in the cold days of late autumn or early
spring, when birds were at their hungriest, and fields had just been plowed
and planted. Boy, in *Play of the Wether,* especially wants "great frost for

Fig. 6-13. January. Winter Feast with Servants. Playfair Hours, made in France (Rouen) for the English market, late fifteenth century. The Victoria and Albert Museum, London, MS L475-1918. Courtesy of the Board of Trustees of The Victoria and Albert Museum.

e Dedicatio falua A Petri Alexãdri
xv f Triphois.mris viii b Iacobi mris.
iiii g Martini epi. c Profperi epi.
 A Martini pape. xvi d Vigilia.
xii b Bricii epifco. v e Andree apli.
 i c Felicis epi.

Fig. 6-14. November. Game of Handball. Book of Hours (Use of Rome), French, second quarter of the sixteenth century. The Bodleian Library, University of Oxford, MS Douce 135, fol. 7 recto. Detail.

my pytfallys."[35] While the occupation did not become a regular feature in the cycle, the figure of the adult fowler made an occasional appearance in the calendar's cast of characters, from the days of late antiquity; his work is one of the tasks for October in Roman examples of the fourth century A.D.[36]

In one or two rare instances, children are included in a scene for their importance not as themselves but as symbols. The January picture in Fig. 6-11 shows a woman holding out a tightly swaddled baby to a prosperous old man seated at table. The man is the traditional figure for the month, descendant of the Roman god Janus, guardian of gateways, who sat by the entrance looking back at the old year and forward to the new. In this picture the nurse has come through the open door, to bring in the newborn baby, symbol of the newborn year. Another treatment of the same theme appears in a fifteenth-century fresco in the Salone of the Palazzo della Ragione in Padua. There January's representative, the old man who warms himself by the fire, gently strokes the cheek of a small child, as a woman watches the encounter from an open doorway.

Characteristically, the calendar tradition represents the progress of the year as a series of small steps, with each month sealed in its own compartment. Any attempt, like these, to capture change itself is highly unusual, although there is one similar case at Vézelay. There, carved in the decorative scheme around the twelfth-century doorway of the west front, is a scene for February. The customary figure sits hunched over the fire, but near him stands a young man in a very odd costume. On the side that is turned to the flames he is warmly dressed, but on the side turned away from the heat he is naked.[37] It is possible that this unlikely reversal of the body's needs may symbolically express the season's first, tentative step from winter into spring. Winter requires heavy clothing, nakedness is the response to summer's heat. February days are so often dismal that it may seem strange to associate the month with such stirring prospects, but a number of medieval authorities taught that spring did indeed begin in February, weeks before the vernal equinox in March.[38]

One April scene also makes use of children as symbols. Fig. 6-16 shows lovers, perhaps a betrothed couple, holding hands in a garden. Two children play nearby, one picking flowers, the other stretching hands to the stream of water gushing from the fountain which dominates the tiny enclosure. In the calendar, April was by long tradition the month that represented renewal, new growth, new life. At first it was embodied in a single figure holding up a flower or a green branch, but slowly, over the centuries, the emphasis shifted from the renewal of nature to the renewal of the human race. More and more often, the single figure is replaced by two—a young man and woman shown in the state of courtship that will lead to marriage, children, and the replenishment of the family. This development in the calendar scene may have been influenced by a development in the depiction of its zodiac sign. Gemini, the Twins, was the sign that dominated the month from late April to late May, and it was often represented as a pair of young men but, once again, slowly over time an alternative pair was sometimes chosen instead: two young lovers, man and woman, holding hands, as in the beautiful thirteenth-century example on the north porch of the west front of Amiens Cathedral.[39] (For more on this theme, see Chapter 7.)

Because the calendar image of courtship is infused with the hope of new life, it might be expected that the tradition would gradually have found a place for children in the picture. In fact this did not happen, and Fig. 6-16 is a rare exception to the rule. Once again, the early sixteenth-century artist who made this April scene may have taken a hint from the design for another month in the currently fashionable "ages" calendar. In that

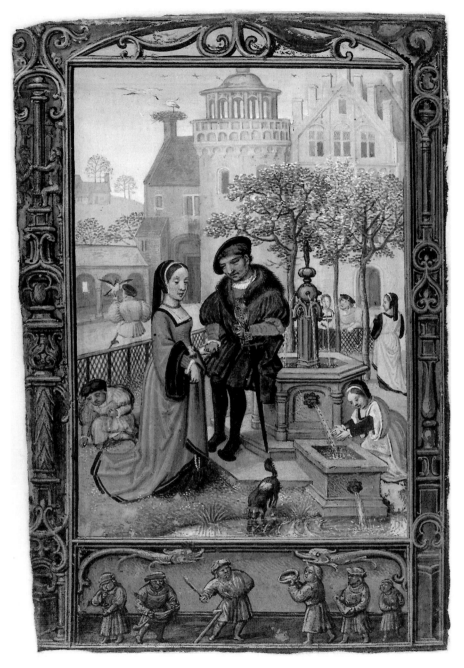

Fig. 6-16. April. Lovers in a Garden. Book of Hours, Flemish, early sixteenth century. The British Library, London, Add. MS 24098, fol. 21b. By permission of The British Library.

convention, the peak and prime of life was reached in July, and represented by a scene that showed a young married couple surrounded by their children. (See Fig. 6-17.)

By now it will be clear that children in any capacity are hard to find in the calendar tradition, even in its later, more expansive years. The state of childhood had no proper place at the core of the occupations cycle and so, when children make an appearance there, they often do so quite literally at the edge, in some ornamental frame or border. Even when one does manage to squeeze into the main scene, it is almost always as a small extra, a minute detail only to be seen by the alerted eye. In a Flemish scene for May, designed around 1540, the foreground is filled with a water party, a boatload of revelers celebrating the season. Far in the distance, a May Day festival is in full swing. A ring of grown-up dancers can be seen in a town square, and by looking very closely, it is just possible to make out beside them another, smaller group—this time a ring of tiny children, holding hands in happy imitation.[40]

Fig. 6-17. July. Parents with Children. Prymer of Salisbury Use, Paris, François Regnault, 1529. The Folger Shakespeare Library, Washington, D.C., MS STC 15961-5. By permission of The Folger Shakespeare Library.

Children love to dance. Certainly, by the late Middle Ages, the art of dancing was taught as part of a courtly education, and boys and girls were encouraged by indulgent parents to perform on adult occasions. Elizabeth of York, daughter of Edward IV, danced at two balls at Windsor Castle in 1472, when she was just six years old.[41] Children were also very fond of musical instruments, as even the most exalted fathers learned the hard way. In 1305, two sons of Edward I, age four and three, banged away so enthusiastically on a drum belonging to one of the court musicians that the royal accounts office had to make payment to "Martinet the minstrel," not only for "making his minstrelsy in the presence of Thomas and Edward," but also for "repairing his tabor, broken by them."[42]

In at least one manuscript, another witty adaptation of a zodiac sign made it possible to show two children enjoying a musical entertainment in a calendar scene for May. On one surviving page from a Dominican missal, produced in Bologna early in the fourteenth century, the Gemini sign has been transformed into a pair of performers, one musician and one dancer, who are amusing a little girl and boy.[43]

Rare as it is to find a child included in a calendar scene, whether at play or at work, as symbol or as decoration, it is even more remarkable to come across one included simply for interest, a subject caught, as though by camera, in a state of suspended animation. The February scene of the Flemish Grimani Breviary (c. 1518) shows a farmyard under snow. Right in the middle of the composition, impossible to ignore, there stands a small boy, relieving himself at the entrance of a cottage.[44] The act has been observed with a sharp eye for detail, down to the yellow-stained snow by the doorway, but there seems to be no explanation for the figure's presence, except that the challenge of depicting it had fired the artist's fancy.

In the border of the late French "Annunciation to the Shepherds" page (c. 1475), illustrated in Fig. 4-10, there is a scene, borrowed from an April calendar, that pictures a goat being milked while sheep are led out for spring grazing. At the very center of the action, a bold little boy bestrides the foreground. Obviously destined to become tiresome as he grows up, he is at this moment young enough to be endearing, as he clutches the string of his toy wagon in one hand, and with the other confidently directs the traffic flow as the flock plods out to pasture. Once again, with art's caprice, star billing has been given to a bit player whose part is all show and no substance.

These glimpses of childhood are arresting, or amusing, but to the calendar tradition they are irrelevant. Very different are those exceptional cases

where the child's sport has been selected as the defining occupation of the month.

A French manuscript of the mid-fifteenth century, the Hours of Adelaide of Savoy, has a most unusual calendar, which strays far from the conventional round of work to emphasize instead a round of pastimes, punctuated with an occasional view of such high points in the church year as the ritual of Ash Wednesday, the first day of Lent.[45] The January page (Fig. 6-18) is devoted to the climax of the Christmas season. The Feast of Epiphany, on January 6, commemorates the showing of the baby Jesus to those Wise Men who have been long identified, by hallowed tradition, as the "Three Kings." For centuries, the day has been celebrated in many parts of Europe with a game, a light-hearted joke on the theme of monarchy, the election of a "Bean King."[46] Rules varied from region to region, but the core of the ceremony remained the same. A special cake was cut up and shared. Whoever received the slice in which a bean had been buried was hailed as king, or queen, for the occasion. In some parts of France, this mock monarch was led to church the next day with cheerful pomp and circumstance, a grand finale that is illustrated in this picture. The winner, a lucky young woman wearing her crown, is escorted by friends through the streets, as musicians salute her and spectators applaud.

At the top of the right-hand border, above a roundel which frames January's zodiac sign, Aquarius, that smart young wine waiter, there is set a small compartment within which the game itself is shown in progress. The players stand around the table, the master of ceremonies holds up the cake, and an all-important little boy sits on the floor. His key role in the proceedings is explained in an account published in Paris in 1621:

> A small child is put under the table, and is interrogated by the master. . . . The master calls on him to say to whom he shall give the piece of cake which he has in his hand. The child names whoever comes into his head, without respect of persons, until the portion with the bean is given out. He who gets it is reckoned King of the company, although he may be a person of the least importance. This done, everyone eats, drinks, and dances heartily.[47]

The choice of a Bean King is a game made for interiors, one to be enjoyed, ideally, against a background of bright fire, soft candlelight, and snug suppers, but snowballing, as everybody knows, can be played properly only in the great outdoors. The sport of snowballing quite often found a place for itself in the decorative borders of late calendars,[48] but it

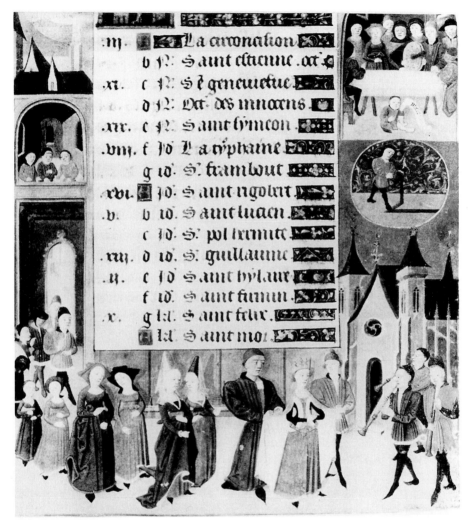

Fig. 6-18. January. Bean King Game and Celebration. Hours of Adelaide of Savoy, French, 1450–60. Musée Condé, Chantilly, MS Lat. 1362, fol. 1 recto.

is highly unusual for it to be offered as the principal occupation for the month of December. (See Fig. 6-19.) No childish activity is given quite the same treatment in any other calendar, or in any other quarter of the year, and this treatment of snowballing is one more reminder of the strange, special link between childhood and the winter months.

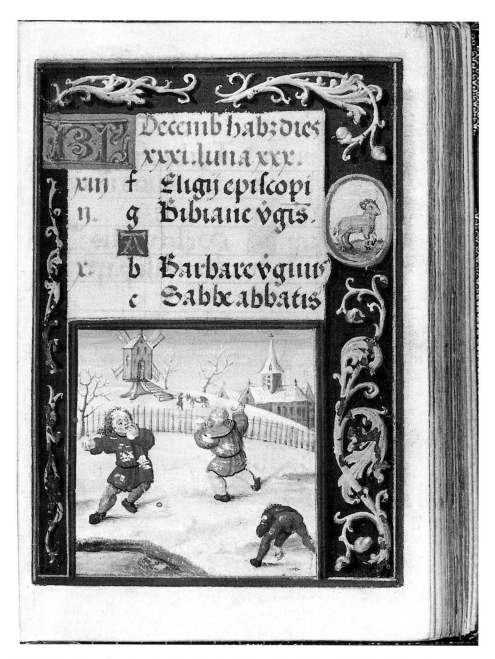

Fig. 6-19. December. Snowballing. Book of Hours, Flemish, c. 1520. The Walters Art Gallery, Baltimore, MS W425, fol. 12.

That link is taken for granted in John Heywood's *Play of the Wether* (1533), in which different characters petition Jupiter to grant them their favorite kind of weather. The Wind-miller wants wind, the Water-miller rain, the Laundress bright sunshine. As has been mentioned already, the Boy, a part given in the stage directions to an actor "the lest [least, smallest] that can play," begs for frost and snow. He needs them not only for his bird traps, but also for "makynge of snow ballys, and throwyng the same." Sufficiency of snow will be a guarantee of certain bliss. "O, to se my snow ballys lyght on my felowes heddys." At the end of the play, while Jupiter is still considering all the petitions, the Boy offers him an irresistible bribe:

> I promyse yow, yf any snow come,
> when I make my snow ballys ye shall have some.[49]

In late calendars, the act of courtship was often chosen to represent the months of April and May. The scenes are charming and light-hearted but, beneath the playful prettiness of gesture and response, there runs the age-old, serious theme of life's renewal. No such cosmic significance has ever been detected, by even the most ingenious commentator, in a snowball fight but, however frivolous the choice of subject may be, its treatment in Fig. 6-19 keeps the action securely anchored in the authentic tradition. The sturdy little figures, warmly wrapped for winter, belong indisputably to a recognizable world of everyday activities. Very different is the effect of another calendar, made in Paris circa 1514.[50] The work of the world is there entrusted to *putti*, who skip through the year with the appropriate tool for each allotted task clutched in a dimpled hand, here a toy rake, there a toy scythe. Child has been changed into cherub, effort into ease, work into play, duty into dance. The familiar annual round has been turned into fantasy, the dignity of labor degraded into decoration.

Chapter 6 Notes and References

1. G. R. Owst, *Literature and Pulpit in Medieval England* (Oxford: Basil Blackwell, 1961), p. 34.
2. H. Bober, ed., *The St. Blasien Psalter* (New York: H. K. Kraus, 1963), plate xii.e, fol. 3 recto.
3. For further reading, see J. A. Burrow, *The Ages of Man* (Oxford: The Claren-don Press, 1986); M. Dove, *The Perfect Age of Man's Life* (Cambridge and New York: Cambridge University Press, 1986); E. Sears, *The Ages of Man* (Princeton: Princeton University Press, 1986).
4. The work (Bibliothèque Nationale, Paris, MS fr. 1728) is described in L.

Delisle, *Recherches sur la Librairie de Charles V* (Paris, 1907; reprint Amsterdam, 1967), vol. 1, 260 and plate xi.

5. For a full discussion of the tradition, see E. Dal and P. Skårup, *The Ages of Man and the Months of the Year* (Copenhagen: Royal Danish Academy of Sciences and Letters, 1980).

6. E. Duffy, *The Stripping of the Altars; Traditional Religion in England c. 1400–c. 1580* (New Haven and London: Yale University Press, 1992), p. 229.

7. D. Cressy, *Bonfires and Bells; National Memory and the Protestant Calendar in Elizabethan and Stuart England* (Berkeley and Los Angeles: University of California Press, 1989), p. 20.

8. Dal and Skårup (see note 5), p. 59.

9. Ibid., pp. 18–20, 41, fig. 56.

10. S. L. Hindman, "Pieter Breugel's Children's Games, Folly and Chance," in *Art Bulletin* 63 (1981), pp. 455–58.

11. R. Freeman, *English Emblem Books* (London: Chatto & Windus, 1948), p. 211.

12. Duffy (see note 6), p. 182, and plate 74.

13. Lilian M. C. Randall, *Images in the Margins of Gothic Manuscripts* (Berkeley and Los Angeles: University of California Press, 1966), plate xcvii, fig. 471.

14. B. White, ed., *Alexander Barclay's "Eclogues,"* Early English Text Society, Original Series, 175 (1927), p. 184: Fifth Eclogue, lines 87–90.

15. G. A. Lester, ed., *Three Late Medieval Morality Plays* (London: Ernest Benn Ltd., 1981), p. 115: "Mundus et Infans" (c. 1520), lines 78–79.

16. R. Steele, *Medieval Lore from Bartholomew Anglicus* (New York: Cooper Square Publishers Inc., 1966), p. 52.

17. The Grimani Breviary, Flemish, c. 1517–18, Biblioteca Marciana, Venice, MS Lat. XI.67 (7531).

18. White (see note 14), p. 184, lines 93–94.

19. August calendar page, border, manuscript fragment, Flemish, Simon Bening, c. 1540, Bayerische Staatsbibliothek, Munich, Clm 23638.

20. Steele (see note 16), p. 51.

21. A. Chatelet, Introduction to *Heures de Turin* (Turin: G. Molfese, 1967), plate ii, February. The calendar scenes are thought to have been made in a Flemish studio, toward the end of the reign of Philip the Good, Duke of Burgundy (d. 1467).

22. B. A. Hanawalt, *The Ties That Bound; Peasant Families in Medieval England* (New York and Oxford: Oxford University Press, 1986), pp. 157–58.

23. P. Mane, *Calendriers et Techniques Agricoles (France-Italie, XIIe–XIIIe Siècles)* (Paris: Le Sycomore, 1983), pp. 136, 283, fig. 48.

24. February. Warming by the Fire. The Psalter and Prayer Book of Bonne de Luxembourg, French, 1345, The Metropolitan Museum of Art, New York, The Cloisters Collection, MS 69.86, fol. 2 verso.

25. C. Woodforde, *The Norwich School of Glass Painting in the Fifteenth Century* (New York and London: Oxford University Press, 1950), p. 156.

26. H. Read and J. Baker, *English Stained Glass* (New York and London: Thames & Hudson, 1960), p. 165, plate 57.

27. A. Fourrier, ed., *Jean Froissart, "L'Espinette Amoureuse"* (Paris: Librairie C. Klincksieck, 1863), line 212. See also S. Shahar, *Childhood in the Middle Ages* (New York and London: Routledge, 1990), p. 103.

28. B. A. Hanawalt, *Growing Up in Medieval London* (New York and London: Oxford University Press, 1993), p. 113.

29. January. Chopping Wood. Manuscript fragment, Flemish, Simon Bening, c. 1540, Bayerische Staatsbibliothek, Munich, Clm 23638.

30. Hanawalt (see note 22), p. 158.

31. F. N. Robinson, *The Works of Geoffrey Chaucer* (New York and Oxford: Oxford University Press, 1957), p. 293:

The House of Fame, book 3, lines 1223–26.

32. N. Orme, *From Childhood to Chivalry; the Education of the English Kings and Aristocracy, 1066–1530* (New York and London: Methuen, 1984), p. 208.

33. P. Happé, ed., *Tudor Interludes* (Harmondsworth, Middlesex, U.K.: Penguin Books, 1972), pp. 139–80: John Heywood, *The Play of the Wether* (1533), lines 1010–20.

34. Woodforde (see note 25), p. 154.

35. *The Play of the Wether* (see note 33), line 105.

36. M. R. Salzman, *On Roman Time; The Codex Calendar of 354 and the Rhythms of Urban Life in Late Antiquity* (Berkeley and Los Angeles, and Oxford: University of California Press, 1990), p. 95 and figs. 21, 41, 50. For medieval examples, see also Mane (see note 23), p. 243.

37. Mane (see note 23), fig. 89.

38. J. B. Oruch, "St. Valentine, Chaucer, and Spring in February," *Speculum* 56, no. 3 (1981), pp. 550–51.

39. F. Goodman, *Zodiac Signs* (London: Brian Trodd Publishing House Ltd., 1990), p. 62, fig. 69.

40. May. Boating Party. Book of Hours, Flemish (Bruges), Simon Bening, c. 1540, The Victoria and Albert Museum, London, Salting MS 2538 verso, detached leaf.

41. Orme (see note 32), pp. 170–74.

42. C. Bullock-Davies, *Menestrellorum Multitudo* (Cardiff: University of Wales Press, 1978), p. 136.

43. O. K. Gordon, "Two Unusual Calendar Cycles of the Fourteenth Century," *Art Bulletin* 45 (1963), pp. 245–53.

44. February. Farmyard in Snow. The Grimani Breviary (see note 17), fol. 2 verso.

45. March. Ash Wednesday. Hours of Adelaide of Savoy, French, 1450–60, Musée Condé, Chantilly, MS Lat. 1362, fol. 3.

46. B. A. Henisch, *Cakes and Characters; an English Christmas Tradition* (London: Prospect Books, 1984), chap. 2.

47. Etienne Pasquier, *Les Recherches de la France* (Paris, 1621). Quoted in C. A. Miles, *Christmas Customs and Traditions* (New York: Dover Publications, 1976), p. 339 (first ed. 1912).

48. Examples of snowballing in borders can be found in: December Calendar Page, Book of Hours, French (Use of Rome), second quarter of the sixteenth century, The Bodleian Library, University of Oxford, MS Douce 135; December Calendar Page, Book of Hours (Salisbury Use), Paris, Nicola Higman for Simon Vostre, c. 1520, The Pierpont Morgan Library, New York.

49. *The Play of the Wether* (see note 33), lines 1011, 1018, 1238–39.

50. V. Leroquais, *Les Livres d' Heures Manuscrits de la Bibliothèque Nationale*, vol. 3 (Paris, 1927), p. 252.

7

A Woman for All Seasons

When the gate of Eden was barred, two little figures, not one, were left disconsolate outside. From that fateful moment Eve, as well as Adam, had to face forever the bleak consequences of disobedience. The punishments chosen by God for the unhappy pair, and all their descendants, were different in kind, if not in degree. Eve was to bear the heavy burden of childbirth, and the even heavier weight of a husband's authority. Adam had to do the digging. It was he who must struggle with the land, and force it to feed him. Nothing would ever be easy again: "In the sweat of thy face shalt thou eat bread, till thou return unto the ground" (Genesis 3:19).

The two were coupled together in picture and story, but the partners shared a common misery; they did not share a common task. It is rare indeed to find them bent at the same moment, over the same back-breaking work, as they are shown in a mid-twelfth-century frieze on Modena Cathedral, both tilling the ground with hoes.[1] In almost every case, Adam

does his best to tame the wilderness, while Eve nurses her babies. By tradition, Eve has one other allotted task: she is always spinning wool. There is no hint of this activity in the Genesis account, but the idea of it probably stemmed from the statement there that God made clothes for Adam and Eve after the Fall (Genesis 3:21). Their sin had turned the confident nakedness proper to Paradise into something shameful that must be concealed. Once that first set of camouflage had been worn to tatters Eve, and every woman after her, was expected to spin, and weave, and clothe the family. In art, Adam and Eve led very different working lives, and could be recognized by very different attributes. Late in the Middle Ages, the Cappers' Guild of Coventry produced a Resurrection play, and listed among the essential stage props "a hell-mouth, Adam's spade and Eve's destaffe."[2]

Perhaps partly at least because of this traditional division of labor, the overwhelming majority of calendar scenes throughout the medieval period show man alone, shouldering the burden of each season's unchanging demands. In the workaday world of real life, a woman, by necessity, played a very active role. Expected to turn her hand to any one of a hundred tasks, inside the home and out in the field, she was an essential, ever-present part of the labor force in her family, her village, her town. By contrast, in art's ideal image of that world, her figure is very hard to find. It has always proved difficult, however, to exclude every woman entirely from any particular forum, and from time to time it is possible to detect a distinctly female form that has edged its way into a calendar scene. Naturally enough, such sightings occur most often in the later Middle Ages, when each month's traditional motif was being developed into a self-contained vignette that, though tiny, offered scope for landscape detail, and room for more than one human actor in the frame. Nevertheless, it is also true that the occasional woman worker slips in and out of the calendar scheme in earlier centuries as well. Just as the table fork was known to the Middle Ages but did not come into general circulation until much later, so it is clear that the calendar woman had a long-established toehold in the artist's pattern book but, until the time was ripe, she rarely figured in the finished work of art.

Whenever she does make an appearance, however, she is treated in the same way as her male counterpart. There is never any tinge of tiresome medieval misogyny in the portrayal. The characteristic calm of the tradition envelops the woman worker as well as the man. Although, inescapably, a daughter of Eve, the calendar woman is not scarred by Eve's flaws, or invested with her attributes. Neither a nuisance nor a temptress, she works companionably side by side with her fellow laborers. She is a help,

not a hindrance in the common task, and she is rarely engaged in Eve's defining occupations, spinning and nursing babies.

To spin requires two hands, and while it is possible to cradle a child in the arms and still have both hands free to pull the thread, it is out of the question to spin and reap, or spin and bind sheaves, at one and the same time. There is another plausible explanation for the absence of spinning from the scene. The calendar world is a working world, and the women who inhabit it are busy with the month's official occupation. The main emphasis is on the production of raw materials, the basic ingredients of the food supply. In contrast, spinning is one step in the manufacture of cloth, an essential activity, but one irrelevant to the tradition. It has no proper place there, and is shown only in those rare instances where a figure has been given no real job to do. In Fig. 1-10, for example, a man is knocking down acorns for his pigs. The woman who stands nearby is not actually helping him, she is just his companion, and so has both hands free for distaff and thread.

The demands of the tradition ensured that little emphasis was ever laid on motherhood either. Here and there, as was shown in the previous chapter, there is a glimpse of a woman with a baby in her arms, or one with a small child in tow (Figs. 6-1, 6-4), but these are incidental grace-notes, not the essence of the story told. In the calendar world, children sometimes accompany their mother, but they never distract her from her first responsibility, the task at hand. One thread, however, links the calendar woman to the traditional domestic duties shouldered by her sisters throughout the centuries: some of her work has to do with the all-important preparation and provision of meals.

In the depth of winter, the calendar woman is occasionally found seated comfortably by the fire with her husband, waiting for dinner (Fig. 6-8). More often, she is the servant, laying the table for the meal to come (Color Plate 6-6). As pointed out in the previous chapter, the servant figure in such winter scenes was probably developed from January's zodiac sign, Aquarius, the Water Carrier. Aquarius is almost invariably depicted as a young man, and so, naturally enough, his human followers are almost always young men too. Any female attendant at the winter feast is most likely to appear in the calendars of the late Middle Ages, but examples are not quite unknown in earlier periods. One is shown in the December scene carved in 1130 on the west front of Saint-Denis. Another is pictured on the great stone fountain in Perugia, designed by Nicola and Giovanni Pisano, and built in 1278. On this, each month is represented by two separate figures, placed side by side in two distinct compartments. For January,

a man sits by the fire with a plate of meat in one hand and a goblet in the other, while next door a seated woman with a jug held in her lap seems ready both to dine and serve.[3]

Signs of the actual preparation of food can also be detected from time to time. Far in the background of Color Plate 6-6, the tiny outline of a woman is busily at work by the kitchen fire. More significant is that women take part in both of December's traditional occupations, bread-making and the slaughter of a pig for the winter meat supply. The early fourteenth-century book of hours shown in Fig. 7-1 offers two vignettes for the month. In one, a man and a woman put loaves into an oven, and in the other, two women make the dough. (For more on the subject of baking, see also Chapter 2.) In Fig. 7-2, one woman kneads, another tends the oven, and a third holds a pan to catch the blood of a dying pig, whose throat has just been slit by the man kneeling on top of it. This particular method of killing the animal begins to appear in calendars during the four-

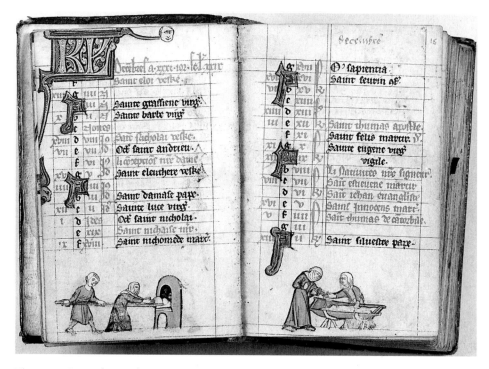

Fig. 7-1. December. Baking Bread and Making Dough. Book of Hours, Franco-Flemish, Cambrai(?), early fourteenth century. The Walters Art Gallery, Baltimore, MS W88, fols. 14 verso and 15 recto.

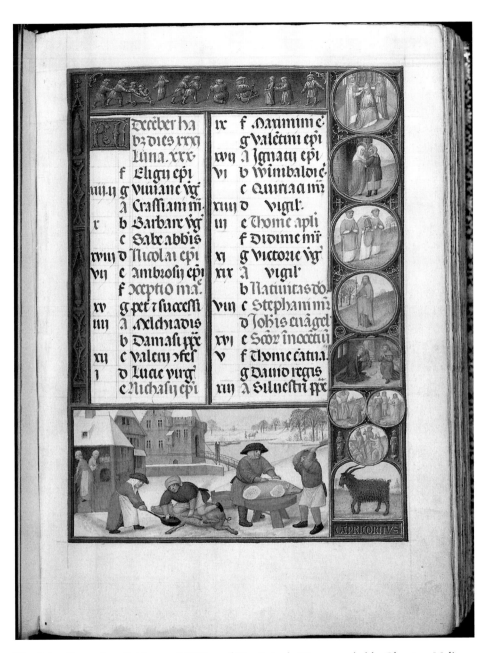

Fig. 7-2. December. Baking, and Killing of Pig. Spinola Hours, probably Ghent or Malines, c. 1515. The J. Paul Getty Museum, Los Angeles, California, Ludwig MS IX.18, fol. 7 recto.

teenth century, and is often chosen by artists in the late medieval period.[4] Almost always, in such cases, a man and a woman work in partnership. The blood collected, combined with oatmeal or cereal and steamed in a cloth bag or a sausage skin, made such savory dishes as black pudding, a comforting treat on a cold winter day. It is rare to find a woman playing any other role in the operation, but on one late stained-glass roundel from a set in Colville Hall, Essex, a man and a woman share the task of cutting up a pig's carcass into manageable portions.[5] As a slight variation on the traditional theme, the December page of late calendars occasionally shows a meat market, where women can be found both as customers (Fig. 6-5) and as traders (Fig. 7-3).

An even more unusual scene appears on the February page of an early sixteenth-century book of hours (Fig. 7-4). A convivial party eats and drinks at table, while a man cooks pancakes by the fire, assisted by the woman at his side who is beating batter in a bowl. (For another example, see Chapter 2.) Lent almost always starts in February, and the cheerful occupation shown here may represent the Shrove Tuesday practice of using up all the dairy products in the larder on one irresistible feast of eggs, milk, and butter, poured into recipes of every kind—especially that crowning glory of the day before Lent's rigorous fasting, the pancake. Just when the custom began is not established, but its popularity was cresting by the time of this manuscript, and there are many happy, lip-smacking tributes to the pleasures of

> The day whereon both rich and poor
> Are chiefly feasted from the self-same dish,
> When every paunch, till it can hold no more,
> Is fritter-filled, as well as heart can wish.[6]

In the height of summer, a welcome sight is the woman bringing picnic supplies to sheep-shearers, or to tired workers resting in the field (Fig. 1-8). Usually, the figure with the enticing, napkin-covered basket and the large jug is there to serve others, but in at least one example she is equipped to serve herself. On a stained-glass roundel for August, at Brandiston Hall in Norfolk, the solitary reaper is a woman, steadily at work while her bundle of provisions waits behind her.[7] The link between the pressure of work at harvest time and the sustaining snack is strong but, in one rare exception to the rule, a woman brings her basket to cheer some vineyard workers on a cold March day, months away from the vintage.[8]

Although women's work of filling larders and making meals is most

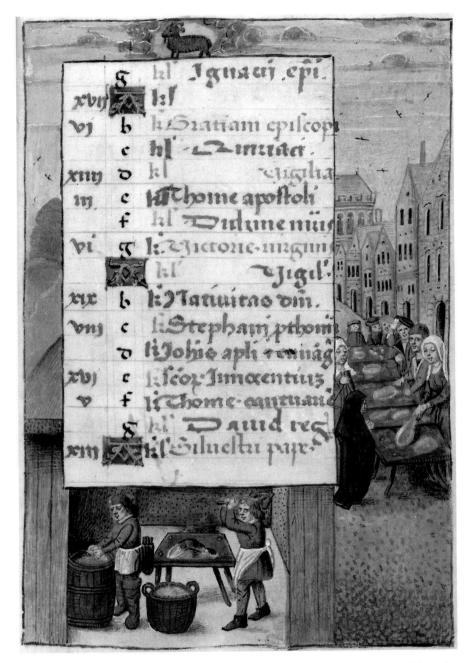

Fig. 7-3. December. Butchers and Meat Market. Book of Hours, Bruges, late fifteenth century. The British Library, London, Add. MS 18852, fol. 13. By permission of The British Library.

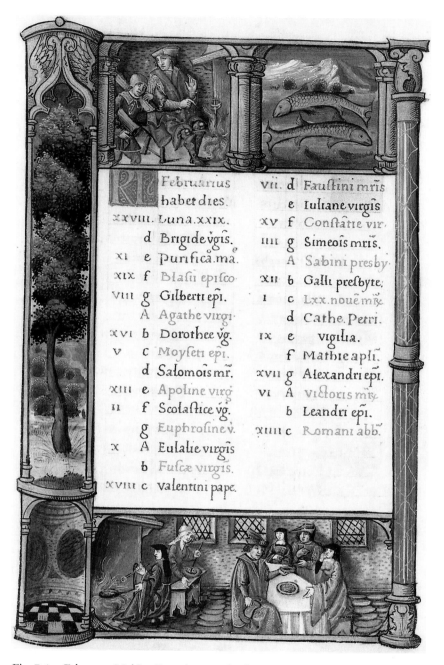

		Februarius habet dies.	vii.	d	Fauſtini mris
				e	Iuliane virgis
xxviii.		Luna.xxix.	xv	f	Conſtātie vir.
	d	Brigide vgis.	iiii	g	Simeois mris.
xi	e	Purificā.ma.		A	Sabini presby·
xix	f	Blaſii epiſco	xii	b	Galli presbyte.
viii	g	Gilberti epi.	i	c	Lxx.nouē mře
	A	Agathe virgi·		d	Cathe.Petri.
xvi	b	Dorothee vg.	ix	e	vigilia.
v	c	Moyſeti epi.		f	Mathie apli.
	d	Salomois mr̃.	xvii	g	Alexandri epi.
xiii	e	Apoline virg	vi	A	victoris mr̃s
ii	f	Scolaſtice vg.		b	Leandri epi.
	g	Euphroſine v.	xiiii	c	Romani abb̃
x	A	Eulalie virgis			
	b	Fuſcæ virgis.			
xviii	c	valentini pape			

Fig. 7-4. February. Making Pancakes. Book of Hours, French (Use of Rome), second quarter of the sixteenth century. The Bodleian Library, University of Oxford, MS Douce 135, fol. 2 verso.

likely to be found in scenes for winter and summer, there are occasional hints of this traditional responsibility in the two other seasons, spring and autumn. Late in the Middle Ages, a scene for April was developed in which the essence of spring was embodied in a new way. In the ancient convention, which never lost its dominance, flowers and fresh green leaves always convey the message of rebirth and renewal, but in the alternative image, often chosen in the books of hours produced by Flemish work-shops in the early sixteenth century, the emphasis falls on the farmyard animals. Sheep are led out to pasture, lambs are nursed, and cows are milked. Sometimes while all this is going on, and one dairymaid is busy with her charge, another can be seen standing in a doorway, churning the milk into butter; see Figs. 4-2, 6-10.

The same slight shift of emphasis, from ingredient to product, can at times be detected in the autumn scene of the grape harvest. Women are quite often included in the group of workers picking clusters from the vine, but on rare occasions they act as assistants when the new wine is being stored. In the September picture in a late fifteenth-century book of hours, made in northwestern France, a woman holds the funnel while wine is being poured in a cask.[9]

When not actually feeding the work force, the calendar woman takes her own place in its ranks, and can be found playing some part in each of the year's seasons. The fire that made rooms cozy in the dreary winter days had to be encouraged to burn brightly. In a stained-glass roundel for February, from Colville Hall in Essex, a man toasts his toes while a woman works the bellows to blow up the flames.[10] That fire also had to be kept alive with a steady supply of fuel, and a female figure can at times be seen in the first months of the year, picking up the sticks chopped by her companion in a backyard (Fig. 6-1), or crouched in some grove, bundling together for firewood the trimmings left by workers as they prune the trees. (See Fig. 7-5.)

It is by no means always clear in such scenes of early spring activity whether in fact that bundle contains kindling, stakes to support new plants, or living plants themselves. The February scene in the Spinola Hours, a Flemish manuscript of circa 1515, shows a woman carrying her load of stakes into a vineyard, rather than away from it, while in a French example from the same period it is hard to tell whether the woman in a gardening scene for March is pulling up a piece of wood to add to her collection, or pushing one down into the ground.[11] In this instance, it is quite possible that the object shown is neither a piece of firewood nor a stake but, instead, a rootless cutting being planted in a vineyard.

ij f Scolasticæ virginis.
 g
x d
 b
xviij c Valentini epi.

Fig. 7-5. February. Pruning Trees. Book of Private Prayers, written for George Talbot, Earl of Shrewsbury, c. 1500. English rubrics, Flemish decoration. The Bodleian Library, University of Oxford, MS Gough Liturg. 7 (s.c. 18340), fol. 2. Detail.

On occasion, women were trusted with more responsibility. The stained-glass roundel for March from Colville Hall[12] shows a man and a woman companionably side by side, pruning trees. In late examples, such tiny hints of the essential tasks demanded by the start of the growing season were woven together to create the entirely new March scene of work in a private garden that was discussed in Chapter 3. In that agreeable setting, women play their parts, both as owners giving orders and as gardeners carrying out instructions. (See Figs. 3-2, 3-3, 3-7, 3-8, 3-9, 3-10.)

This garden motif for March, like the farmyard motif for April that has been mentioned already, found some favor in the late fifteenth and early sixteenth centuries, particularly in books of hours produced by Flemish workshops. In each case, an animated, fully developed landscape was presented, with parts for several actors in the tiny drama. In these new scenes, there was room for women as well as men, and they can be found firmly planted in the foreground, absorbed in their appointed tasks. Indeed, one example is peopled entirely by charming dairymaids, one busy with her cows and the other scrambling over a stile, jug in hand, in search of fresh milk.[13]

As the cycle wheels toward the midpoint of the year, the shepherd's work is sometimes chosen as the theme for June or July (see Chapter 4). Here too, from time to time, a woman makes her way into the picture. On rare occasions she is actually guarding the flock (Fig. 1-9), but she is more likely to be one of the shearers, clipping fleece (Fig. 4-9).

Shepherding, however, never became a major motif in the calendar scheme. The unvarying imperative at the core of the tradition is the need to harvest hay and grain crops in high summer. In illustrations for the months of June, July, and August throughout the later Middle Ages, a woman is quite often in the team of harvesters, raking hay (Color Plate 7-6), binding sheaves (Fig. 7-7) or, in a rare variant, helping a man to load a cart with bundles of wheat, by hoisting up each one to him on the prongs of her fork.[14] A woman is one of the tired pair in Fig. 1-8, sitting in a half-reaped field with their tools on the ground beside them, looking forward to the dinner break.

All these scenes come from the end of the medieval period, when an occasional female in a group of workers is no longer a surprise, but in rare instances it is also possible to find such a figure in far earlier examples. It has been pointed out that, whereas it was not the custom to show women harvesters in French calendars until the later centuries, they are occasionally featured in early German and Bohemian manuscripts.[15] A woman hay-raker stands as the figure for July in the Saint Blasien Psalter, a book made in the Black Forest region, circa 1230–35, and a woman cutting wheat with a sickle represents July in another psalter of slightly later date, produced in Lower Saxony.[16] In such early instances, it is the almost invariable custom to show just a single figure in the scene, and so in these two pictures one woman stands alone, to represent the entire work force. Such a choice is unusual, but even more rare is the illustration for July in a later example, a Franco-Flemish book of hours of the early fourteenth century. In this, a cheerful girl is engaged in that most extraordinary of all activities in the calendar world, a time-wasting flirtation with her fellow hay-raker. (See Fig. 7-8.) It can only be hoped that this regrettable episode took place well after working hours.

As summer turns to autumn, the focus of attention shifts to the grape harvest. In calendars of the late Middle Ages, women quite often play their part in the vintage,[17] but they can also be found, on occasion, in earlier versions of the scene. The single figure of a woman gathering grapes represents August in a calendar sequence carved in the early thirteenth century on the church of Borgo San Donnino in Cremona.[18] The grape always has pride of place in the calendar world, but attention is paid to other fruit

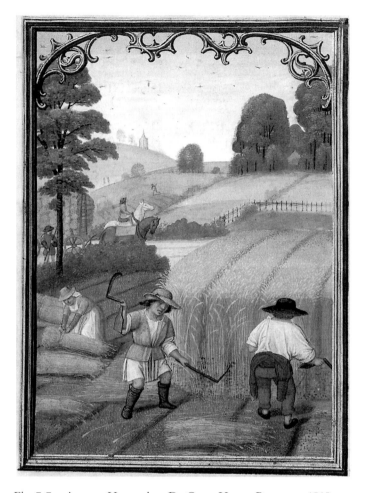

Fig. 7-7. August. Harvesting. Da Costa Hours, Bruges, c. 1515,
Simon Bening. The Pierpont Morgan Library, New York, MS M399,
fol. 9 verso.

from time to time. On the fountain built for Perugia in 1278, a man and a
woman are shown in the month of August, plucking figs and putting them
in baskets.[19] On a fifteenth-century misericord in the Cathedral of Notre
Dame in Rouen, one woman pours apples from her store into another's
lap.[20]

Incidental details strengthen the links between women and the fruit har-
vest. In one late book of hours, the official subject of the scene for October

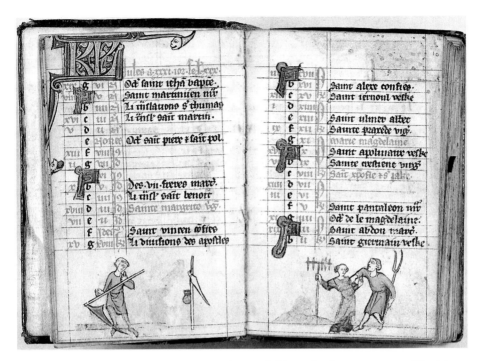

Fig. 7-8. July. Mowing and Flirtation in the Hayfield. Book of Hours, Franco-Flemish, Cambrai(?), early fourteenth century. The Walters Art Gallery, Baltimore, MS W88, fols. 9 verso and 10 recto.

is a cattle market (Color Plate 5-12) but, far behind the looming figures in the foreground, there is a man on a ladder, gathering grapes from a trellised vine, and underneath him stands a woman with her apron held out to catch the clusters.[21] One particularly touching vignette (Fig. 8-3) reveals a mother pausing for a moment from her work in an orchard to hand an apple to an eager little boy.[22]

No sooner have the fruits of the earth been gathered in than plans must be laid for next year's crop. Autumn is the season not only for fruition but for foresight. Fields are plowed and seeds are sown in September or October, in preparation for the summer harvest. In the calendar world, no woman's hand ever steers the plow, but in one case at least it guides the horse that pulls the harrow used to break up the hard clods left by the first plowing, and cover the seeds with soil.[23] When it comes to the actual sowing, the responsibility of scattering the seed is entrusted to a man, but a woman can be the backup member of the team, walking behind him with the sack of supplementary supplies.[24]

The year draws to a close with the slaughter of farm animals for the winter meat supply. Almost always, the representative victim is the pig but, before he is killed in December, he is granted a happy November, gorging to his heart's desire. When the herd is led out into woodland to feast, it is a man who knocks down acorns for his charges; any woman present in the picture is simply there to keep him company (Fig. 1-10). If, on the other hand, the pigs are fattened on the farm, then often it is a woman who feeds them at the trough.[25] (See Fig. 8-6.) Even when a huntsman returning from the chase fills the foreground of a November scene, far behind him stands a woman in a doorway, watching her pigs as they forage in the yard.[26] On another November page (Fig. 7-9), there is a woman in the crowd of potential buyers at a pig and cattle sale in town.

The calendar's characteristic tone is one of purposeful sobriety, but cheerfulness breaks in from time to time, to brighten the mood with a flash of frivolity, a welcome break in the daily round. When permitted to

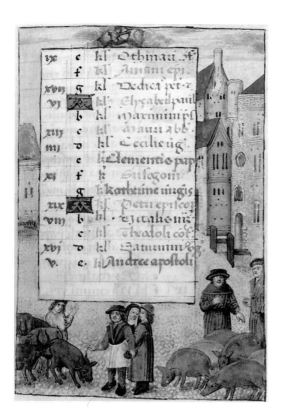

Fig. 7-9. November. Pig and Cattle Market. Book of Hours, Bruges, late fifteenth century. The British Library, London, Add. MS 18852, fol. 12. By permission of The British Library.

set foot in such a scene, women dance to the same tune, with the same zest, as their male companions.

Feasting by the fire is the principal indoor pleasure of the winter season, but in at least two late examples there is the heightened excitement of a dance by torchlight in a handsome hall.[27] Outdoors, there are more varied possibilities. One idiosyncratic French manuscript of the mid-fifteenth century offers for January a glimpse of Twelfth Night entertainments for Epiphany, on the sixth day of the month (Fig. 6-18). The game shown in this illustration is discussed in Chapter 6, so it is enough now to point out that the mock monarch who has just been chosen by lot to reign over the festivities is not here the usual King of the Bean but a Queen, already crowned and on a royal progress through streets lined with her loyal subjects.

January 6, being a special day, has its own special amusements. Ordinary winter days are whiled away with ordinary winter sports. Two young couples share a sleigh ride on the ice in January (Fig. 7-10); another scene offers a glimpse of a snowball fight in which young girls as well as boys are happily engaged.[28] The charm of such a contest was listed as one of January's particular attractions by an Italian poet, Folgòre da San Gimignano, early in the fourteenth century:

> Uscir di for'alcuna volta il giorno
> gittando de la neve bella e bianca
> a le donzelle che staran da torno.

> [Going out many times a day, to throw the lovely white snow at the girls who are standing about.][29]

Summer and autumn are demanding seasons for the diligent, but spring is a persuasive advocate for pleasure. A man and a woman ride out hawking in May on the Perugia fountain. Flirtatious parties set off on May Day by land[30] and by water (Fig. 7-11), to salute the season and bring home armfuls of fresh greenery. In the medieval calendar tradition, April and May are always special months, set apart from the workaday round as a salute to new life, new growth, the surge of vitality that ensures the survival of every species. To modern eyes, a picture like Fig. 7-11, with its little group of young men and women enjoying each other's company, seems an appropriate, indeed obvious, illustration of the theme. In fact, it was only gradually, over the centuries, that human courtship came to be chosen as the image to embody the idea. The ancient, securely established

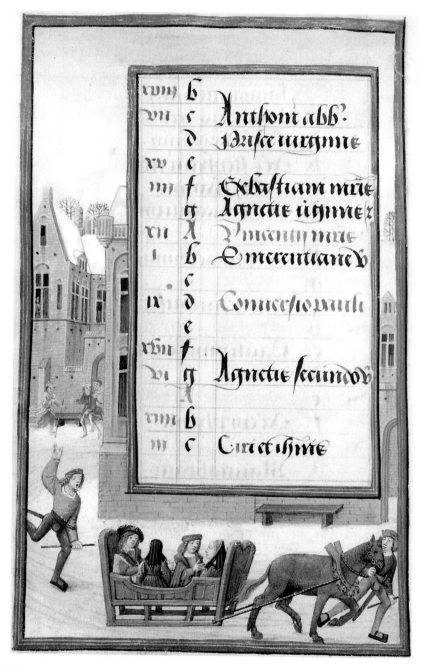

Fig. 7-10. January. Winter Sports. Book of Hours (Use of Rome), Flemish, probably Bruges, c. 1500. The Fitzwilliam Museum, Cambridge, MS 1058-1975, fol. 1 verso.

Fig. 7-11. May. May Day Celebrations. Da Costa Hours,
Bruges, c. 1515, Simon Bening. The Pierpont Morgan Library,
New York, MS M399, fol. 6 verso.

convention was to symbolize the subject by a single figure, holding a
flower or a branch of leaves. Usually that figure is a man but, from time
to time, it is a woman.

In the Saint Blasien Psalter (c. 1230–35), May is represented by a young
girl, standing on her own with a bud in each hand.[31] Later in the same
century, on the fountain in Perugia, a man and a woman face the spectator
in April's frame, each with flowers on the head and in the hand.[32] The two
stand side by side and yet apart, visible to the viewer but invisible to each
other. This image and its many cousins remained in circulation through-

out the Middle Ages, but in the later years it was replaced more and more
often by a simple scene of straightforward courtship. In the Hours of
Margaret de Foix (c. 1470s), a young man lies in a bright spring meadow
with his head in a young girl's lap.[33] Fig. 6-16 is a dignified variation on
the same theme; feckless flirtation has here given place to serious business.
Betrothal and marriage settlements are in the air.

The opening of the old, bare calendar compartment, and the develop-
ment within its frame of a small landscape, offered exciting new possibili-
ties for background detail. Not every artist had the gifts to exploit the new
freedom, or the patron to afford it, but those who did found themselves
able to squeeze in behind the foreground figures, still busy with the
month's appointed task, enticing glimpses of extracurricular activity never
before shown in the cycle. The most familiar to modern eyes of all the
books of hours, the sumptuous Très Riches Heures, made circa 1415 by
the Limbourg Brothers for the Duke de Berry, displays a full-page picture
for each month of the year. Later manuscripts in the same luxurious tradi-
tion provided even more elbowroom for illustration. The full-length scene
was set beside a calendar page that carried not only the key dates of the
month, but also an ample border space for supplementary pictures.[34] Only
the grandest commissions would provide such freedom but, throughout
the fifteenth and sixteenth centuries, even far less gifted artists, working in
far more restricted conditions, were encouraged by the spirit of the age to
cram into their calendars as many extra touches as they could.

The expanded background became an easy point of entry for women.
Tiny figures, doing this or that, could decorate a landscape without in any
way disturbing time-hallowed expectations. Enthusiasts today owe a debt
of gratitude to the new fashion, for how else could they hope to spot
within the constricted confines of the calendar world a washerwoman
scrubbing laundry on a riverbank as a boatload of May revelers glides by,[35]
a tavern-keeper chatting to her customers while shearers cut the fleece
from their sheep (Fig. 4-4), or a woman bather sunning herself on a hot
August day, far in the distance as a hunting party rides across the fore-
ground?[36]

When a woman does make her way to center stage, it is often as a mem-
ber of a team (Color Plate 7-6 and Fig. 7-7). Occasionally she works with
another woman (Fig. 7-1); more often a woman and a man are presented
as a pair, part of a deliberate design (Fig. 7-2). That partnership is formal-
ized in an early example, one on the fountain in Perugia (1278). In that
calendar scheme, two figures are allotted to each month. They are set side
by side, in a pair of compartments. One of these contains the main repre-

sentative of the month, in each case a man, with a small zodiac sign behind him. The other frame presents a second figure, engaged in some appropriate, supplementary task. In eight cases this is a man, whose function is defined by the title carved into the stone beside him: "Socius," comrade or companion. For four months—January, April, May, and August—the partner is a woman, characterized by her label as "Uxor," wife or help-meet.[37]

Some late calendars follow the same pattern, showing a matched pair of men at work in most scenes, and a mixed pair in the remainder.[38] It is rare to find one calendar, as in the Hours of Margaret de Foix, in which every single month is represented by a man and a woman smoothly functioning together as one team. In this particular manuscript, there is even an endearingly domestic scene for February, in which the man huddles by the fire while his back is briskly rubbed with a towel by his helpful companion.[39]

It is even more unusual to find a woman alone, carrying the whole weight of the scene on her shoulders. Two examples that have been discussed already appear in the Saint Blasien Psalter, on the pages for May and July. On the page for February, in an early fourteenth-century book of hours, it is not the customary old man who is warming himself by the fire but a woman, heavily cloaked just as her male counterpart would be, and stirring a stewpot (Fig. 7-12). Another, later February scene shows a woman all by herself, making pancakes.[40] At the end of the period, such a solitary female figure occurs from time to time—for example, in a stained-glass roundel,[41] while in another case one woman standing alone, binding a sheaf, represents June in a book of hours made in the mid-fifteenth century.[42]

Only in one instance does a woman seem to be consistently preferred as the representative of a month, and that is in a highly uncharacteristic scene for February. The picture cycle of the calendar tradition makes no obvious reference to religious beliefs or practices, and yet in the early Middle Ages there is a cluster of examples (all from Flanders or northern France) in which the feast of Candlemas, on February 2, is the chosen theme for the month. The feast commemorates the Purification of Mary, and the presentation of the Infant Jesus in the Temple, forty days after Christmas. It was celebrated with an elaborate procession, in which each parishioner brought a candle to church, to be blessed by the priest. After the service, the candles were lighted, and carried around the church in a solemn yet joyful ceremony. The lighted candles recalled in a beautiful image Simeon's words in the Temple as he held the baby in his arms and

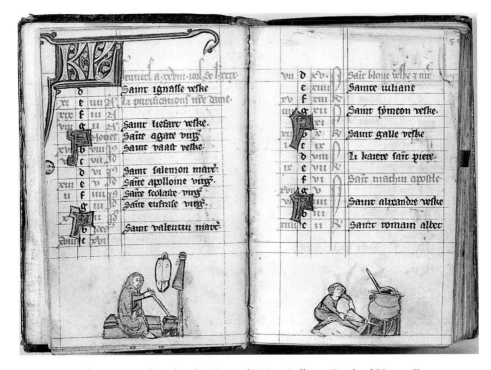

Fig. 7-12. February. Cooking by the Fire and Using Bellows. Book of Hours, Franco-Flemish, Cambrai(?), early fourteenth century. The Walters Art Gallery, Baltimore, MS W88, fols. 4 verso and 5 recto.

described him as "a light to lighten the Gentiles, and the glory of thy people Israel" (Luke 2:32). The typical February scene with this motif shows one woman holding one tall candle (Figs. 7-13, 8-1), and a scattering of examples can be found from the late twelfth century until the early fourteenth.[43] After that, the picture drops out of the canon. This is both understandable, because such an overtly religious reference has no proper place in the tradition, and puzzling, because the ceremony itself remained enormously popular right up to the very end of the Middle Ages.[44] On the rare occasions when there is an allusion to a religious practice in a late calendar, it is not to the joy of Candlemas but to the gloom of Ash Wednesday, the first day of Lent. In one or two cases,[45] that is the theme chosen for March and there, in the congregation waiting to receive ashes from the priest, women and men kneel side by side, fellow sinners at the start of the shared penitential season. (See Color Plate 7-14.)

When gathered together like this, into a bright bouquet, these random

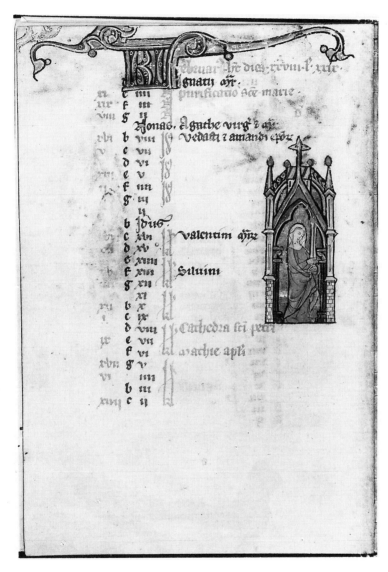

Fig. 7-13. February. Candlemas. Psalter, northern France, end of the thirteenth century. The Pierpont Morgan Library, New York, MS M79, fol. 2 verso.

examples, plucked one by one from scattered sources, may well leave the impression that the calendar landscape is alive with energetic little women, bustling their busy way from season to season. This would be misleading, for always, in every period, the vast majority of calendars are inhabited by men, and men only. Nevertheless, a handful of women did manage to enter the calendar world throughout the Middle Ages, and it is interesting to reason why. To shrug and say that women always played a part in the work force, and therefore took their place by right in the tradition, is not sufficient, because if this were indeed the deciding factor they would appear far more often, and on a regular basis. Each picture is an image of life, not life itself, and what artists decide to put in, and leave out, is determined to some degree by the models they draw on, and by the current conventions that shape the raw material of every day into acceptable aesthetic form.

A web of associations, delicate but strong, bound women to the calendar cycle, even though it was never taken for granted that they must stand within it. From the first, the female figure was used to personify different aspects of the passing year. Sometimes a month was embodied in this way: February is a woman in the Roman Codex Calendar of A.D. 354.[46] More often, in the classical world, the seasons were represented by women, and this ancient convention still lived on in the Middle Ages. On a capital of the choir at Cluny, carved in the early twelfth century, Spring is a young girl holding a casket.[47] In *Secretum Secretorum,* an influential treatise on good government and good health that originated in the east and then circulated widely throughout the west in various translations from the early thirteenth century onward, the seasons are compared to the ages of a woman. Spring is a beautiful bride, and winter a dying old crone.[48]

The zodiac signs can be points of entry for women into the calendar cycle. Occasionally an artist will have fun, devising a drama in which the zodiac figure plays a part. In Queen Mary's Psalter, an English manuscript made in the first quarter of the fourteenth century, each month is allotted two "story" scenes, one for its occupation and one for its sign. In April, girls pick flowers in one compartment, while next door another girl drives two cows to meet a young man with a bellowing bull, Taurus himself.[49]

The possibility that the characteristic occupation of Aquarius, pouring out water from a container, may have encouraged the addition of a servant figure to January's feast has already been raised in this chapter and in Chapter 6. The figure of the sign is almost invariably male, but in a rare exception Aquarius has been portrayed as a woman, sitting astride a sea monster and holding a large bowl.[50] January's feast is sometimes enjoyed

by Janus, the two-headed Roman god who guarded doorways, and could see both past and future at the same time. In this particular manuscript, produced in the early fifteenth century, not only is Aquarius a woman but the Janus eating dinner has become one too.

Gemini, the Twins, is the sign for May. By long tradition, rooted in the old story of Castor and Pollux, it is personified by two young men, but gradually a different choice is made from time to time, and the two become a young man and a girl. They are shown as lovers, either exuberantly entwined or just beginning to enjoy each other's company. In a thirteenth-century sculpture on Amiens Cathedral, the couple are portrayed with touching tenderness, gently holding hands.[51] Such an interpretation of the sign may have paved the way for the depiction of spring as a season of human courtship rather than of nature's renewal, a presentation that became ever more popular as the Middle Ages drew to a close. One particularly endearing scene for May is shown in Fig. 7-15. Up in the sky, Gemini's loving pair embrace, while down in the real world a portly Romeo climbs a ladder to present his Juliet with a potted plant.

Artists may have been struck by the attributes of one other sign, and led to sense how small the step would be from the portrayal of a zodiac figure to the portrayal of an ordinary mortal at work. Virgo, the Virgin, was by custom shown as a young woman holding either a palm frond or some ears of wheat. August was Virgo's month and, being also one of the favored months for the grain harvest, there could be a natural association between the sign and the task. On the August page of the Saint Blasien Psalter (c. 1230–35), a man reaping is the main actor, but standing in the margin there is a woman with a bundle of wheat on her head.[52] It is also possible to imagine how easy it would be for the pictorial influence of the zodiac figure to extend beyond its own month to one next door to it. In a French book of hours, made in Paris for Simon de Varie in 1455, Virgo stands between two bound sheaves of wheat on the August page.[53] The occupation chosen for the month itself is threshing, carried out by two men, but in the July scene, one page before, a woman bends to tie up a stand of wheat into a sheaf of just the same kind as those that flank Virgo.

Beyond the confines of the calendar tradition, there were in the later period both individual texts and iconographical schemes that included women at work in their repertoire of themes and images. Cross-currents from these may have helped to make the idea of including women in the calendar cycle more and more acceptable to artist and patron alike. One example of a book with some illustrations of female figures engaged in agricultural tasks is *L'Épître d'Othéa,* written around 1406 in Paris, by

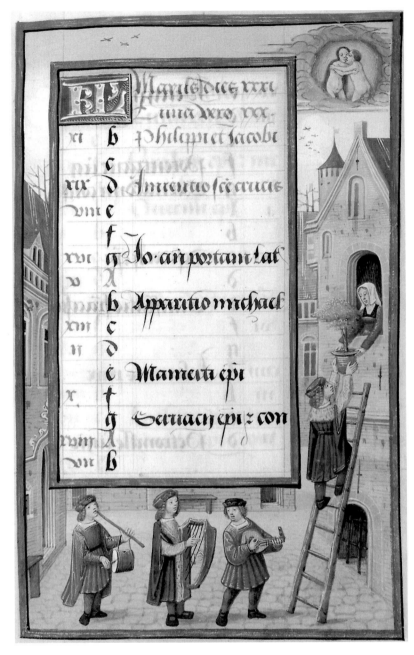

Fig. 7-15. May. Courtship. Book of Hours (Use of Rome), Flemish, probably Bruges, c. 1500. The Fitzwilliam Museum, Cambridge, MS 1058-1975, fol. 5 recto.

Christine de Pisan.[54] The goddess Isis, a character in this moral treatise, represents Mother Earth, and teaches society how to feed itself. In the course of her instructions, she gives a lesson in the art of grafting, and is pictured in the act of tying a new shoot to an old stock. Though dressed at the height of fashion, and floating in mid-air as she carries out the task, the goddess obviously knows what she is doing, and demonstrates her method with the calm competence of an experienced gardener.

Of far greater significance, because of far wider circulation, is the iconographical scheme known as "The Children of the Planets." Ingenious thinkers in the late Middle Ages became increasingly fascinated by the conviction that the planets and the stars exerted influence over every aspect of human life, governing each stage and determining the temperament, the health, and the occupation of each individual. To apply this theory in practice required complicated calculations, because of the many combinations and permutations of heavenly power brought to bear on any single person at the moment of birth, but it was found possible to embody the idea itself in one or two vivid visual images.

During the 1360s, in Padua, the artist Guariento decorated a chapel in the Church of the Eremitani with seven vignettes, in each of which a planetary deity is shown, placed between two figures, male and female.[55] The pictures set forth the seven stages of life, every one under the influence of a different planet, and so the age of the human actors changes, from childhood under the authority of the Moon, to old age under Saturn. In this balanced composition, equal weight is given to the two sexes. Variations on the design appear in several manuscripts.

Another presentation of the planets' power over life on earth became popular in the fifteenth and sixteenth centuries. In this a planet was pictured, surrounded by a multitude of human beings, all busily engaged in occupations that were considered to be specially under the influence of that particular god. So Mercury, in a lively German woodblock print made around 1470, presides over a crowd of his subjects: musicians, artists, clock-makers, and master chefs.[56] Although the planets' world of work is peopled mainly by men, women also find a place there from time to time, and are presented as full-fledged members of society, either engaged in characteristic tasks, or given the same prominence as their male companions.[57] In a painted panel picture, produced in the Netherlands early in the sixteenth century, Jupiter is shown being petitioned by his "children," a group of wealthy, well-dressed suppliants that includes one woman.[58]

Yet another fashionable pictorial scheme in the fifteenth century was one designed to demonstrate the effect of temperament on conduct. The

planets were thought to have a profound influence on character; individu-
als unfortunate enough to be too much under the sway of Saturn, for
example, suffered from deep depression and from sloth. To illustrate the
consequences in daily life, a woodcut of 1481, from Augsburg, shows a
scene of domestic disarray: a man slumped asleep at the dinner table, and
a woman too listless and idle to spin wool on her distaff.[59] Once again,
both sexes have a part to play in the lesson taught.

The way in which the "occupations calendar" was affected by the alter-
native tradition, where the months and seasons of the year were linked to
the stages of human life, has already been discussed in Chapter 6. Here it
is sufficient to recall that the figures both of women and of children had a
natural place in the latter convention, because birth, marriage, and the
making of a family were major milestones in the story. The popularity of
this "ages of man" scheme in the late medieval period ensured that it
would exert some influence on its older cousin, and encourage the intro-
duction of women and children to the familiar scenes of farmwork. At
times the two programs are made to run side by side in the same setting,
not fused but paired for the eye of the observer. This is strikingly demon-
strated in Fig. 4-9, which displays the June page of an early sixteenth-
century occupations calendar. In the top border is the zodiac sign for the
month, and the job of sheep-shearing is here carried out, as it happens,
not by a man but a woman. At the bottom of the page is the appropriate
June activity from an "ages of man" calendar. June represents the midpoint
of life, when a young man is mature enough to be ready for marriage, and
so the scene is a happy wedding procession for the groom and his bride.
The physical layout of such a page so narrows the gap between the two
conventions that it is possible not merely to sense but to see the ease with
which ideas and figures could be made to step across from one to the
other.

There was also developed in the later Middle Ages a picture cycle which,
though without formal ties to the old calendar tradition, still took its pat-
tern from the seasons' round and illustrated its theme with views of men
and women at work. The cycle appears in a cluster of manuscripts made
in northern Italy during the last twenty years of the fourteenth century.
These were copies of the *Tacuinum Sanitatis,* a contemporary health hand-
book based on a much earlier Arabic source.[60] The treatise gives advice on
the best way to cope with changing conditions throughout the year, how
to furnish the house, how to dress, what to eat and drink. The all-impor-
tant question of diet leads to instruction on how to cook and how to grow
the best ingredients. Each copy is splendidly illustrated with elegant and

detailed pictures of the subject in hand; the pictorial program, indeed, is far more rich and varied than that of the calendar itself. Women take their place in many of the images, working on their own, with men, or with each other. They are seen indoors in a hundred occupations, from making pasta to cutting out clothes, and they are shown in the fields, involved in everything, from pulling cabbages to picking sage. Whenever they do appear, they are not tucked away in the background, but allowed to stand confidently at center stage. The existence of this self-contained group of luxurious manuscripts is one more indication of a growing response to the everyday scene, and a growing eagerness to capture its complexity in art.

All these decorative schemes were current in the late Middle Ages, and their popularity may have encouraged artists engaged in the calendar tradition to add women more readily to the familiar old formulae. Even without the influence of such programs, illustrators unfettered by the silent assumptions of that convention did on occasion choose to show women at work on the farm. In the borders of the Luttrell Psalter (English, c. 1330s), one woman milks a sheep, and another labors side by side with a man at the disagreeable task of uprooting thistles.[61] The only distinction made between them is that it is the man who is wearing the protective gloves.

Perhaps the strongest influence, however, on the increasing presence of women in the calendar came from one compellingly persuasive source. Over long centuries, the Church had refined its devotional exercises for the laity. By the end of the period, confessional manuals contained a variety of questions, tailored for people in many walks of life. One English handbook for a priest, drawn up in the fifteenth century, advised him on how to lead the members of his flock to talk about their conduct, and how to adjust his approach to different kinds of parishioners, whether merchants, craftsmen, or housewives.[62] The inclusion of women in this list, and others like it, brought them more into focus as subjects for attention in their own right. The design of such a treatise both reflected and enhanced a growing awareness that while the ideal community might be likened to a seamless garment, its fabric was woven from strands of many colors. The increasing emphasis on individual souls, all alike, because of a shared human condition, and yet each different, with its own idiosyncratic character and bias, led to a shift of emphasis in the representation of life, even in the entrenched and conservative calendar tradition. Although the single figure of a man continued to be the familiar personification of society, occasional hints of complexity crept in, to change the picture and its message. Whenever women joined the cast of actors, their presence sig-

naled a recognition of life's diversity. They had always had a place in the real world, but it was only when conditions were ripe that a place could be found for them in art's image of that world. Women are presented with men as fellow sinners in the congregation on Ash Wednesday, in Color Plate 7-14; more and more often in the calendar, as the Middle Ages draw to a close, they are shown with men as fellow workers.

Chapter 7 Notes and References

1. George Zarnecki, *Romanesque Lincoln* (Lincoln: Honywood Press, Lincoln Cathedral Library, 1988), p. 46 and fig. 47.

2. M. D. Anderson, *Drama and Imagery in English Medieval Churches* (Cambridge: Cambridge University Press, 1963), p. 176.

3. P. Mane, *Calendriers et Techniques Agricoles (France-Italie, XIIᵉ–XIIIᵉ siècles)* (Paris: Le Sycomore, 1983), pp. 99, 285, fig. 72; p. 305, fig. 188.

4. J. Le Sénécal, "Les occupations des mois dans l'iconographie du moyen âge," *Bulletin de la Société des Antiquaires de Normandie* (Caen), 35 (1924), p. 102.

5. C. Woodforde, *The Norwich School of Glass Painting in the Fifteenth Century* (London and New York: Oxford University Press, 1950), p. 155.

6. W. Fennor, *Pasquil's Palinodia* (London, 1619), quoted in David Cressy, *Bonfires and Bells; National Memory and the Protestant Calendar in Elizabethan and Stuart England* (Berkeley and Los Angeles: University of California Press, 1989), p. 18.

7. Woodforde (see note 5), pp. 150–51.

8. E. Le Roy Ladurie, ed., *Paysages, paysans; l'art et la terre en Europe du Moyen Âge au XXᵉ siècle* (Paris: Bibliothèque Nationale de France and Réunion des Musées Nationaux, 1994), p. 51, illustration 18.

9. September, Pressing Grapes and Pouring Wine into Casks. Book of Hours of Margaret de Foix, France (northwest), c. 1470s, National Art Library, The Victoria and Albert Museum, London, Salting MS 1222, fol. 9 recto.

10. Woodforde (see note 5), p. 155.

11. Spinola Hours, probably Ghent or Malines, c. 1515, The J. Paul Getty Museum, Los Angeles, California, Ludwig MS IX.18, fol. 2 recto, February; Book of Hours, France, early sixteenth century, The Walters Art Gallery, Baltimore, MS 451, fol. 5, March. Illustrated in Roger S. Wieck, *Time Sanctified; The Book of Hours in Medieval Art and Life* (New York: George Braziller Inc., in association with The Walters Art Gallery, Baltimore, 1988), p. 51, fig. 18.

12. Woodforde (see note 5), p. 155.

13. The Grimani Breviary, Flemish, c. 1517–18. Calendar pages probably by Gerard Horenbout, Biblioteca Marciana, Venice, MS Lat. XI. 67 (7531), calendar page for May. Modern edition with introduction by Mario Salmi, preface by Giorgio E. Ferrari (London: Thames & Hudson, 1972).

14. G. L. Remnant, *A Catalogue of Misericords in Great Britain* (Oxford: The Clarendon Press, 1969), p. 94. Misericord, possibly from East Anglia, now no. 5 in a collection of thirty-one misericords in The Victoria and Albert Museum, London.

15. *Paysages, paysans* (see note 8). Essay by Perrine Mane, "Le Paysan mis en scène," p. 46.

16. H. Bober, ed., *The St. Blasien Psalter* (Black Forest, c. 1230–35) (New York: H. P. Kraus, 1963), fol. 4 recto, July; H. Appuhn, *Der Psalter; Eine Bilderhandschrift* (Dortmund: Die bibliophilen Taschenbücher, Harenberg Kommunikation, 1980), modern edition of psalter from Lower Saxony, c. 1250–60, fol. 4b, July.

17. Women grape-harvesters can be seen, for example, in a Flemish book of hours of the early sixteenth century: The Fitzwilliam Museum, Cambridge, MS 1058–1975, fol. 9, September.

18. Mane (see note 3), p. 301, fig. 136.

19. Ibid., p. 305, fig. 195.

20. D. and H. Kraus, *The Hidden World of Misericords* (London: Michael Joseph, 1976), fig. 32.

21. Da Costa Hours, Bruges, c. 1515, Simon Bening. The Pierpont Morgan Library, New York, MS M399, October.

22. Book of Hours, Flemish, c. 1540, Simon Bening. Bayerische Staatsbibliothek, Munich, Clm 23638, August calendar page (b).

23. Book of Hours of Margaret de Foix (see note 9), fol. 10 recto, October.

24. Playfair Hours, French, c. 1480s, made in Rouen for the British market, The Victoria and Albert Museum, London, MS L475–1918, October.

25. Spinola Hours (see note 11), fol. 6 verso, November.

26. Flemish Book of Hours (see note 22), November.

27. Ibid., December; the "Golf" Book of Hours, Flemish, early sixteenth century, Simon Bening's workshop, The British Library, London, Add. MS 24098, fol. 19b, February.

28. The Hours of Adelaide of Savoy, French, c. 1450–60, Musée Condé, Chantilly, MS Lat. 1362, fol. 12 verso, December.

29. Folgòre da San Gimignano (active 1309–17). *De gennaio*, in *The Penguin Book of Italian Verse*, introduced and edited by George Kay (Harmonds-worth, Middlesex, U.K.: Penguin Books, 1958), p. 72.

30. Très Riches Heures of the Duke de Berry, French, Limbourg Brothers, 1415, Musée Condé, Chantilly, MS 65, fol. 5 verso, May.

31. St. Blasien Psalter (see note 16), fol. 3 recto, May.

32. Mane (see note 3), fig. 191.

33. Book of Hours of Margaret de Foix (see note 9), fol. 4 recto, April.

34. Two examples of manuscripts designed with a full-page illustration for each month and a supplementary border scene on the calendar page itself are the Grimani Breviary (see note 13) and the book of hours from Simon Bening's workshop, Munich MS Clm 23638 (see note 22).

35. Detached calendar leaf for May, Flemish, Simon Bening, c. 1540, The Victoria and Albert Museum, London, Salting MS 2538 verso.

36. Très Riches Heures of the Duke de Berry (see note 30), fol. 8 verso, August.

37. Illustrations of the entire Perugia fountain calendar are in Mane (see note 3), figs. 188–99.

38. For example, the Playfair Hours (see note 24) shows a man and a woman together in May, June, October, November, and December.

39. The Hours of Margaret de Foix (see note 9), fol. 2 recto, February. Another complete set of twelve calendar scenes, with a man and a woman in each scene, exists in the form of late medieval stained-glass roundels, from Colville Hall in Essex. See Woodforde (see note 5), p. 155.

40. Book of Hours, Flemish, end of the fifteenth century, Bibliothèque Nationale, Paris, MS nouv. acq. lat. 215, fol. 9 verso, February.

41. Woodforde (see note 5), pp. 150–52.

42. Book of Hours (Use of Tournai), Master Guillebert of Metz, c. 1440. The Bodleian Library, University of Oxford, MS Rawl.liturg. 14, fol. 10.

43. Le Sénécal (see note 4), pp. 71, 88.

44. E. Duffy, *The Stripping of the Altars; Traditional Religion in England, c. 1400–c. 1580* (New Haven and London: Yale University Press, 1992), pp. 15–22.

45. Book of Hours, French (Use of Rome), second quarter of the sixteenth century, The Bodleian Library, University of Oxford, MS Douce 135, fol. 3 recto, March; Hours of Adelaide of Savoy, French, c. 1450–60, Musée Condé, Chantilly, MS Lat. 1362, March.

46. M. R. Salzman, *On Roman Time; the Codex-Calendar of 354 and the Rhythms of Urban Life in Late Antiquity* (Berkeley and Los Angeles, and Oxford: University of California Press, 1990), pp. 95–96.

47. Le Sénécal (see note 4), p. 60, plate II, fig. 1.

48. E. Sears, *The Ages of Man; Medieval Interpretations of the Life Cycle* (Princeton: Princeton University Press, 1986), pp. 99–100.

49. Queen Mary's Psalter, English, first quarter of the fourteenth century, The British Library, London, Royal MS 2B VII, folios 75 verso–76 recto, April.

50. Book of Hours, Paris, c. 1415, The Walters Art Gallery, MS W.260, fol. 1 recto; listed in L. Randall, *Medieval and Renaissance Manuscripts in the Walters Art Gallery* (Baltimore: Johns Hopkins University Press in association with The Walters Art Gallery, 1989), vol. 1, no. 94.

51. F. Goodman, *Zodiac Signs* (London: Brian Trodd Publishing House Ltd., 1990), p. 62, fig. 69.

52. St. Blasien Psalter (see note 16), fol. 4 verso, August.

53. The Hours of Simon de Varie, French (Use of Paris), 1455; James H. Marrow, ed. The J. Paul Getty Museum, Los Angeles, in association with the Koninklijke Bibliotheek, The Hague, 1994; Plates 13 and 14, fols. 94 recto and 95 recto, July and August.

54. *Paysages, paysans* (see note 8), pp. 68–69, fig. 55.

55. Sears (see note 48), pp. 110–13.

56. A. M. Hind, *An Introduction to a History of Woodcut* (New York: Dover Publications, 1963) vol. 1, pp. 252–55, fig. 105.

57. R. Klibansky, E. Panofsky, and F. Saxl, *Saturn and Melancholy; Studies in the History of Natural Philosophy, Religion and Art* (New York: Basic Books Inc., 1964), pp. 204–7 and plate 40.

58. A. Morrall, "Saturn's Children; a Glass Panel by Jörg Breu the Elder in the Burrell Collection," *Burlington Magazine* 135, no. 1080 (March 1993), pp. 212–14, fig. 58.

59. E. Panofsky, *The Life and Art of Albrecht Dürer* (Princeton: Princeton University Press, 1971), p. 160, fig. 212.

60. L. C. Arano, *The Medieval Health Handbook, "Tacuinum Sanitatis"* (London: Barrie & Jenkins Ltd., 1976).

61. J. Backhouse, *The Luttrell Psalter* (English, c. 1330s), The British Library, London (1989), p. 17, fig. 15 (fol. 163 verso) and plate 24 (fol. 172).

62. Duffy (see note 44), pp. 58–59.

8

Pain into Pleasure

 Much was written in classical and biblical texts about the need for hard work, none of it designed to cheer the fainthearted. From Hesiod's *Works and Days,* to Virgil's *Georgics,* to the Bible's book of Proverbs, the message remained remarkably consistent and resolutely bleak:

> Hunger goes always with a workshy man.[1]

> Toil mastered everything, relentless toil
> And the pressure of pinching poverty.[2]

> The sluggard will not plough by reason of the cold;
> therefore shall he beg in harvest, and have nothing.[3]

For the Christian Europe of the Middle Ages, the picture was darkened still further by the belief that the harshness of the human condition had

been caused not by the caprice of fate but by human folly. Unremitting toil was the punishment imposed by God after the Fall; the burden was a penance, a daily reminder of the disobedience that had blighted the world, and barred the gate of Paradise: "Cursed is the ground for thy sake; in sorrow shalt thou eat of it all the days of thy life. . . . In the sweat of thy face shalt thou eat bread, till thou return unto the ground." (Genesis 3:17, 19)

Work had been enjoined on every class of society, every walk of life, but this concept of universal labor was traditionally embodied in the figure of a single peasant toiling on the land. The image was appropriate enough, for most people in the ancient and medieval worlds were engaged in some branch of agriculture, but the choice was unfortunate because farmwork was both obviously demanding and socially despised. All agreed, in public, that it had to be done, while all, in their hearts, felt comfortably convinced that it was best done by somebody else. As the anonymous author of a thirteenth-century French motet cheerfully confessed:

> On parole de batre et de vanner
> Et de foir et de hanner;
> Mais ces deduis trop me desplaisent,
> Car il n'est si bone vie que d'estre à aise
> De bon cler vin et de chapons,
> Et d'estre avec bons compaignons. . . .
> Et tout ce treuve on à Paris.

[Some talk of threshing and winnowing, digging and plowing, but I care nothing for these sports; for there is no life so good as to be well supplied with good clear wine and capons, and to be with good companions. . . . And all this can be found in Paris.][4]

The peasant's lot was not only hard but downright disagreeable, with few rewards to be hoped for except in the afterlife. The dreariness of its drudgery was so repellent to the hero of the charming thirteenth-century French romance, *Aucassin et Nicolette,* that he frankly preferred hell, "where the gold and silver go, . . . the harpers and minstrels and the kings of the world," to the social wasteland of heaven, populated by "those dressed in old worn cloaks and old garments, naked, barefoot and bare-legged, who die of hunger and thirst and cold and wretchedness. They go to Paradise; I have nothing to do with them!"[5]

Work on the land was a burden for the peasant, but it also posed a

problem for the artist. How was it possible, with such unpromising materials, to fashion an image of labor that would be acceptable to every viewer? The answer, as always, lay in art's miraculous power to reshape reality, to soften the harshness, sweeten the bitterness, distance the pain.

The simplest approach was to dwell, whenever possible, on the comfort to be found in the pleasures and pauses of the workday, those precious punctuation points that change the rhythm of an all-too-familiar routine. Such hints of relaxation were added most often to the calendars of the later period, the fifteenth and sixteenth centuries, but occasional flashes of fun light up the scene in earlier examples as well. The little figures gaily sledding and skating their way across the bottom of a February page in Fig. 8-1 appear in a Flemish psalter of the fourteenth century. (For other images of winter sports, see Fig. 1-2 and Fig. 7-10.)

Fig. 8-1 shows not only this border illustration but also the principal scene chosen for the month in the same manuscript, the celebration of

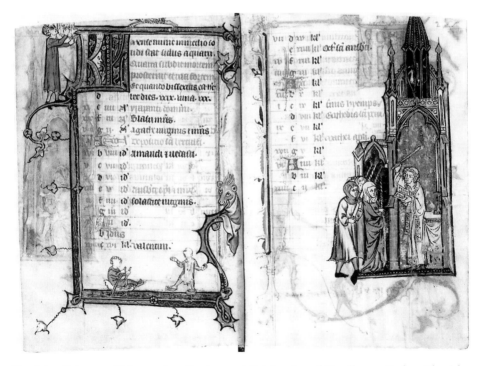

Fig. 8-1. February. Tobogganing, Skating, and Celebration of Candlemas. Psalter, Flemish, Ghent(?), early fourteenth century. The Bodleian Library, University of Oxford, MS Douce 5, fol. 1 verso–fol. 2 recto.

Candlemas, on February 2. The Church's cycle of feast days to commemorate the most important events in the Christian year broke and brightened the monotony of the daily round. On these dates, attendance at church services took precedence over labor in the field, and the form of the services brought drama and dignity, color, ceremony, and an element of grandeur to the humdrum world of the community. Such annual commemorations enriched the emotional life of those taking part. They were occasions not simply for devotion or penance, but also for excitement and release, and they were relished accordingly, as serious entertainments. The "labors of the months" tradition rarely makes reference to the church year, but two of the great feasts do, from time to time, appear in the calendar cycle: Candlemas, as here, and Ash Wednesday, the first day of Lent (see Color Plate 7-14).

Long hours of work leave little time for leisure, but the enterprising can always find a moment to catch enjoyment on the wing. In Fig. 7-8, two mowers are giggling and flirting in June's hayfield and, in another scene, shepherds companionably make music together as they guard the goats that represent the zodiac sign for December. (See Queen Mary's Psalter, The British Library, London, Royal MS 2B VII.)

Eating while on the job is a welcome diversion in a demanding day, and artists sometimes used the theme to brighten their picture of working life. There was the official, sanctioned break, a picnic lunch enjoyed in the field at the height of harvest (Fig. 1-8), and there was the unofficial treat, the self-awarded indulgence. The September scene in the Duke de Berry's Très Riches Heures shows, among the busy laborers in the vineyard, one who has paused for a moment to pop a grape into his mouth. In the late twelfth-century labors cycle sculpted at Autun, a peasant picking fruit in June pensively treats himself to one sample as he strips the cherries from a laden branch.[6]

Even more endearing are the recorded moments of kindness, the sharing of impromptu pleasures with others. In Fig. 8-2, a man patiently holds a bowl of food for two tired cart horses as they wait for the signal to move off with their heavy load, and in Fig. 8-3, from the same manuscript, a woman in an orchard holds out an apple to an eager little boy, while the serious business of harvest goes on behind them.

The presence of animals or children adds a special sweetness to any scene, whether or not they make a contribution to the work in hand, and artists, well aware of this, occasionally include them just for the sake of their charm. In the border of Fig. 4-10, it is impossible to overlook the determined little boy who stands with his toy wagon in the middle of a

Fig. 8-2. July. Feeding Cart-Horses During Harvest. Manuscript
fragment, Flemish, Bruges, illustrated by Simon Bening, early
1540s. Bayerische Staatsbibliothek, Munich, Clm 23638, fol. 9 recto.

farmyard while April's occupation, the driving out of sheep from winter
quarters to spring pasture, goes on around him. The small figure is irrele-
vant, but irresistible.

A late Flemish stained-glass roundel from Foulsham Church in Norfolk
shows an autumn scene, in which one man is doing the real work, harrow-
ing a field while, tucked away to the side, another man is engaged in the
far more absorbing task of teaching his dog to beg.[7] The tiny detail makes

Fig. 8-3. August. Apple Harvest. Manuscript fragment, Flemish, Bruges, illustrated by Simon Bening, early 1540s. Bayerische Staatsbibliothek, Munich, Clm 23638, fol. 10 recto.

the medieval world feel, for a moment, very close to the viewer today, just in the same way as does the discovery that a memorial brass, from yet another church in Norfolk, shows not merely the figure of a knight with a dog at his feet but, carefully cut into the metal, a record of the dog's name, "Jakke."[8]

Farmwork made heavy demands on those who performed it. Out in all weather, they had few defenses against the vagaries of climate, and were

especially vulnerable to the extremes of cold and heat. The miseries, in real life, of freezing temperatures, little fuel, little food, a leaking roof, and a persistent draft make it entirely understandable that the corrective calendar image for January or February is of a snug interior, relaxation round a blazing fire, and supper ready on the table (Fig. 6-1). (For this theme, see Chapter 2.)

Dogs, cats, and children have a fine-tuned appreciation of their own creature comforts, and are sometimes to be seen contentedly toasting toes on a well-swept hearth (Color Plate 6-6 and Fig. 6-8). They found their way to this prime position quite early in the history of the medieval calendar tradition. In an English manuscript from the end of the twelfth century, now in the Bodleian Library, a cat superintends the cooking activity in a January picture,[9] and another warns herself at her master's side in an early thirteenth-century stained-glass window from the church of Brie-Comte-Robert in northern France.[10]

The other side of discomfort that had to be countered in the calendar scheme was the misery of hard labor under a burning sun, harvesting a very dusty grain crop. Nothing could be more welcome in such conditions than a long, cold drink to quench the thirst, and that is exactly the reward being enjoyed by a reaper in Fig. 8-4. He stands between the fruits of his labors, two neatly bound stacks of wheat, and pours down his parched throat the contents of one large jug. How basic was the human need, and how profound the satisfaction, of such pleasure at the height of harvest are implied by the fact that the act of drinking deep has been an image for August since classical times. In the Roman calendar of A.D. 354, the figure for that month is a naked young man, drinking from a large glass bowl.[11]

Whether softened by such touches of indulgent observation, or presented with severe sobriety, the calendar cycle's familiar images were supposed to convey to their viewers, in every rank of society, a spiritual lesson about the necessity of work in life on earth. Sometimes the cycle was displayed in a public place, and then indeed the figures were set forth for all to have the chance to see them. Rich and poor, the powerful and the helpless, passed through the great western doorway of Autun Cathedral, and could not fail to notice, sculpted above their heads in the entrance, a gigantic Last Judgment, framed by an ornamental band in which appeared the labors of the months. Any citizen could make use daily of the public fountain in Perugia, and look at the cycle carved around it. Every baby in the village of Brookland in Kent was christened at the lead font inside the church; that child, and every one of its relations, had ample opportunity over the years to study the calendar scenes that adorned the font.

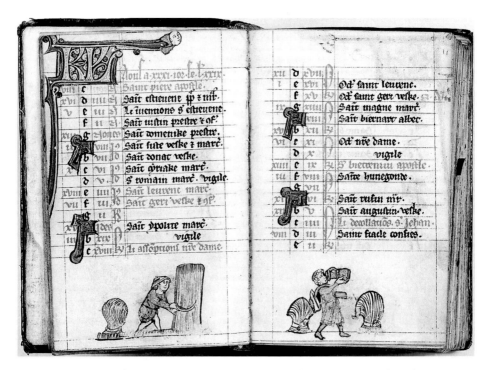

Fig. 8-4. August. Refreshment at Harvest Time. Book of Hours, Franco-Flemish, Cambrai(?), early fourteenth century. The Walters Art Gallery, Baltimore, MS W88, fol. 10 verso–fol. 11 recto.

More and more often, however, and particularly so in the late medieval period, the labors cycle decorated far more private spaces. The motif might appear, with charming incongruity, on a sumptuous gold and enamel bowl, made to gleam at a great man's feast,[12] in the calendar pages of a book of devotions that belonged to just one person, or on a stained-glass roundel set in the window not of a public building but a family home (see Fig. 8-7). Those who could afford such pleasant luxuries of ownership were rarely very interested in the details of the life led by peasants who performed the necessary agricultural tasks enshrined in the tradition. They loved the harvest, not the harvesters. This being so, there came the inevitable human reaction. Quite naturally, artists began to introduce details—indeed, whole scenes—that were of far more absorbing interest to their patrons, because they directed attention not to the peasants' labors but to activities enjoyed by those patrons and their peers. So, in Fig. 8-5, February's traditional scene of warming by the fire has been transformed.

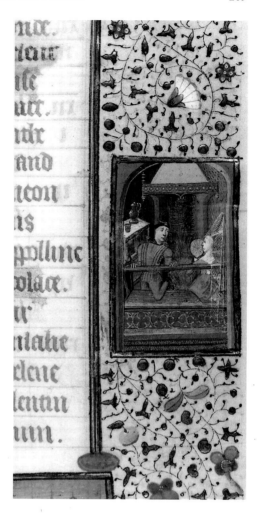

Fig. 8-5. February. Fireside Flirtation. Book of Hours, French, 1480. The Fitzwilliam Museum, Cambridge, MS 74, fol. 2 recto. Detail.

The fire is still there, so hot that one figure has to screen her complexion from the blaze, but it is no longer presented as a robust defense against the rigors of winter. Instead, the fireside has become the setting for a comedy of cautious flirtation, between a haughty young woman and a dashing young man with a bold, appraising eye.

The temptation to insert such congenial scenes was hard to resist, and resistance was rarely very resolute, although few if any carried cheerful self-indulgence quite as far as the owner of a book of hours made in south Germany or Austria at the beginning of the sixteenth century, for whom a calendar cycle was designed in which every single month of the year was

illustrated with a hunting scene.[13] More conventional variations were more conservative. The traditional labor of the month was always included in the design, but pushed well away into the background, so that the spotlight could focus on glamorous new features in the picture. In Fig. 8-6, a November scene, the month's usual preoccupation—fattening pigs—has been woven into the composition, but it is now a minor thread, an incidental detail. The foreground is dominated by the figure of a powerful, wealthy huntsman, riding home after a day of sport with his trophy, a stag, slung over the back of the second horse pacing beside him.

Although the huntsman is an unusual addition to the November scene, he is an appropriate one. His own occupation is suitable for a month that is not only dominated by the question of the winter meat supply but also under the influence of a zodiac sign, Sagittarius the Archer, who is himself a huntsman. However arbitrary the selection of new activity for a calendar month may seem at first sight, it is usually possible, as here, to trace the web of associations that bind it lightly to the conventions of the ancient tradition.

In the Flemish Hennessy Hours (Brussels, Bibliothèque Royale, MS II. 158), made c. 1530–35 and illustrated by Simon Bening, the November scene is an archery contest, enjoyed by a very comfortable, well-to-do group of friendly competitors. No room has been found for any pig-fattening, even though the scene is daringly spread over two full calendar pages, with arrows shot from the left landing right on target on the facing leaf. Still, there is one link, however tenuous, between the pastime and the month. High up in the sky can just be seen the tiny figure of Sagittarius with his bow and arrow, hovering with approval over his acolytes below.

It is interesting that a Mahzor, a Jewish festival prayerbook made long after the Middle Ages had come to an end, for Alexander David of Braunschweig, adapted the old "labors of the months" conventions for its own purposes, and represented Kislev, the month in which Hanukkah is celebrated, by a hunter with a pair of hounds.[14] Hanukkah is a movable feast, whose date falls at some time in December, a month that is still under the influence of Sagittarius the Archer-Hunter, the zodiac sign that is dominant from November 21 to December 21.

The interest in the pleasures of the powerful and the prosperous that marks many calendars of the later period is a new departure, but it is a development that had certain justifying precedents in the long-established conventions of the ancient tradition. From the early days, January's feast was often enjoyed by an obviously important householder, and sometimes, indeed, by crowned monarchs, as in the early fourteenth-century

Fig. 8-6. November. Return from the Hunt. "Golf" Book of Hours, Flemish, early sixteenth century. The British Library, London, Add. MS 24098, fol. 28 verso. By permission of The British Library.

manuscript made in England and known today as "Queen Mary's Psalter" (London, The British Library, Royal MS 2B VII). The figure for May in French and Italian calendars of the twelfth and thirteenth centuries was either a youthful knight—sometimes riding, sometimes leading his horse to graze—or a gallant, courtly young man with a hawk on his wrist, enjoying a day of sport.[15]

Such figures, however, are abstractions or types. They represent Spring itself, personified as carefree, courageous youth. By contrast, in the most striking examples among the later calendars, the cycle has been deliberately tailored to fit the personality and interests of one particular patron. In the most familiar example, the Très Riches Heures, made for the Duke de Berry in the early fifteenth century, the duke himself presides over January's feast, and the farming activities in several of the other months go on beneath the walls of the duke's own castles, or of the city of Paris that he knew so well. An even more elaborately personalized cycle can still be seen in the fifteenth-century frescoes inside the Palazzo Schifanoia in Ferrara, where the occupations chosen to represent the months of the year are the favorite pastimes and pleasures of the city's current master, the great Duke Borso.[16]

These are exceptional cases, created for patrons of unusual power, means, and aesthetic daring. Such exotic specimens drew nourishment, however, from a fertile ground of tastes and attitudes held in common by many in far less liberating circumstances. Most of the books of hours and other manuscripts in which calendar illustrations are found were never custom-made with one particular patron in mind. They were produced, instead, for an international market, and tailored to satisfy the "average" taste of an "average" customer, a buyer who might walk in from the street to select a ready-made manuscript in person, or one who lived hundreds of miles away, in a different country, and came into possession of the finished product by choice or by chance. The Da Costa Hours (New York, The Pierpont Morgan Library, MS 399) was a book created around 1515 in a Flemish studio, with calendar scenes designed by Simon Bening. The manuscript seems to have been intended originally for a royal owner, the Infante John of Portugal, but in the end it was presented to Don Alvaro da Costa, first chamberlain to the Infante's father, King Manuel I. In due course, on several leaves, the Da Costa arms were painted over those of the royal family.[17]

It is fascinating, though futile, to speculate about what the reactions might have been when Portuguese eyes studied the very Flemish calendar cycle. What did Don Alvaro think when he first looked, for example, at

Color Plate 6-6? Was he intrigued or disturbed by some inevitably unfamiliar details in that cozy fireside scene? When he examined a farming picture, was he aware, as a modern expert might be, that the equipment of a Flemish sheep-shearer (Color Plate 4-11) was not quite the same as that used by a Portuguese counterpart? Did he notice? Did he care? Was he puzzled, provoked, or delighted by such differences? Or, having only the haziest notion of what even a Portuguese spade looked like, let alone a Flemish one, was he comfortably cushioned from any pressure to provide informed analysis?

These are tantalizing questions, impossible to answer because so little is known about the way the medieval mind responded to such pictorial representations of the real world. That they gave pleasure seems indisputable, for the book trade of the late fifteenth and early sixteenth centuries was dominated by Flemish workshops that made their reputations with ever more engaging simulations of daily life. Whether they were universally popular despite or because of their regional idiosyncrasies remains a mystery. The problem posed by local details in manuscripts intended for an international market must have been somewhat like that lying behind the debate today on the merits of celebrating Mass in Latin or in the vernacular. The use of the latter adds immediacy for the local congregation, but diminishes the sense of shared community for the visiting stranger from elsewhere.

To make the mystery even more baffling, it is hard to tell how knowledgeable the eye of any owner of a set of calendar scenes was when it fell on the images of working life depicted there. We may strongly suspect that a great lord and master of vast estates like the Duke de Berry was alert to fluctuations in rents and yield, while profoundly indifferent to the niceties of current agricultural practice, but, for lack of evidence, we cannot be quite sure. It is a rare stroke of good luck to be able to link somebody known for his informed interest in farming matters with a surviving labors cycle. "Master Fitzherbert," Sir John Fitzherbert (d. 1531), first published his *Book of Husbandry* in 1523, a practical treatise on farming so popular that it was reissued many times. Sir John lived at Norbury Manor, in Derbyshire, a house where one can still see a set of six late fifteenth- or early sixteenth-century Flemish stained-glass roundels, illustrating the calendar tasks for the first half of the year. The scene for June (Fig. 8-7) shows a man pulling up weeds, with the help of two tools, a forked stick and a weeding hook. Each is set on a long handle, so there is no need for the laborer to bend down to the job. Instead, he stands comfortably upright, just as Fitzherbert claims he will be able to do in chapter 21, "Howe to

Fig. 8-7. June. Weeding. Stained-glass roundel, Flemish(?), Norbury
Manor, Derbyshire, late fifteenth to early sixteenth century. Reproduced
from an illustration in George Bailey, "The Stained Glass at Norbury
Manor House," *Transactions of the Derbyshire Archaeological and Natural
History Society,* vol. 4 (1882), pp. 152–58, plate ix.

wede corne": "And with these two instruments, he shall never stoupe to
his warke."[18] It is pleasant to think of the author glancing with satisfaction
at the roundels from time to time in the course of an ordinary day, to find
their naive charm not totally at odds with the hard realities of the life he
knew on the land.

Sir John is a notable exception. In general, it may be claimed that the
upbringing of most medieval book or property owners, in other words, of
those comfortably well-to-do in their society, conditioned them to view
farmwork from a great distance with, if anything, distaste rather than any
sense of engagement. One of the many eccentricities that brought down

on the unfortunate Edward II of England nothing but the brutal disdain of his contemporaries was an inappropriate enthusiasm for digging ditches and mending fences with his own hands.[19] Far more usual, and far more socially acceptable, was an appreciation of country life in principle, once it had been safely refined and rarefied by art.

The trouble with art's powerful magic is that the glamorous illusion it creates can be disconcertingly deceitful. An Italian humanist, Maffeo Vegio, was enchanted by the picture of rustic joys painted by Virgil in his *Georgics,* but bitterly disillusioned when, in 1425, the plague forced him to exchange the familiar corruption of big-city life for the innocent charm of a real village, where he was faced with those special country pleasures never mentioned by the great Roman poet: bugs, midges, and unending rain.[20] Sir John Harington, in 1591, confessed that he found his own plow-man's hard-won advice on how to prepare a field for planting intolerably tedious, but confided that, fired by a line or two from the *Georgics* on the same subject, "I could find it in my heart to drive the plough."[21] Other, unrecorded, enthusiasts were doubtless similarly disconcerted to discover that art is not a mirror-reflection of life but a bewitching rearrangement of reality.

Though misleading, art's illusions can provide sustaining pleasures, and it is possible to imagine the owner of a book of hours taking refuge with relief from the mud-caked fields and sullen skies of an all-too-real day of early spring, in the brilliant colors and confident design of the appropriate calendar page for March.

The realistic and yet romanticized depictions of country tasks and country pleasures, however enjoyable, are not the most important reasons for the sense of serene well-being conveyed so satisfyingly by the calendar convention. Such touches are only punctuation points, tiny highlights put in to brighten the occasional scene. They are scattered too thinly through-out the vast body of surviving material to change the nature of the genre itself. Far more profound in its effect is the steady, consistent tone charac-teristic of the tradition as a whole.

Each example, whether crude or courtly, demonstrates the satisfaction to be earned by prudence, foresight, skill, and preparation. Each conveys a sense of pleasure in performance, and trust in a system where effort and reward are held in perfect balance. Work is viewed not as drudgery and not as penance, but as self-fulfillment. Neither pain nor pressure casts a shadow to darken the mood, although it is true that one particular image of injury can be found in some of the earlier examples. March is a month often associated with the tasks of pruning vines and trimming trees, activi-

ties that produce plenty of sharp splinters and, from time to time, as in the cycle carved around the great public fountain in Perugia (1278), it is represented, rather appropriately, by the figure of a man trying to pull a thorn out of his foot.[22] The motif was inherited from the classical world but, because any image of accident and injury jarred the tone of the tradition, this one did not keep its place there, and had vanished from the scheme by the later Middle Ages.

Even more remarkable, in the hierarchical world of medieval society, is the absence of authority figures, or signs of orders being given and obeyed. Exceptions to this general rule are very rare in the early period. One can be found in the August scene of a psalter, possibly from Liège, and made in the 1280s, where the harvest is being gathered under the eye of an overseer armed with a club.[23] In calendars made at the very end of the Middle Ages, there is indeed acknowledgment at times that in this life some direct, while others drudge. In Color Plate 4-11, a bailiff watches the sheep-shearers as they concentrate on the job at hand, and in Fig. 3-10, a gardener receives instructions from his master. Touches like these must have come to seem entirely fitting in calendars designed for the private pleasure of prosperous patrons, even though they defied tradition.

Despite these hints of life's realities, there is nothing to suggest resentment or coercion. The dignity of all parties is preserved, and the relationship is one of respect. Each encounter is one more proof that the world is in tune. In the calendar tradition the whole community is at work, but all the figures seem to function without pressure or constraint. They are independent, and freely make their contribution to the common good. Interestingly, those classical authors like Virgil who praised the beauties of country work and country life chose to write not about absentee landlords and huge, brutally run slave farms, but about the free farmer of modest means, the smallholder and his wife, who worked their own land and reaped their own sufficient livelihood.[24]

Something of this spirit shapes the labors of the months convention. The workers shown are not the desperately poor but the decently poor; there is no sense of humiliation or fear, no hint of utter dependence on the whim of an all-powerful lord. The sharp abrasions of working life in the real world have been smoothed away, to make a picture comfortable, and therefore pleasurable, to contemplate. Once both pain and pressure have been removed, it is possible to appreciate without reservation the spectacle of work itself as an art, one in which skill and experience, applied in the right way and at the right time, conjure order out of chaos, and coax from the reluctant earth a rich reward:

Moving thusgait, grit myrth I tuke in mynd
Of lauboraris to se the besines,
Sum makand dyke, and sum the pleuch can wynd,
Sum sawand seidis fast from place to place,
The harrowis hoppand in the saweris trace.
It wes grit joy to him that luifit corne
To se thame laubour, baith at evin and morne.

[As I strolled along in this way, I was really delighted to watch the farmhands busily at work, some building walls, some plowing, some scattering seed here and there, while the harrows hopped along in their track. For anyone who loved a harvest it was a joy to see them working away from dawn to dusk.][25]

Chapter 8 Notes and References

1. Hesiod, *Works and Days,* trans. M. L. West, The World's Classics (New York and Oxford: Oxford University Press, 1988), p. 46, line 302.

2. Virgil, *The Georgics,* trans. L. P. Wilkinson (Harmondsworth, Middlesex, U.K.: Penguin Books Ltd., 1982), p. 61, book 1, lines 145–46.

3. Proverbs 20:4.

4. B. Woledge, *The Penguin Book of French Verse,* vol. 1: *To the Fifteenth Century* (Harmondsworth, Middlesex, U.K.: Penguin Books Ltd., 1961), p. 207.

5. L. R. Muir, *Literature and Society in Medieval France; The Mirror and the Image, 1100–1500* (Basingstoke & London: Macmillan, 1985) p. 102: "Aucassin et Nicolette", S.vi, lines 26–43.

6. P. Mane, *Calendriers et Techniques Agricoles (France-Italie, XIIᶜ–XIIIᶜ siècles)* (Paris: Le Sycomore, 1983), p. 206, fig. 20.

7. C. Woodforde, *The Norwich School of Glass Painting in the Fifteenth Century* (Oxford, London, and New York: Oxford University Press, 1950), p. 156.

8. G. E. Hutchinson, "Attitudes Towards Nature in Medieval England," *Isis,* March, 1974, p. 13, n. 8.

9. J. C. Webster, *The Labors of the Months* (Princeton: Princeton University Press, 1938), plate LXIII.

10. Mane (see note 6), pp. 98, 298.

11. M. R. Salzman, *On Roman Time; The Codex-Calendar of 354 and the Rhythms of Urban Life in Late Antiquity* (Berkeley and Los Angeles, and Oxford: University of California Press, 1990), p. 94, n. 153, figs. 19, 39, 47.

12. J. Stratford, *The Bedford Inventories* (London: Society of Antiquaries of London, 1993), pp. 61, 318.

13. J. Backhouse, *Books of Hours,* The British Library, London (1985), p. 12 and fig. 8.

14. S. Schama, "Narrow Spaces; In the Salons of the Court Jews and the Cellars of War-Time Holland," *The New Yorker,* September 23, 1996, p. 96.

15. Mane (see note 6), pp. 81–87, figs. 5, 19.

16. J. Seznec, *The Survival of the Pagan Gods* (New York: Harper Torchbooks,

The Bollingen Library, Harper & Brothers, 1961), pp. 74–76.

17. M. Smeyers and J. Van der Stock, eds., *Flemish Illuminated Manuscripts, 1475–1550* (Ghent: Ludion Press, 1996), pp. 38–39. Distributed by Harry N. Abrams, New York.

18. W. W. Skeat, ed., *"The Book of Husbandry," by Master Fitzherbert,* English Dialect Society (Ludgate Hill, London: Trübner & Company, 1882), p. 31, chap. 21.

19. H. Johnstone, *Edward of Carnarvon, 1284–1307* (Manchester: Manchester University Press, 1946), pp. 129–30.

20. L. P. Wilkinson, *The Georgics of Virgil,* (Cambridge: Cambridge University Press, 1969), p. 291.

21. R. McNulty, ed., *Sir John Harington's Translation of "Orlando Furioso"* (1591) (Oxford: Clarendon Press, 1972), Harington's "Preface," p. 7.

22. Mane (see note 6), fig. 190.

23. J. H. Oliver, *Gothic Manuscript Illumination in the Diocese of Liège (c. 1250–c.1330)* (Leuven: Uitgeverij Peeters, 1988), item no. 32 (The Bodleian Library, University of Oxford, Add. MS A. 46).

24. Wilkinson (see note 20), pp. 52–54.

25. P. Bawcutt and F. Riddy, *Selected Poems of Henryson and Dunbar* (Edinburgh: Scottish Academic Press, 1992), p. 43: Robert Henryson, *The Preaching of the Swallow,* lines 1720–26.

Appendix:
The Calendar Page Decoded

From time to time, the labors scenes and zodiac signs were chosen as ornamental motifs for calendar pages placed at the beginning of such devotional volumes as psalters and books of hours. Because of this connection, it may interest some readers to learn more about the functional nature of the calendar pages themselves, the information they offered, and the ways in which that information was conveyed.

The calendar was a guide to the church year, listing all the major feasts, such as Christmas and the Annunciation, and some important saints' days. Whereas the feasts were celebrated everywhere, there were considerable variations in the choice of saints to be honored. That was determined by local custom in the region for which the calendar had been prepared, or by the personal preference of the patron who had commissioned it.

The year was divided into months, of course, with each month allotted either one or two pages, depending on the lavishness of the available resources. Different degrees of refinement in taste and technique led inevitably to different degrees of elegance in the finished result, but most examples provide much pleasure for the eye. Some, like Fig. 1-6, are so packed with detail that they resemble densely patterned carpets, glowing with color and sparkling with gold. Especially important feasts are often highlighted by the use of a special color, either red (the choice responsible for the familiar phrase "red-letter day") or gold. The rest of the calendar may be written out in black or brown, but the most charming, and most

luxurious, examples often use blue or red, sometimes in alternate lines, with the liturgical peaks of the month highlighted in gold.

The list of feast days presented on such a page is offered in the form of a *perpetual* calendar—that is, a calendar intended for use year after year forever, or at least until the loss or destruction of the page itself. Half-hidden, to modern eyes, within the elaborate design is an elegant calculating system that provided those able to master it with three methods by which to fit this general information into the framework for any one particular year. Application of the first method established the actual date in the month on which a specific feast was to be celebrated. Application of the second method determined the day of the week on which that date fell, and the use of the third method made it possible to calculate the date of Easter, a feast which, unlike Christmas (December 25) is not fixed but movable.

Establishing the Date

The technique used to pinpoint a date in the month is hard to grasp for readers today, because the calendar conventions now in common use are very different from their medieval counterparts. The Middle Ages inherited the Julian calendar system, introduced by Julius Caesar in 45 B.C., in which dates were reckoned by their relation to three key days in each month: Kalends, Nones, and Ides.

The *Kalends* was the first day of any month, and so a large, decorative "KL" stands at the head of the calendar page, usually followed by a reminder (in Latin or in a vernacular) of the number of days in that month, and the days in its corresponding *lunar* month: "Aprilis habet dies XXX. luna XXIX," or "Avril a XXX iours. Et la lune XXIX." After this straightforward beginning, the important feasts of the church and saints' days for the month are listed in chronological order, one to a line, while to the left of this main block of text run either *two* columns, of numbers and abbreviations (KL, ID, N), or else just *one* column of abbreviations alone; see Figs. 5-1b and 5-1a. These are the places to which readers turned for information about the actual day of the month on which a particular feast was celebrated.

The *Ides* denoted the thirteenth day of the month, except in March, May, July, and October, when it came on the fifteenth day. The *Nones* were deemed to fall on the ninth day before the Ides (including the Ides

day itself in that reckoning). So, in January, for instance, the Kalends are on January 1, the Ides on January 13, and the Nones on January 5. In March, on the other hand, because the Ides come on the 15th, the Nones are on the 7th. Every other day in the month was assigned a number, reckoned *backward* from one of the three key dates. By consulting the column that contains numbers, it is possible to work out the numerical relationship between any given day and the key date which governs it. The abbreviations in the other column indicate whether a date is being calculated from the Kalends, Nones, or Ides.

A table which matches the modern calendar convention with the medieval one throws some light on how the earlier system worked:

			January		
Medieval Notation				*Modern Notation*	
Kalends		=		Jan.	1
IIII (= IV)	N	=			2
III	N	=			3
II	N	=			4
Nones		=		Jan.	5
VIII	ID	=			6
VII	ID	=			7
VI	ID	=			8
V	ID	=			9
IIII	ID	=			10
III	ID	=			11
II	ID	=			12
Ides		=		Jan.	13
XIX	KL	=			14
XVIII	KL	=			15
XVII	KL	=			16
XVI	KL	=			17
XV	KL	=			18
XIIII	KL	=			19
XIII	KL	=			20
XII	KL	=			21
XI	KL	=			22
X	KL	=			23
IX	KL	=			24

Medieval Notation			*Modern Notation*
VIII	KL	=	25
VII	KL	=	26
VI	KL	=	27
V	KL	=	28
IIII	KL	=	29
III	KL	=	30
II	KL	=	31

February

Kalends		=	Feb. 1

Two examples illustrate the way in which the date is identified in each system:

1. In a modern calendar, Epiphany is said to fall on January 6. In a medieval calendar, the feast is indeed celebrated on the same day, but the date is expressed as VIII ID—that is, the 8th day before the Ides of January (the 13th).

2. In a modern calendar, the date of the Feast of the Conversion of Saint Paul is January 25. In a medieval one, the date is set down as VIII KL—that is, the 8th day before the Kalends of February.

Establishing the Day of the Week

Yet another column, also placed in parallel, and to the left-hand side of the main body of the text, displays the letters A B C D E F G, repeated in sequence throughout each month of the year (see, for example, Fig. 5-1a). These, known as the hebdomadal (weekly) letters, represent the days of the week. The one which stands for Sunday is called the dominical letter. In the modern world, new calendars and pocket diaries flutter into every household in December, ready for instant use in the year to come. In the medieval world, by contrast, any household could consider itself lucky to be in possession of just one perpetual calendar for private use, designed to be consulted again and again as year succeeded year. This being so, it was important to master a simple code which, once deciphered, would indicate on which particular day of the week a particular feast would fall in any

one year. The key lay in making note of the day on which January 1 fell. Fortunately, for this step in the calculation, the owners of private calendars were not locked away in solitary confinement. They lived in the world, and received a hundred helpful signals from their neighbors. New Year's Day came exactly on the seventh day after Christmas, and both were true red-letters days, honored with elaborate church services and celebrated with gusto in grand feasts and general merrymaking. January 1 was very hard to miss. Its place in the week, too, was easily established, simply by counting the number of days that separated it from Sunday, that most distinctive pause in the workday week.

The code works as follows. If January 1 happens to fall on a Sunday, then the letter A will represent Sunday in the calendar throughout that particular year. If, on the other hand, the first Sunday comes on January 7, its letter will be G. Every other day of the week is fitted into the same alphabetical scheme, depending on the place of Sunday in the first week of the year. If Sunday falls on January 7, and is represented by G, then Monday will be A, Tuesday B, and so on. January 6, the Feast of the Epiphany, is always indicated in the medieval calendar by the number "VIII," the abbreviation "ID," and the letter F. VIII and ID are constants, since Epiphany is celebrated on the 8th day before the Ides of January, but F, representing the day of the week on which the feast day comes, is a variable, which must be calculated anew in each succeeding year. Whatever letter is assigned to Sunday becomes as well the letter by which the year is identified. When F represents Sunday, then the year is known as an F-year.

Establishing the Date of Easter

The outermost of the three, or four, narrow columns ruled in the left-hand margin of a calendar page contains a sprinkling of numbers, always within the range of 1 to 19, arranged apparently at random, in no obvious order (Fig. 5-1a). These, known as the "golden numbers," had an important part to play in the annual search for the date of Easter.

The Christian Easter, like the Jewish Passover to which it is historically linked in the Gospel narratives, is set according to the lunar calendar (of 354 days), not the solar calendar (of 365). Easter is celebrated on the first Sunday following the first full moon after the vernal equinox (March 21).

The golden numbers range from 1 to 19 because, according to calculations first made in 432 B.C. by Meton, a Greek astronomer, the new moon

falls on January 1 in every nineteenth year. The Christian world uses this "metonic cycle" (reckoned from 1 B.C.) in the calculation of Easter. In this "golden number" column on the calendar page, every day of the year is assigned either a number or a blank space. It is possible, using a complicated mathematical formula, to work out which of these is the "golden number" for a particular year. Armed with this knowledge, plus the *dominical letter* for that year (see the preceding section), and an "Easter Table" (a chart of supplementary information helpful in the reckoning), an experienced researcher can arrive at the date for Easter.

Quite obviously, this is not work for the fainthearted or the mathematically challenged. No calendar page could be considered properly dressed without these "golden numbers," and they were always included as essential elements in the composition, but only a trained mind could work out the combination that would unlock their secrets. Most readers must have expected to find them on the page, and been dimly aware of their importance, while lacking the ability to release the power of these elegant enigmas.

The system comprises many added refinements, including a solution to the problem posed by a leap year, but enough has been said to convey some idea of the official medieval approach to calendar computation. How many proud possessors of perpetual calendars could make the necessary calculations with sufficient competence remains a mystery. Familiarity breeds confidence, and brings a certain measure of comfort to the performance of any task, but most people were probably content to marvel over the elegance of their calendar pages, and then turn for guidance on knotty points to the more knowledgeable in their own familiar world.

In the ordinary transactions of daily life, the somewhat archaic Roman system, preserved like a fossil in the medieval calendar, may have been more honored as a powerful mystery than relied on as a practical tool. Certainly, by the late Middle Ages, everyday correspondence was dated in a very straightforward way that does not seem at all alien to the modern eye. Instead of any reference to, say, VIII ID or XV KL there is "At great Calais . . . the first day of June," or "Written at the Hirst, the thirteenth day of May," or "Given at Venice at the ninth hour of the night, on Saturday after Candlemass in the year 1506," or "Given at Nürnberg on Bartholomew's day 1508."[1] Indeed, in some late calendar pages (for example, Fig. 5-11), the numbering by reference to Kalends, Nones, and Ides has disappeared, and only the hebdomadal letters have been retained.

The official calendar, with its cryptic codes and conventions, required a cool head and a firm grasp of numbers. It will come as no surprise to the

bemused reader of today to learn that there was at least one medieval joke, preserved in a fifteenth-century Italian collection of tall tales, about the priest of a remote country village whose arithmetic became hopelessly muddled when he tried to calculate the date of Easter. On a visit to a neighboring town, he was disconcerted to discover that everybody there was celebrating Palm Sunday, while he himself had not yet even started his own parishioners on their Lenten penances. He had to rush back to his flock, explain that Lent was too old and tired to reach their village that year, and plunge them straight into the Easter festivities.[2]

For those interested in the subject, it is possible to become familiar with the layout of particular calendar pages by looking at a number of the illustrations in this book (for example, Figs. 1-2, 1-6, 1-7, 2-2, 5-2, 5-11, 6-13, 7-3, 7-8, 7-9 and Color Plate 6-15), or by studying the relevant pages in the modern editions listed in the Selected Bibliography. A comparison of several examples brings out clearly both the strong family resemblance shown by all calendars, and the variety of ways in which individual specimens present the same basic information to their readers.

For more detailed and expert guidance on the subject, the following studies are recommended:

Boyd, B. *Chaucer and the Liturgy,* Dorrance & Company, Philadelphia, 1967, chap. 2, pp. 9–25.

Neugebauer, O. *Astronomical and Calendrical Data in the "Très Riches Heures."* This is Appendix C in M. Meiss, *French Painting in the Time of Jean de Berry; the Limbourgs and Their Contemporaries,* The Pierpont Morgan Library, New York, 1974, text vol., pp. 421–32.

Pickering, F. P. *The Calendar Pages of Medieval Service Books,* Reading Medieval Studies, Monograph no. 1, Graduate Centre for Medieval Studies, University of Reading, U.K., 1980.

Wieck, R. *Time Sanctified; the Book of Hours in Medieval Art and Life,* George Braziller Inc., New York, in association with The Walters Art Gallery, Baltimore, 1988, Appendix, pp. 157–58.

Appendix Notes and Reference

1. C. Moriarty, ed., *The Voice of the Middle Ages in Personal Letters, 1100–1500* (New York: Peter Bedrick Books, 1989), pp. 211, 295, 296, 298.

2. S. Morris, *Fons Perennis; an Anthology of Medieval Latin* (London: George G. Harrap & Company, 1962), no. 53, pp. 83–84.

Selected Bibliography

This Selected Bibliography is divided into two sections. The first lists modern commentaries on the "labors of the months" motif and its historical background; the second lists modern editions of some medieval manuscripts that contain calendar pages decorated with "labors of the months" motifs.

Modern Commentaries on the "Labors of the Months" Motif and Its Historical Background

Arano, L. C. (1976). *The Medieval Health Handbook, "Tacuinum Sanitatis,"* Barrie & Jenkins Ltd., London.

Backhouse, J. (1985). *Books of Hours,* The British Library, London.

Brown, R. A.; Colvin, H. M.; and Taylor, A. J. (1963). *The History of the King's Works,* Her Majesty's Stationery Office, London.

Buchanan, I. (1990). "The Collection of Niclaes Jongelinck, II: The 'Months' by Peter Bruegel the Elder", *The Burlington Magazine,* 132 (August), pp. 541–50.

Burrow, J. A. (1986). *The Ages of Man,* The Clarendon Press, Oxford.

Cooper, H. (1977). *Pastoral: Medieval into Renaissance,* D. S. Brewer Ltd., Ipswich, U. K., and Rowman & Littlefield, Totowa, New Jersey.

Dal, E., and Skårup, P. (1980). *The Ages of Man and the Months of the Year,* Royal Danish Academy of Sciences and Letters, Copenhagen.

Dove, M. (1986). *The Perfect Age of Man's Life,* Cambridge University Press, Cambridge and New York.

Duby, G. (1980). *The Three Orders; Feudal Society Imagined,* trans. Arthur Goldhammer, University of Chicago Press, Chicago and London.

Duffy, E. (1992). *The Stripping of the Altars; Traditional Religion in England c. 1400–c. 1580*, Yale University Press, New Haven and London.

Egbert, V. W. (1974). *On the Bridges of Mediaeval Paris; A Record of Early Fourteenth Century Life*, Princeton University Press, New Jersey.

Fowler, J. (1873). "On Medieval Representations of the Months and Seasons," *Archaeologia*, vol. 44, pp. 137–224.

Frandon, V. (1998). "Du multiple à l'Un. Approche iconographique du calendrier et des saisons du portail de l'église abbatiale de Vézelay," *Gesta*, vol. 37, no. 1, pp. 74–87.

Goodman, F. (1990). *Zodiac Signs*, Brian Trodd Publishing House Ltd., London.

Hamel, C. de (1986). *A History of Illuminated Manuscripts*, David R. Godine, Boston.

Hansen, W. (1984). *Kalenderminiaturen der Stundenbücher; Mittelalterliches Leben im Jahreslauf*, Verlag Georg D. W. Callwey, Munich.

Harthan, J. (1977). *The Book of Hours*, Thomas Y. Crowell Company, New York.

Harvey, J. (1974). *Early Nurserymen*, Phillimore, London and Chichester.

———. (1981). *Medieval Gardens*, B. T. Batsford Ltd., London.

Hellerstedt, K. J. (1986). *Gardens of Earthly Delight: Sixteenth and Seventeenth Century Netherlandish Gardens*, The Frick Art Museum, Pittsburgh.

Howard, M. (1987). *The Early Tudor Country House; Architecture and Politics, 1490–1550*, George Philip, 27A Floral Street, London.

Kaiser-Guyot, M. T. (1974). *Le Berger en France aux XIVᵉ et XVᵉ siècles*, Editions Klincksieck, Paris.

Kipling, G. (1977). *The Triumph of Honour*, Leiden University Press, Leiden.

Klibansky, R.; Panofsky, E.; and Saxl, F. (1964). *Saturn and Melancholy; Studies in the History of Natural Philosophy, Religion and Art*, Basic Books Inc., Publishers, New York, and Thomas Nelson & Sons Ltd., London.

Kren, T. (1988). *Simon Bening and the Development of Landscape in Flemish Calendar Illumination*, Faksimile-Verlag, Lucerne.

Ladurie, E. Le Roy, ed. (1994). *Paysages, paysans; L'art et la terre en Europe du Moyen Âge au XXᵉ siècle*, Bibliothèque Nationale de France and Réunion des Musées Nationaux, Paris.

Lawson, S. trans. (1985). *Christine de Pisan, "The Treasure of the City of Ladies,"* Penguin Books Ltd. Harmondsworth, Middlesex, U.K.

Leroquais, V. (1927). *Les Livres d'Heures Manuscrits de la Bibliothèque Nationale*, Paris.

Le Sénécal, J. (1924). "Les occupations des mois dans l'iconographie du moyen âge," *Bulletin de la Société des Antiquaires de Normandie* (Caen), vol. 35, pp. 1–218.

Mane, P. (1983). *Calendriers et Techniques Agricoles (France-Italie, XIIᵉ–XIIIᵉ siècles)*, Le Sycomore, Paris.

Manion, Margaret M., and Vines, Vera F. (1984). *Medieval and Renaissance Illuminated Manuscripts in Australian Collections*, Thames & Hudson, London.

McLean, T. (1980). *Medieval English Gardens*, The Viking Press, New York.

Meiss, M. (1969). *French Painting in the Time of Jean de Berry; The Late Fourteenth Century and the Patronage of the Duke*, 2nd ed., Phaidon Press, London.

Morand, K. (1962). *Jean Pucelle*, The Clarendon Press, Oxford.

Owst, G. R. (1961). *Literature and the Pulpit in Medieval England*, 2nd ed., Basil Blackwell, Oxford.

Pächt, O., and Alexander, J. J. G. (1963–73). *Illuminated Manuscripts in the Bodleian Library, Oxford,* The Clarendon Press, Oxford.

Pearsall, D., and Salter, E. (1973). *Landscapes and Seasons of the Medieval World,* Paul Elek, London.

Pérez-Higuera, T. (1998). *The Art of Time; Medieval Calendars and the Zodiac,* Weidenfeld and Nicolson, London.

Power, E. trans. and ed. (1928). *The Goodman of Paris* (c. 1393), Routledge, London.

Pritchard, V. (1967). *English Medieval Graffiti,* Cambridge University Press, Cambridge.

Randall, L. (1989). *Medieval and Renaissance Manuscripts in The Walters Art Gallery,* Johns Hopkins University Press in association with the Walters Art Gallery, Baltimore.

Remnant, G. L. (1969). *A Catalogue of Misericords in Great Britain,* The Clarendon Press, Oxford.

Ryder, M. L. (1983). *Sheep and Men,* Gerald Duckworth & Company Ltd., London.

Salzman, M. R. (1990). *On Roman Time; The Codex-Calendar of 354 and the Rhythms of Urban Life in Late Antiquity,* University of California Press, Berkeley and Los Angeles, and Oxford.

Schapiro, M. (1941). "Review of J. C. Webster, *The Labors of the Months,*" *Speculum,* 16, pp. 131–37.

Sears, E. (1986). *The Ages of Man,* Princeton University Press, Princeton, New Jersey.

Seznec, J. (1961). *The Survival of the Pagan Gods,* Harper Torchbooks, The Bollingen Library, Harper & Brothers, New York.

Smeyers, M., and Van der Stock, J. eds. (1996). *Flemish Illuminated Manuscripts, 1475–1550,* Ludion Press, Ghent, distributed by Harry N. Abrams, New York.

Spencer, J., trans. (1984). *The Four Seasons of the House of Cerruti,* Facts on File Publications, New York and Bicester, England.

Starn, R. (1994). *Ambrogio Lorenzetti; The Palazzo Pubblico, Siena,* George Braziller, New York.

Tarapor, M., and Little, Charles T. eds. (1993). *The Art of Medieval Spain, A.D. 500–1200.* Exhibition catalogue, The Metropolitan Museum of Art, New York. Distributed by Harry N. Abrams Inc., New York.

Thrupp, S. (1962). *The Merchant Class of Medieval London,* Ann Arbor Paperbacks, University of Michigan Press, Ann Arbor.

Tuve, R. (1974). *Seasons and Months; Studies in the Tradition of Middle English Poetry,* D. S. Brewer Ltd., Cambridge, and Rowman & Littlefield Inc., Totowa, New Jersey. (Reissue; the book was first published in 1933.)

Webster, James C. (1938). *The Labors of the Months,* Princeton University Press, Princeton, New Jersey.

West, M. L. trans. (1988). Hesiod, *"Theogony" and "Works and Days,"* The World's Classics, Oxford University Press, Oxford and New York.

Wieck, Roger S. (1988). *Time Sanctified; The Book of Hours in Medieval Art and Life,* George Braziller Inc., New York, in association with The Walters Art Gallery, Baltimore.

———. (1997). *Painted Prayers; The Book of Hours in Medieval and Renaissance Art,* George Braziller Inc., in association with The Pierpont Morgan Library, New York.

Wilkinson, L. P. trans. (1982). Virgil, *The Georgics,* Penguin Books Ltd., Harmondsworth, Middlesex, U.K.

Williams, J. W. (1993). *Bread, Wine, and Money; The Windows of the Trades at Chartres Cathedral,* University of Chicago Press, Chicago and London.

Wood, M. (1983). *The English Mediaeval House,* Bracken Books, London (1st ed. 1965).

Woodforde, C. (1950). *The Norwich School of Glass Painting in the Fifteenth Century,* Oxford University Press, Oxford, London and New York.

Modern Editions of Some Medieval Manuscripts That Contain Calendar Pages Decorated with "Labors of the Months" Motifs

Bober, H. ed. (1963). *The St. Blasien Psalter,* H. P. Kraus, New York.

Chatelet, A. ed. (1967). *Les Heures de Turin,* G. Molfese, Turin.

Destrée, J. ed. (1923). *The Hennessy Hours,* Lamertin & Weckesser. Brussels.

Longnon, J., and Cazelles, R. eds. (1969). *The "Très Riches Heures" of Jean, Duke of Berry,* George Braziller, New York.

Marrow, James H. ed. (1994). *The Hours of Simon de Varie,* The J. Paul Getty Museum, Los Angeles, California, in association with the Koninklijke Bibliotheek, The Hague.

Meiss, M., and Beatson, E. H. eds. (1974). *The "Belles Heures" of Jean, Duke of Berry,* George Braziller, New York.

Meiss, M., and Thomas M. eds. (1973). *The Rohan Master, a Book of Hours,* George Braziller, New York.

Salmi, M., and Ferrari, G. E. eds. (1972). *The Grimani Breviary,* Thames & Hudson, London.

Thomas, M. ed. (1971). *The "Grandes Heures" of Jean, Duke of Berry,* George Braziller, New York.

Warner, G. ed. (1912). *Queen Mary's Psalter,* Printed for the Trustees of The British Museum, London.

Watson, R. ed. (1984). *The Playfair Hours,* The Victoria and Albert Museum, London.

Wormald, F. ed. (1973). *The Winchester Psalter,* Harvey Miller & Medcalf Ltd., London.

Index